July 2023

Harris—
 What an amazing
experience in Gettysburg.
May you find inspiration
in the stories of the people
and insight from the past!.
 Love
 Sarah

GETTYSBURG

GETTYSBURG
THE LIVING AND THE DEAD

KENT GRAMM

PHOTOGRAPHS BY CHRIS HEISEY

Southern Illinois University Press ✺ Carbondale

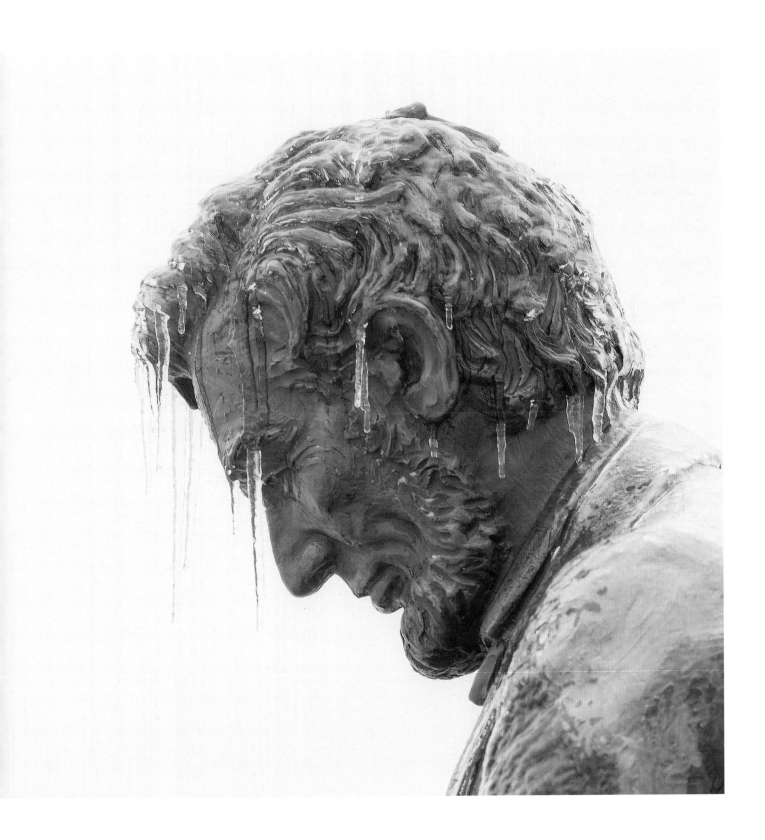

Southern Illinois University Press
www.siupress.com

22 21 20 19 4 3 2 1

Jacket illustration: Union General Gouverneur Warren
 Monument, Little Round Top; photo (cropped) by
 Chris Heisey

Frontispiece: Stan Watts, Abraham Lincoln Emancipation
 Proclamation Statue, Gettysburg College campus; photo
 by Chris Heisey

The authors thank Gettysburg College and the Civil War
 Institute for their generous assistance in financing the cost
 of the photographic images in this book.

Library of Congress Cataloging-in-Publication Data
Names: Gramm, Kent, author. | Heisey, Chris, photographer.
Title: Gettysburg : the living and the dead / text by Kent
 Gramm ; photographs by Chris Heisey.
Description: Carbondale : Southern Illinois University Press,
 [2019] | "The authors thank Gettysburg College and
 the Civil War Institute for their generous assistance in
 financing the cost of the ninety photographic images in
 this book."
Identifiers: LCCN 2018039596 |
 ISBN 9780809337330 (cloth ; alk. paper) |
 ISBN 9780809337347 (e-book)
Subjects: LCSH: Gettysburg, Battle of, Gettysburg, Pa., 1863.
Classification: LCC E475.53 .G735 2019 |
 DDC 973.7/349—dc23 LC record available at
 https://lccn.loc.gov/2018039596

Printed on recycled paper ♻

This paper meets the requirements of ANSI/NISO
 Z39.48-1992 (Permanence of Paper). ∞

For the living and the dead at Gettysburg

In great deeds something abides. On great fields something stays. Forms change and pass; bodies disappear, but spirits linger, to consecrate ground for the vision-place of souls. And reverent men and women from afar, and generations that know us not and that we know not of, heart-drawn to see where and by whom great things were suffered and done for them, shall come to this deathless field to ponder and dream; And lo! the shadow of a mighty presence shall wrap them in its bosom, and the power of the vision pass into their souls.

—Colonel Joshua Lawrence Chamberlain, 1889, Gettysburg

CONTENTS

Italic type indicates a historic or ghostly voice; plain type indicates a modern voice.

1. *Prologue: The Photographer (1863)* 1

I. THE FIRST DAY 2
2. *Carolina* 5
3. *Incident* 7
4. *What Is Truth?* 9
5. *One Art* 11
6. The Musician 13
7. *The Singer* 16
8. Blood Trail 17
9. 'Stang 21
10. The Forester 23
11. *A Mighty Fortress* 26
12. *Shame* 28
13. *Iverson's Pits (1927)* 29
14. *Courage* 33
15. *The Music Teacher* 36
16. Barlow's Knoll 37
17. *Almshouse* 41
18. Stayin' Alive 43
19. Peace Light 45
20. *Orphan* 48

II. THE SECOND DAY 50
21. *Blood and Water* 53
22. Excelsior 55
23. *Carolina Hell* 60
24. *The Old Country* 61
25. Sláinte *Forever* 65
26. *Brothers (1863)* 67
27. *Semper Fi* 70

28. *Adams County* 72

29. *The Face of Battle* 73

30. Tour Guide 77

31. *War Means Fighting* 79

32. *Bluebird* 81

33. *Revenants* 83

34. *Deep River* 85

35. *Surgeon* 90

36. *Unrest* 92

37. *Colonel Cross* 93

38. The Gate 97

39. *Brothers (Fall of 1968)* 100

40. *Stone Horses* 102

41. *Sleepwalking* 104

42. *Chaplain* 106

43. *Warren* 108

44. *Valley of Death* 109

45. *Overheard* 113

46. *Faith* 115

47. *Face-to-Face* 117

48. *Dreams* 119

49. Perish 121

50. *Rosa's Republic* 126

51. *Culp's Hill* 128

52. *Poet* 130

53. Many Mansions 131

54. *Peonies* 135

55. *Night at Devil's Den* 137

III. THE THIRD DAY 140

56. *The Woman in White* 143

57. Carry Me Back 145

58. *In Memoriam* 147

59. *Judgment* 151

60. Rain 153

61. Light in the Trees 155

62. Home Sweet Home 157

63. *Bryan House* 160

64. *Stars and Bars* 162

65. *Innocence* 164

66. The Game 166

67. *The Universal Soldier* 167

68. *Legion* 171

69. Wings 173

IV. AFTER THE BATTLE 174

70. *The Sixth Circle* 177

71. *Heaven* 179

72. *Mystery* 181

73. *Four Mourning Women: Sarah Lincoln Grigsby* 183

74. *Four Mourning Women: Nancy Hanks Lincoln* 184

75. *Four Mourning Women: Anne Rutledge* 185

76. *Four Mourning Women: Sarah Bush Lincoln* 186

77. Soldiers' National Cemetery 187

78. Brahma 191

79. Remembrance Day 193

80. *Pain* 195

81. Hardtack and Coffee 199

82. *Beauty and Truth* 201

83. Honor (The Reenactor) 204

84. Major Dunlop's Hat 206

85. North and South 207

86. *Night* 211

87. *Light* 213

Photographer's Acknowledgments 219
Chris Heisey

Photographer's Appendix 221
Chris Heisey

GETTYSBURG

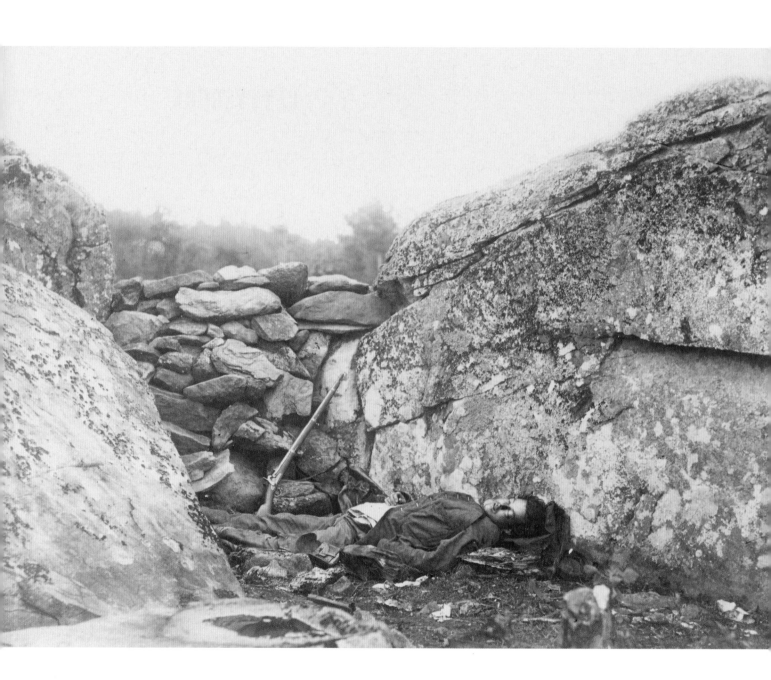

I. *PROLOGUE*

The Photographer (1863)

Oh yes, we shifted the body. And yes, we positioned him somewhat, turning his face toward the camera. We found a musket and propped it up against that wall, suggesting a story—someone's, possibly his. It is conceivable that blood from his ears and nose meant concussion. A Federal gunner could have cut his fuze so that a shell exploded precisely overhead, killing our young man. The blunt facts are indeed that he was in the battle and that he is dead. But of course we created a composition. What is art? Selection and arrangement. Photography is an art. A bloody face is only horrible. We didn't mean only to frame the grotesqueness of war. Our photograph, our portrait, was not of gore—was not even of him, exactly; we meant to photograph his folks back home. Not their faces, but their love and grief. We tried to picture pathos and pity, and the loss his mother felt, his sister felt, perhaps a young and hopeful wife waiting. His body was insensate, empty, an object, but their sorrow, unspeakable, found expression in the photograph: a young man, someone's darling, someone's child—childhood innocence recalled in that repose—that's what we meant. War is loss; war is families destroyed.

Oh yes, no doubt he was not innocent, and neither was his family. Could be he was the sharpshooter who murdered Hazlett and Weed. And Southern women were the backbone of the war; the rage of battle was partly their rage. None of us is innocent. But somewhere beside our murderousness, does there not flutter the better angel of our nature? Is there no light within? That is what we're after, like all the portrait artists of the past. Our medium is light. The medium of everything is light. Without art, it's all a hash of flesh and blood and gore. Our photograph shows nothing of the stench. Can you imagine what the odor was the day we photographed that boy? Horses and men unburied; flies in brazen billions. We vomited what little food we ate. Decay is everywhere; we're dying now. Even Vermeer was forced to catch his light between the sausage and the privy, the rank sweat of a summer afternoon thickening the musty air in his studio. "In the midst of life, we are in death," the old saying goes, but also in the midst of death, there's life.

And so we bare its light; we make visible the invisible. It's all murder: creation feeds upon creation, flesh devours flesh, and the wise die, Solomon wrote, no better than the fool. And yet, isn't there something else—something essential, that is ordinarily unseen? It's all here on this battlefield: cruelty and courage, senseless death and higher purpose, horror and nobility, the flesh and the spirit. Battle is life compacted. One little bit of light enters the camera, the eye, illuminates the dark, imprisoned soul, and the blind see. ❧

1. THE FIRST DAY

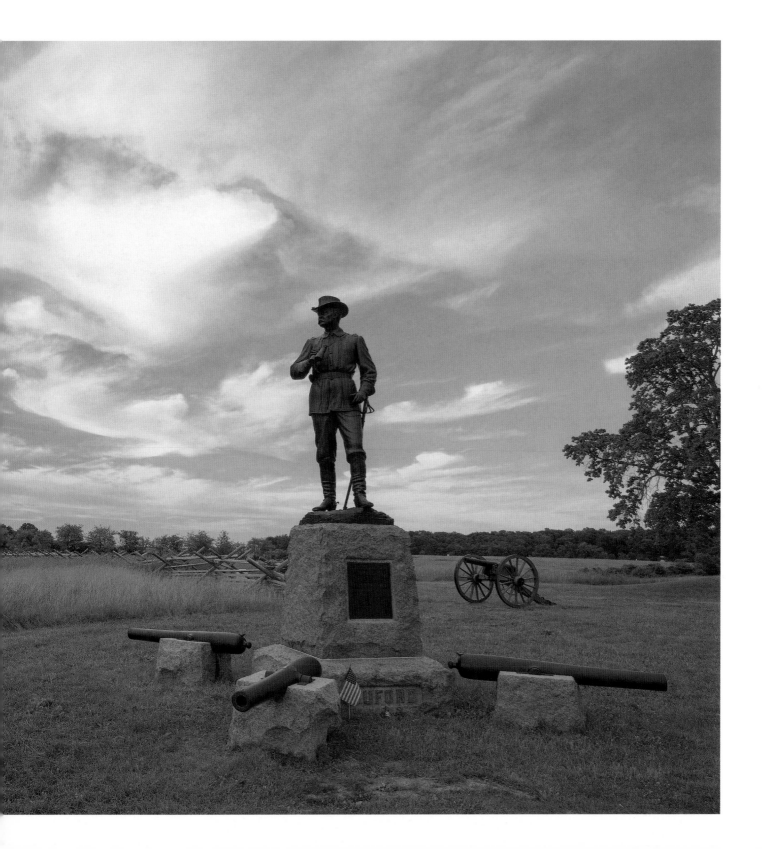

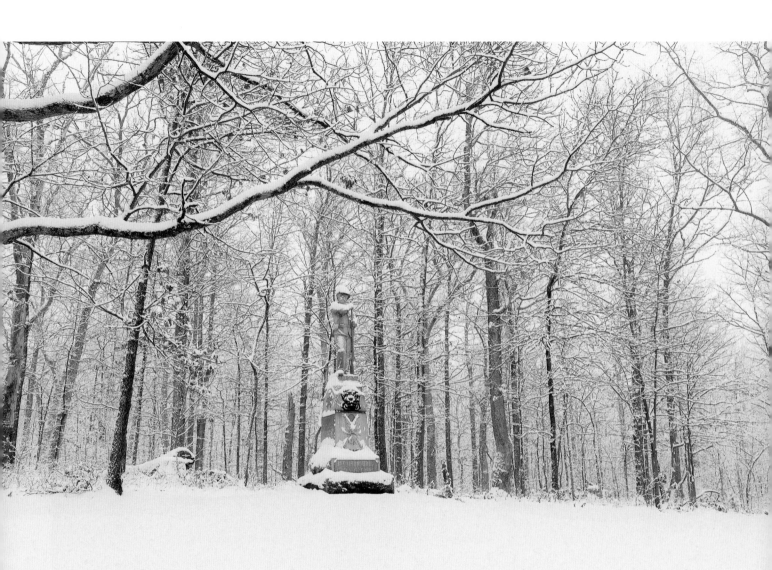

2. CAROLINA

You didn't know you could get killed. I mean, you knew it, but you didn't know. The suddenness of how everything changed still perplexes me. I reached for the colors as they went down, and took but two steps with them up the slope here, and something kicked me backwards, and in the instant it was all different. I seemed to run ahead with the boys; someone else picked up the flag—I saw "26th NC" vivid against the red—but at the same time, I wasn't moving. How everything could change like that confuses me. I watched them with curiosity, no anger left in me. I could still hear: it was all smoky thunder. Those damned black-hatted fellows just stood their ground and poured it into us. I wondered why this thing was happening. I was watching; that was the strange thing—just watching. No feelings, even about myself, but then grief washed over me when I saw my family, out on our little porch, all together. And then everything inside cried, "No! No!" And I believe that I am still here in these woods because I will not accept that I am killed.

Why, in just a moment everything changed. Without a warning! Couldn't God have warned me? Instantly, it's too late! Look at this world you living folks have—these pretty woods. Reminds me of back home in the springtime. There's dogwood here, but we had magnolia, too. The air would carry perfume. There's nothing like it up North, I expect: the air just redolent, all the time. And you have your families, and you have the stars at night; you have the quiet of slow-moving rivers; you have your friends. You can walk! Now why do we forget all that and go to war? We are insane, I expect. The human race is sick or damned, or both, I am convinced. Why, simple forgetfulness is sin.

So I stand for remembrance; I am memory. The monuments you place are my thoughts. The sorrows of a million households are for me. When mothers grieve, it is for me. The orphans of the world are fatherless of me. When widows stare out windows, it is my spirit they long to touch. And the breeze whispers the grief of God.

I am always with you. ❧

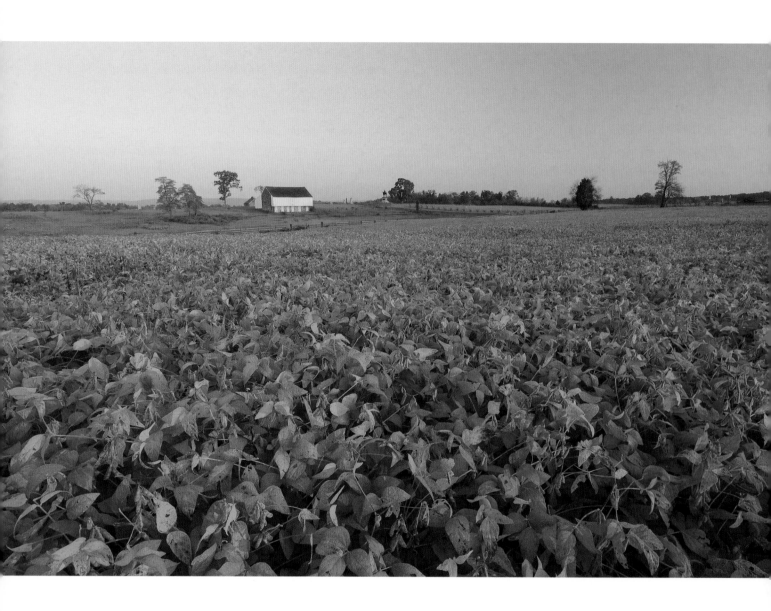

3. INCIDENT

A woman weeps, and with her, her two girls
as battle drives them from their burning home—
an infant cradled in his mother's arms
awed silent by the sudden blazing world.
We led her off to safety in the woods
and dashed back as our regiment advanced,
a little less assured it wasn't chance
but Providence that renders earthly good.

We lost a lot of men in that attack
on what should not have been attacked.
The dead settled on that timothy to bleed—
our sacred color stained that earthly green—
the wounded saved to suffer their unrest.
We saw the mother and her fragile three
beneath the shot-up trees as we fell back:
she held her trembling trinity to her poor mortal breast. ❧

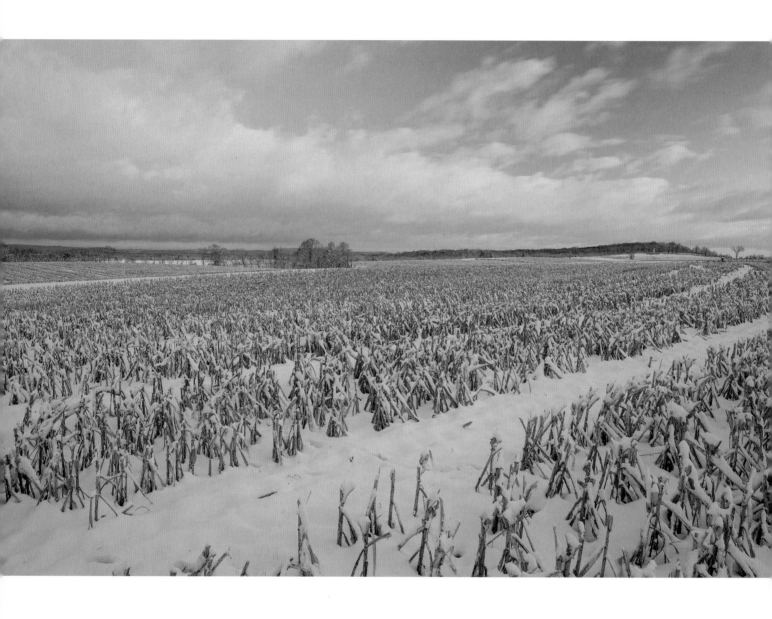

4. WHAT IS TRUTH?

*D*amn calvary. You couldn't hit a barn with them carbines of theirs, but some damn Yank got lucky when it come to me. First felt like some ol' mule come by and kicked my chest, and then a bee-sting pain as big as a tree, and then light. Seemed that everything stood still, and then begun to move again. I saw myself laid out flat on my back, then saw the boys, our flags, our officers, our line of battle left and right of me—they went straight at the Yankee calvary was kneeling all along that little rise ahead. And I don't know, some time must have passed and here I was, still here somehow, just like I always been since then I guess.

I saw our regiment, the Fifty-Fifth, but front of them was infantry this time. I 'spect we run the horse boys off, and then their infantry come up and tuck their place. Both lines was shooting and the smoke was thick, but just enough of breeze would blow it off so's I could see. It's all wide open still. And that's when I knowed God was on our side.

I looked left yonder, and just end to end must have been three or four brigades of ours, a dozen battle flags like on parade. You see, it's Second Corps—they come in just right, down on the Yankee flank and in their rear, while our good boys give them hell in front. Hoo-ee! Who says the times of miracles done passed? I saw me one right here, God's truth.

Now just like miracles, it didn't start too well. A whole brigade of Tarheels, our own boys, moved off and swept down on that Yankee flank, and from nowhere, behind some damn wall, must have been two or three brigades of Yanks rose up and poured in fire. Sounded like a thunderclap, that first volley of theirs, and shot

them boys down something frightful. They laid in rows, but never mind: might half of them, could be, got up and charged again when the next brigade come up behind them.

And they just crushed that flank, about the same time my regiment here put their Yanks on the run. I couldn't follow them to see it all, but what I saw from here sufficed. We druv the Yanks like Joshua blowin' down the walls of Jericho! The boys, they druv the bluebellies off that rise, through the woods, and yonder to the right, a line as pretty as—why, I don't know—as anything this side of hell, a whole division or more of our Third Corps, lines like on parade, just waded through them Yanks and gave them hell, and I saw them all skedaddle, our boys a-followin' after, till the whole tide washed down out of sight in that direction, and that is how we won.

The last battle of the war. Yes, sir. Like Moses looking over Jordan, I saw what was to be. Our army didn't come back this way, sir, and anyone who tries to tell you different is a liar. They did not come back. They whipped the Yanks, sir, and followed them to Washington, just like General Lee planned, and there he made that prairie lawyer to know differences, and to toe the line, and to sign some document before Congress, for Southern independence. That is why you have two countries, sir, instead of one. The old Constitution is defunct, and we are a nation, sir, and it was won here.

You shake your head, but what do you call truth? The truth is what I say it is, what I just done told you. It's so because we made it so, by Southern arms, by Southern shot and steel. No Yankee army this side of hell could whip Marse Robert, and that is a fact. 🕊

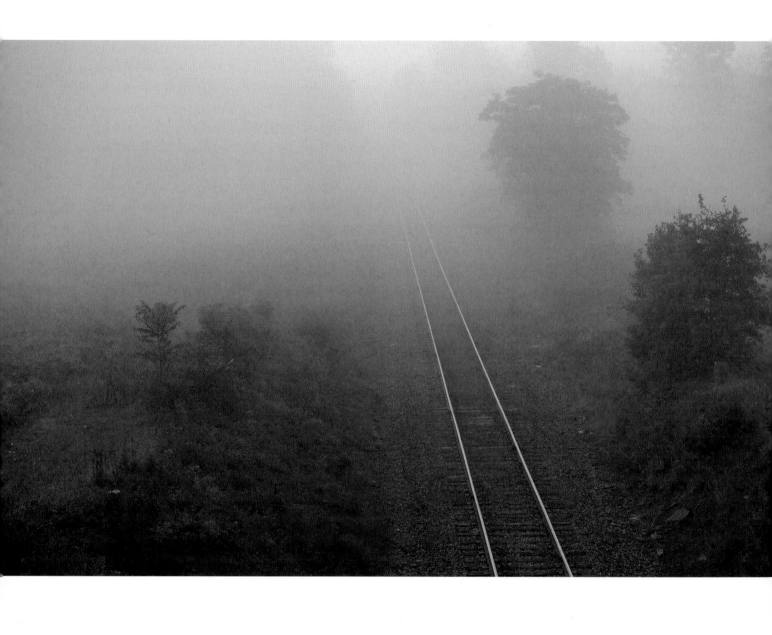

5. ONE ART

You found my bones just twenty years ago, revealed by rains that rinsed away the clinging earth and the soil of my decay, exposing my most intimate remains to any wanderer. You recognized an all-too-human skeleton. You touched my aching hip and thigh, cleansed of the ambition and rage that broke them.

Weeks, then months of careful excavation would sift my last delicate elements. Your hands like wafting underwater fins would brush away the dust and webby mold that clung as I once clung to life, to the sacraments of earthly stuff—to the physicality of all created things. What did that leave? What did you learn of me, or of yourself?

"Forensic anthropologists," they call themselves—detectives who reconstruct deaths and lives with evidence we leave behind: our teeth, the curvature of bones, and shattered skulls or ribs. They determined I rode on horses, growing up; that I was male; that I was in my twenties probably—and that was all. What mattered most to me—the cause that lighted my high way to death, a Rebel or a Union man—they found not. They smote me "hip and thigh," the Bible phrases it, but they could not reveal my heart.

The heart is all that matters, wanderer, and what matters is invisible. Yes, even he who with his lens paints photographs seeks life, as you do: life—seeks to make visible the light within light, the spirit within nature, intention in the art of history, immortality in death, eternity in grief. You hear my spirit, and he sees my soul—though only in its passing, in its shimmer departing; only in my vanishing do you touch intimations of what was and will be. You scrape in your imagination—he filters light—like anthropologists separating flakes of wounds, discerning filaments of treasure in the dirt. You seek fire and the sacred ghost.

But as for me, you know they buried my fragmentary remains on Cemetery Hill with solemn ceremony, the silver solicitude of a single trumpet, dignitaries, scholars—fitting and proper, Unknown forever—in reverence and awe. I witnessed it; their kindness comforted. I read the honor in their hearts, such as honor is. But I came back, and my spirit abides, where I was killed. Why seek the living among the dead? Where else can you go? My timeless visitation haunts the battlefield because it was here, and still is here, that my soul became itself.

The highest arts of humankind—the breath of Homer; Michelangelo's design—they show the soul fulfills its only quest in facing life and death, by courage knowing that life and death are one thing, defying the powers that would destroy us, that grind our bones to dust and burn our uniforms with slow decay, that scorn achievement, that brutalize us, that seek to weave sere leaves of grief into the final laurels on our brow. Cast a cold eye upon what mocks and murders us. Grasp the flag! Shout to anyone who hears, "Forward!" ❧

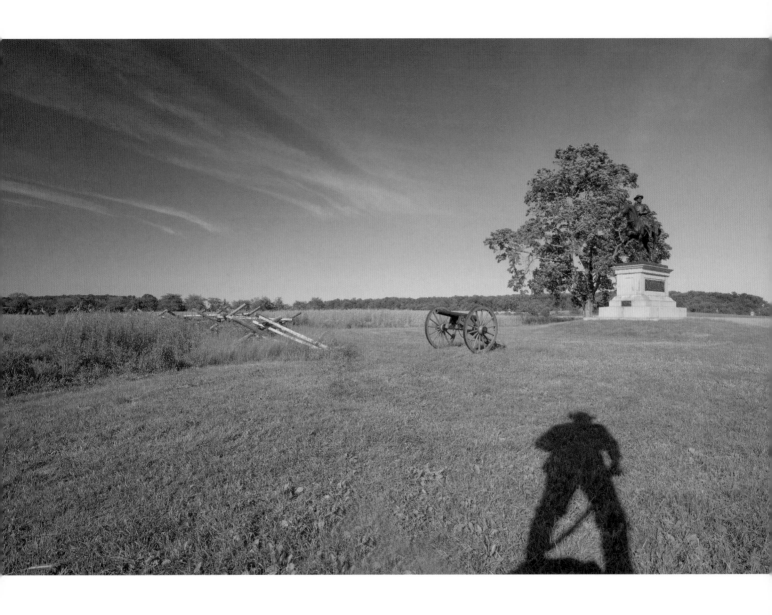

6. THE MUSICIAN

"They knew what they were getting into," he said. He's a musician, a composer, and his presence on a Civil War battlefield might be like seeing Johannes Brahms sitting in the stands at a football game. With flowery gray hair and a mad prophet's long beard, and a beret with a peace medallion affixed at an uncertain angle, he looks like a French Marxist who has come out of his garret to squint at the sunlight—or like a Confederate general: Archer, Mahone, or Hardee. Both of us have studied Civil War music for years—he with professional awareness. I had just remarked that the early songs of the war were optimistic and bracing.

"But even a rousing song like 'The Battle Cry of Freedom,'" he said, "has lyrics that showed they knew what they were getting into."

"*We'll fill the vacant ranks with a million free men more,*" I recited.

"Exactly. And it was only 1862."

"I think you're right," I granted. "Once I looked up the lyrics of 'All Quiet along the Potomac Tonight.' *Harper's Weekly* published the poem on November 30, 1861. Sheet music was out the next year. *Now a picket's off duty forever.*"

"*And I think of the two in their low trundle bed,*" he recited quietly. "Children were made orphans in numbers Americans had never imagined. The real slaughter began in April 1862—only a year after the war started. So at least by then, if not well before, they knew. Willing to pay the unthinkable price." He gazed across the peaceful battlefield. "For decades I have wondered what for. Why did they do it?"

He scratched his long beard, and then continued, "The answer for the South is easy. But Northerners? They could have gone on living pretty much as they always had. It's the great puzzle of the war, I think. What did Union mean to them?

"Maybe harmony. I wonder if Union was a kind of harmony for them. Maybe they heard a music most of us fail to hear anymore.

"Mozart *heard* his music; he didn't invent it. 'Music of the spheres.' I wonder if that phrase is more than a metaphor. One of my piano students remarked recently that she used to hear angels singing.

"There's something solid about it. Music, I mean. A few months ago I got the most solid idea I have ever had for a piece of music. In forty years of writing music, I have never had such a solid idea. An oratorio. First the voice of a man, solo; then the voice of God, chorus. And the keys came to me as well. It begins in B-flat minor, moves through D major, and the distance between those two is resolved by C major in the concluding section.

"I'll base it on an anonymous oratorio that was falsely attributed to J. S. Bach. On the crucifixion and death of Christ. B-flat major, but C minor plays an important role. My C major also resolves the C minor of the original. I want to deal with Holy Saturday, when it was all over, no hope to be seen, only darkness. And terrible silence. I only have to write it down."

"I hope to hear it performed one day," I said.

His laugh was startling in its vehemence. "*Ha!* Are you kidding?" As a gesture of resignation, or perhaps acceptance, he removed his beret and ran a hand through his steel-gray hair. It reminded me of Sam Elliott as General Buford in the movie *Gettysburg*. "I've been a composer for forty years. I've written five symphonies, two piano concertos, innumerable short pieces, and have

any of them ever been performed? I record them electronically and give them to my friends, like you. They'll never see the light of a concert hall."

I hesitated, but then asked, "Back when you began, did you know what you were getting into?"

He thought about it, putting the beret back in place firmly, with both hands. "No and yes. I didn't expect to work a lifetime without getting published. So no. But yes, I knew I was getting into music." ❧

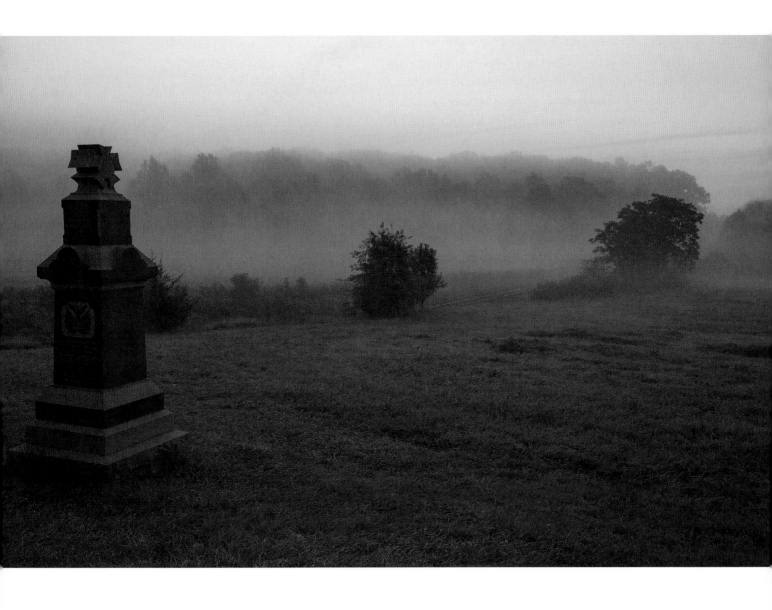

7. *THE SINGER*

His was a deep and ringing baritone that on the march shone clear as water and flowed deep as the Potomac. It cheered us up, and we always shouted up and down the column, "Huzzah for Ticknor! Sing us another one!" So how we'll do without him . . . Well, it's just another war, a different war. And our grand old brigade—the remnant of it, shall we say—must fight in silence, as I walk these silent fields. They shot him there, crossing this little field, and I fell with him, dying as I fell. The boys will do without me well enough, but how shall you replace an angel's voice?

I always thought the Captain sounded like my uncle sometimes when he came from work. The sawmill was a very noisy place, you understand. It trained my uncle's voice; it made him exercise his lungs and throat, and hold his head up, to be heard above the universal whine and grind of blades ripping along the logs like a regiment performing "Fire by File." I think he sang at home to fill the emptiness that my aunt left. And now, with most of the brigade slaughtered in these fields and woods, who will sing our grief?

All quiet where the troubadour
 Once raised our weary hearts:
The campfires under clouds of war
 And under winter stars;

The dusty roads past empty farms
 Where tired soldiers toiled;
The mud fields where we stacked our arms—
 Virginia's bloody soil.

Our singer sleeps among the brave,
 Where all our struggles end.
Is there a place beyond the grave
 We'll hear his voice again?

Then will that voice, so clear and true,
 Be raised again in heaven,
Where for his faded coat of blue
 A robe of white is given?

8. BLOOD TRAIL

I'm sitting there across a big desk from the grandson of my Civil War hero. Colonel Porter lost an arm here at Gettysburg leading one of the best regiments in the Army of the Potomac. They fought two Confederate regiments to a standstill right up there, losing two-thirds of their men. Colonel Porter got his arm amputated that evening and the next spring was back leading the regiment in the Wilderness. After the war, he was elected governor. I grew up in the town of Porter, which might explain my interest in the Civil War at a very early age. Along with Grant and Lincoln, Elihu Porter was my hero.

So in my third year of high school, I applied for the most prestigious college scholarship offered by the state and made it to the final interview. There were only two others. We met in the chambers of Elihu Porter III, who was a justice of the state supreme court. I waited my turn and was last to go in. One on one, in this big wood-paneled office, with a huge portrait of the colonel on the wall behind Justice Porter. The year was 1966.

Justice Porter asked me quite a few questions, and I think I answered well. Then he asked me something about the war going on in Vietnam. You have to keep in mind that this country has always been generally conservative, and no matter what you've heard about Vietnam War protests, the war was popular in 1966. Also keep in mind that the Porter family had been Republicans since the Civil War.

Maybe the third thing to keep in mind is that I was seventeen years old. I told the justice that the war was immoral; we had no right to kill Vietnamese people just for our own national interest. I went on to give the justice a brief history lesson: that Vietnam had fought the Japanese, then had defeated the French colonial army at Dien Bien Phu, and we had promised them a free election. We reneged on the election when we realized that Ho Chi Minh would win, and instead divided the country into North and South. I said that this was as wrong today as it had been during the Civil War, in which his grandfather had fought for Union.

No, wait; there's more! Unbelievably, I wasn't finished. The justice's face had become a thundercloud at that point, but I blew ahead, as if with a Rebel yell. I reminded Justice Porter that General Douglas MacArthur had warned against ever again getting involved in a land war in Asia. I am sure that the justice felt edified by that reminder. I said that the Vietnamese were historical enemies of the Chinese, so we should not be paranoid about a communist monolith. I said that the "domino theory" was nonsense. I said we could not win a guerrilla war without murdering a million Vietnamese, and probably not even then. The war was immoral, I repeated; it violated our principles, and every young man of my age had a duty to refuse to serve, or even to register for the draft (although I later did so when I turned eighteen).

I was intending to give him a brief summary of Thoreau's *Civil Disobedience*, but at my remark about the draft, the justice laid his hand on his desk—forcibly—and stood up. I noticed how much he resembled his grandfather the colonel, who stood in uniform behind him, and thought how formidable a soldier Colonel Porter must have been. I had blown a pea shooter at the Rock of Gibraltar.

The justice said, "Evidently, young man, you know all there is to know about a man's duty to his country. You are dismissed." He declined to shake the hand I

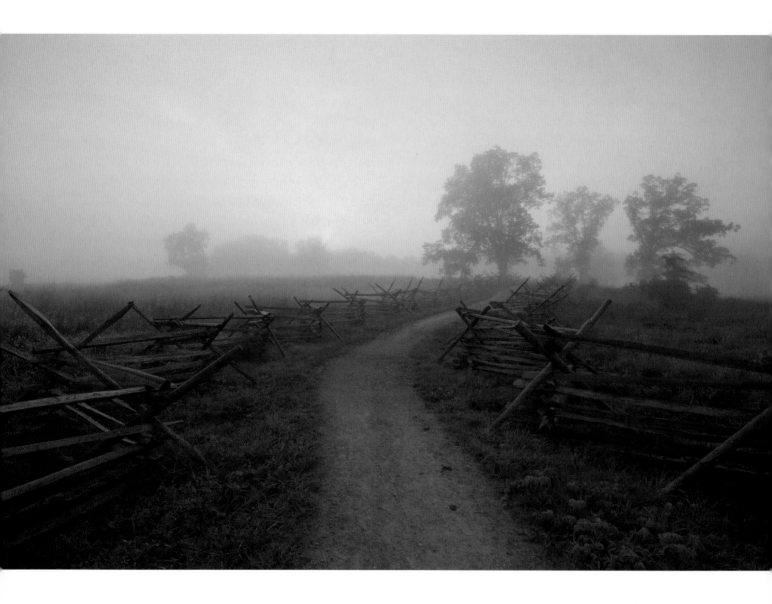

proffered, and I made a rapid and determined exit. Now that I think about it, I believe that I knew from my first sentence about Vietnam that I had torpedoed my chance for a Governor's Award and had decided that as I was going down anyway, I might as well go down in glory and deliver my whole sermon to the face of power.

Like the character in Updike's story "A & P," I learned quickly that the world was a good deal harsher than I had imagined, and it was inhospitable to the *beau geste*, the beautiful romantic gesture. I had decided on the spot that if to win the Governor's Award I had to lie or go back on my principles, then to hell with the Governor's Award.

I believe it was the portrait of the colonel up behind the justice that inspired my determination. I could not be a coward in front of that man. What was he—what were all those great men in blue, and some in gray—but noble-hearted Romantics? Why fight for Liberty and Union—why fight to free a race you never saw—if you weren't an idealist, a Romantic? The Civil War era was the Great Romantic Age in this country. The colonel could disapprove of my mind, but I knew he would not reproach my heart.

Justice Porter had served in World War II. He had lived through the Great Depression. He was part of what some call "the Greatest Generation." Those people were great, but they weren't the greatest generation. They did what they had to do. But the people of Colonel Porter's generation did what they didn't have to do. They were the last Romantics. They were the Greatest Generation. ❧

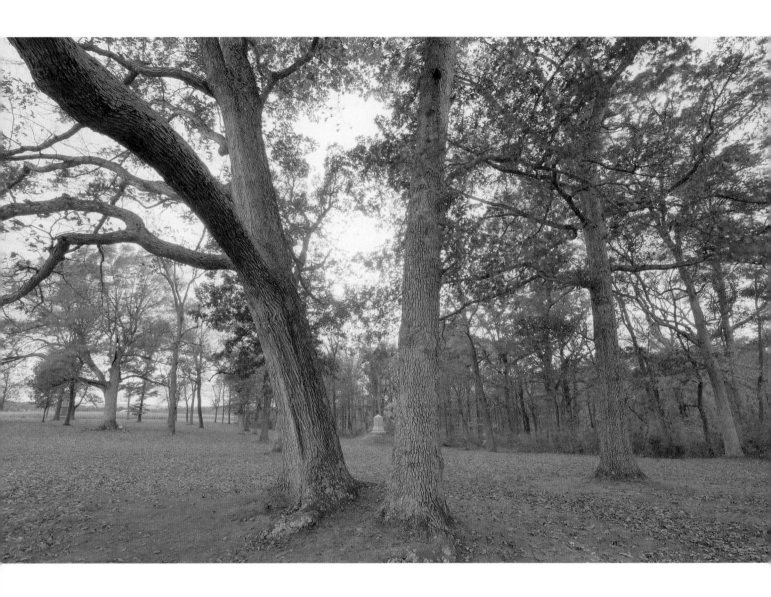

9. 'STANG

Oh yeah, it's the real McCoy. My dad bought it in 1964, and when it passed to me thirty years later it was pristine, with only fifty-eight thousand miles on it. All I've done since then is rebuild the original engine and tranny and keep the rust at bay.

Because it felt like time for a road trip with this baby. You bet Oregon is a long way, but just try it in a '64 Mustang. My back has been yelling at me to get rid of this tin can.

Because, you know, that's basically what it is. Listen to the door close. No *thunk*. Just a tinny clap, right? The cockpit is primitive. I don't trust the brakes, the clutch is springy, and the gears are as notchy as a tractor. But heck, it's got cachet. I'll never get rid of it. I just wish somebody'd drive it back to Eugene for me. I'd pay expenses. Might you be interested? I didn't think so, but it never hurts to ask.

Yes, I teach at the university. Economics, of course. Who else but an econ prof would keep a fifty-year-old car?

No, not much. My daily driver is a Prius. I just take General Meade here out once in a while to keep us both loose.

My dad named it General Meade after we watched an episode of *The Dukes of Hazzard*. He said the blue side ought to get equal time. Of course the car is blue, what I call Maliblue. Real California, beachy.

He was an electrical engineer. That why he thought it was so funny to buy a Ford. Of course, he never would have bought a Japanese car, no matter how much better the electricals were. He fought the Japanese in New Guinea. Thirty-Second Division. He didn't take kindly to the people who killed all his friends. He was somewhat unforgiving. I suppose I would have been, too. He didn't like any Asians.

Oh, we got into some good ones all right, Dad and me, back in the sixties. I was just a high school kid. I would have gone to Canada if my draft number hadn't been high. Dad never forgave me for that. We yelled at each other for the next twenty-five years, and I'd say that underneath we loved each other, but we didn't. Still, when he died, I wore all his clothes, and as you can see, I took care of old General Meade here.

I thought I would show the General where his namesake defeated Robert E. Lee. Dad always wanted to see Gettysburg. I guess this is as close as I can come to showing him the battlefield. I appreciate your giving me a tour.

Where do we start? Really? They were the originals of the Red Arrow Division. Absolutely. Boy, would I ever like to see where the Wisconsin men fought. Dad was from up near Neenah, Wisconsin.

Ah, that's the bigger question. Did *I* ever forgive *him*? Well, put it this way. The only way I could ever understand hate was to think of how I felt about him. The war made him mean. He used to cuss in his sleep and wake up nights and go watch television. God help you if you intruded on him. He despised Lyndon Johnson for not dropping The Bomb on Hanoi, for not "fighting to win," as he said. "Bomb them back to the Stone Age."

There are some wars you can't win. Some wars you shouldn't win. What's that? Seventh Wisconsin? Right here? Oh geeze, holy shit. Sorry. I'll be all right.

Well, Dad, we're home. ✒

10. THE FORESTER

[*Du weisst schon aber, dass . . .*] But you already know that my brother committed suicide. What you don't know is that my father, who was a rather well-known person in Germany, forbade me to send a very long letter I wrote to you at the time. He feared any publicity. It was shortly after the semester Berthold and I spent with my father here, when he was a guest professor at the Lutheran Seminary. Now, decades later, Berthold's death is as much of a mystery to me as it always was. That is why I have come back. Maybe if I can reconstruct what happened here, I can finally understand.

Of course, I had no idea at the time. Berthold attended classes at Gettysburg College and seemed more than happy. We didn't get along. We fought. Nevertheless, as a younger brother, I envied him even as I resented him, with all his parties and American college girls. But I suppose he was somehow desperate. You always think you should have seen something. If I hadn't been so preoccupied with my own teenager interests, then maybe I could have done something. You remember me, I am sure, trying to catch up with the glamorous Berthold. I was constantly running around but trying to be an intellectual like my father. I attended some of his lectures here, you might remember, and I pretended to understand them.

And do you know, I fell in love here, on the seminary campus. In love with the trees. Some were like friends to a homesick teenager. It was the trees that used to be here, where we stand now in a wonderful parking lot— those trees and the great old American hardwoods in the Soldiers' Cemetery—that inspired me to become a forester. I think you know I managed the Harz National Park until I was forced to retire two years ago. Father used to think I was the suicidal son, because I spent so much time in that cemetery, where Abraham Lincoln made his Gettysburg Address.

So, my friends that used to stand here have been cut down so they could make a parking lot for the museum, which was necessary, I am told, so the seminary wouldn't bankrupt itself to preserve it. But if I am correctly informed, the seminary is no longer the Lutheran Theological Seminary at Gettysburg but has merged and is now called something else, and who knows whether it will be here twenty years from now. It all reminds me of the famous thing one of your American officers said during the Vietnam War: "It became necessary to destroy the town to save it."

You Americans have a very small and corrupt view of preservation. I have toured yesterday the battlefield on my own, and I am appalled and angry. Somehow it brings my brother back to mind, that acres of trees have been cut down—acres and acres of beautiful hardwoods. I was so enraged that my heart pounded uncontrollably. I actually went to the visitor center but found it gone. Someone directed me to the new one, and by the time I arrived, I had calmed myself. Why had so many trees been destroyed? I wanted to know. I was told it was to restore the battlefield to its 1863 condition, which is absurd, because now with the trees gone, one can see the roads and businesses and baseball fields that were invisible before. I was told the tree cutting was for *sightlines* and *viewsheds*, two of the most vulgar American words I have yet heard. Trees and people: if we don't like them, we cut them out of the way. My arm happens to be paining me right now: shall I cut it

off? There is always some excuse. We cut the trees for charcoal to smelt iron; we cut the trees to build roads and shopping centers; we cut the trees to provide jobs; we cut the trees to make furniture and printer paper and enormous houses. Always it is the trees that are being cut down, for sightlines and viewsheds and jobs—and it is murder.

Did you know, as one of my colleagues in the Eifel Forest has written, that trees not only feel pain but feel each other's pain? A community of trees will nourish a stump for two hundred years in hopes of keeping it alive. The trees in a community will send out their own nourishment, through their own root systems, to feed the weaker members of their group. Unlike what you humans do in this country. And you wonder why I am deciding forty years ago to spend my career among trees instead of among theologians?

A tree has a heart, of some kind. Of course, it is not a muscle made of flesh, but to pump the moisture up, something other than capillary action and osmosis is necessary. It remains a mystery to science. The heart is always a mystery.

What was in Berthold's heart here? I see all around me the visible manifestation of his heart: trees cut down, huge vehicles everywhere, an atmosphere that is clouded and poisonous and warming all for the same old excuses made by a willfully ignorant, selfishly stupid, and sui-

cidal race. My father used to lecture about Freud's idea of the "death wish," that constantly there is a battle between life and death in us, a constant civil war. I am aware that Abraham Lincoln said that if America ever dies, it will be by suicide. It is evident to me now. It is true of the whole blind, foolish race that has been planted here like green trees in a world and a universe of incredible danger and beauty, on this little spaceship we destroy, and instead of nourishing each other, we kill each other for ideas and religions and power and money and sightlines—like a race of the criminally insane or the desperately hopeless.

Ah, Berthold, what was in your heart, and are you still here, a wandering soul trying to find its way back to the place where it surrendered its life, where you declared yourself the mortal enemy of yourself? I want to know if you still wander here, looking among these murdered companions for the hope and the faith you lost. Is it here that you became alone? Were you abandoned by your brother here? Here I am, my brother; I reach out to you; I try to touch you with my hand and my spirit. You are not alone. All of life is one. We are here together, Brother! I have come back. I will wander with you in the Valley of Death. We will walk together now.

Do you hear me, as I still hear you? I come to meet you, Brother. Let us cross over the river and rest under the shade of the trees. ❧

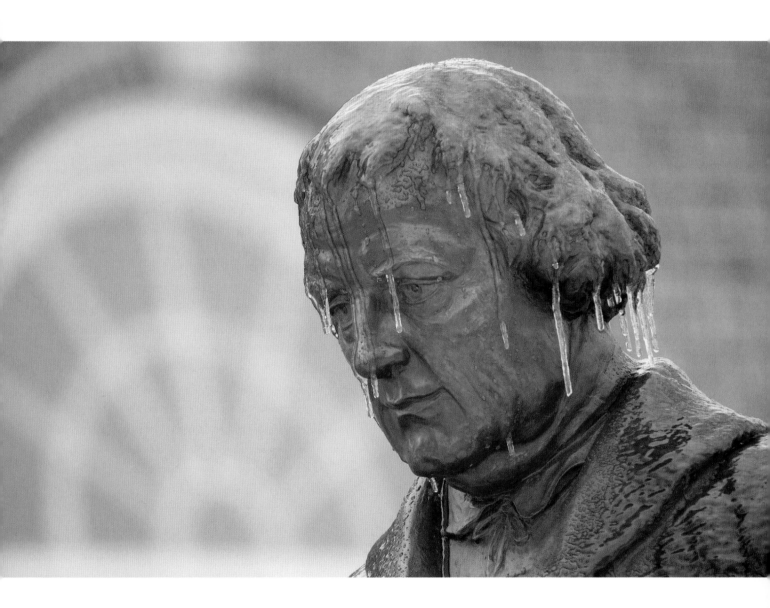

II. *A MIGHTY FORTRESS*

Oh yes, I was a Lutheran. What else could I have been in 1863? A student at this seminary. I went on to live a pastor's life: baptized the infants, married my parishioners and buried them. I preached and taught what I had learned in that cruel building. I studied Luther's theology—"leider auch Theologie"—trusting in grace; trusting that God extends salvation freely, no matter what we do or fail to do. I learned that no one is righteous; we cannot save ourselves. Only the Master of the Universe can make us righteous; can save us from the pains of torment; can make a silk purse of a sow's ear, Luther might have said. And how does God do this? Through faith. That is His vehicle in us. Not that faith comes from us; for it also is given to us. So how through faith does God transform and redeem our vicious human nature? By love. God's love is strong, warming all—good and bad, right and wrong. It radiates like a furnace, Luther said.

I saw that furnace here. That is why I haunt the seminary, even though I was not killed in battle here. I nursed the wounded in these rooms; I assisted surgeons amputating poor soldiers' arms and legs. Outside those windows grew piles of bloody, gruesome limbs. Doctors and orderlies were overworked; there was no time, no one, to take the rotting flesh away. I smelled the sick, sweet odor of blood; the vomit, urine, defecation; the unspeakable stench of gangrene—and I watched the soldiers die.

Many were dug into shallow graves here, where we are standing—loyal and rebellious alike. I heard men moan for their mothers, and children, and wives, and also for God. I prayed with them; I prayed for them; I watched them drool their blood and die—so far from home. So far from God.

My faith was wounded here, and I must walk a limping amputee through all the questions that have no answers. I cannot answer for God. I cannot answer why He lets it happen, or why He makes it happen, or why His kingdom takes so long to come on earth. But I know where He was.

And that is why I wait here. I wait for God to come again. I saw God's light, and I know that in this earth's darkness somehow it will return, or somehow it is here. This is my faith, my fortress. The battle still rages all around. Prophets die; the innocent are murdered in their beds; we humans God created march to kill and die like animals; we spoil the smoking earth; and on it goes, and on it will go until the last crippled and abandoned orphan sobs her last "Why?" with no language but a cry, and Jesus will not come back in time to save us from ourselves. But this is my creed, my fortress:

He does not come who is already here.
God's light lives in the darkness that we make.
The light is here no matter what we do. 🙠

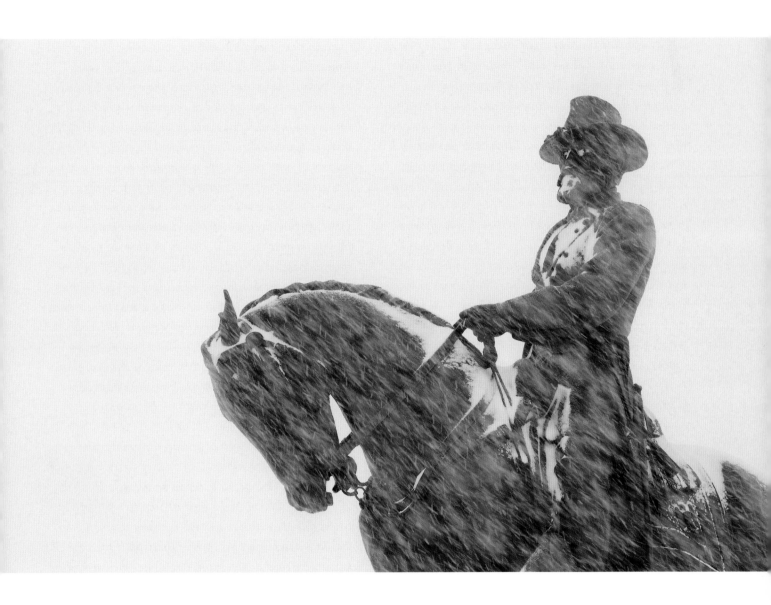

12. *SHAME*

I rode with Howard's staff and saw it all, but more important, I heard it all. I rode with Howard's son carrying the dispatch to Slocum four and a half miles from town, and later I heard Howard telling someone (I do not choose to divulge who it was) that his corps retreated only after Doubleday's was flanked and driven back. He claimed the First Corps ran without much fight. Well, I served loyally and gave my life to our unfairly denigrated corps—the old Eleventh, General Howard's corps—but I was loyal then as now to truth.

I do not wish to be misunderstood: Howard was a good man. I never saw him flinch when under fire—as brave a man as troops could want. Considerate as he was calm, he thanked—I heard it several times—he thanked the orderlies whose duty it was to hold his horse. He wore a somewhat sad or melancholy look at times, as if this killing done by men toward men grieved his Christian heart. He was a Christian through and through.

And yet—and yet he had a weaker side, because he guarded reputation a bit too watchfully. He misrepresented shamefully the fight that General Reynolds's—later Doubleday's—First Corps put up and said they melted back, and that is why our corps retreated when we did. But anyone who knows the army knows the old First Corps troops were giants on the battlefield. They lost a good many more men than we did killed and wounded, inflicting I think six times worse than we upon the enemy. They saved the battle, but Howard wished to save his reputation—which in the army means to save your rank. The army was his life and his career; he knew his job would long outlast the war. It is Position that makes cowards of us all.

And that is why I loathe the man—not Howard; I mean Slocum. Now Slocum was as good a general as Howard was a man. But I was there when General Howard's note was handed to that man—which told him we were under fierce assault at Gettysburg. Hell, I saw his men stand around perplexed because the heavy cannonade and musket fire was audible to every soldier. The ground, I tell you, trembled, or at least communicated, and up behind me rose the smoke of battle not five miles off. But Slocum said that it was not his fight. He had the highest rank of anyone on or near the field, so if he rode into the battle, command would fall on him. "I'll not take responsibility," he said, when any fighting general, any patriot, any decent man would have rushed his divisions toward the sound of the guns. He could have saved our corps! One of his divisions anchoring our right would have saved thousands of our men from capture by the Rebels. He might have even flanked the Rebel line and rolled it up. But no. He wouldn't take responsibility.

I tell you, all the rest of his career cannot make up for what he did, or rather didn't do, at Gettysburg. And "Slow Come" will be his name in perpetuity. Think of all our men, like me, who died in Southern prisons. I haunt this place, but shame has haunted the man who sold us out to salvage his career. That's all it takes for evil to win: the good do not stand up; it's not their fight. The servants of the devil are the ones who look the other way. The unforgivable sin against the future is hearing sounds of battle, seeing cannon smoke, and letting others bear responsibility for sin—letting others bear the blood-stained, rugged cross of war. ❧

13. *IVERSON'S PITS (1927)*

Beloved Mother; Very Honored Father,

I am safe and well in America now already three weeks. The ship landed in New York and a man watching us come off the boat put a silver dollar into my hand. I did not know him, and he did not know me. He said, in our language, "I came over on a boat with nothing, and a man gave me a dollar to start off with. I make a good living, so I now give you a dollar and wish you everything good in America." I have not spent that dollar and will always keep it, to remember that man and to know that as long as I have it I am not broken. The little other money I possessed I spent on an apple pie, which is like a covered torte, and as a refugee from the starvation back home, I ate the whole pie on the train to Philadelphia.

Hermann awaited me at the station, glad to see his younger brother. He looks healthy and well fed. He works in a factory and shares a small flat with other Germans, so there was very little place for me, and after three days, because there is not factory work now, he with great sorrow but many encouragements put me onto a train.

I am now in Adams County, still in Pennsylvania, where also is Philadelphia. Adams County is the largest producer of apples and apple products in the world. It looks quite a bit like southern Germany, so I feel at home—at least when I look at the scenery. I first worked in a little village named Biglerville, which is a joke in English I think, because I have learned that "big" means great of size.

My boss was an officer in the American army during the war, and he is very disrespectful toward us Germans, even though there are many of us in Pennsylvania.

Maybe it is exactly because there are so many of us. But there would be no apple harvest without us, and no Kraus Apple Company, because the Americans do not want to be agricultural workers. He says we are "Huns," but we are hard workers. Sometimes he calls us "Krauts" because, as you know, we Germans are eating always sauerkraut.

The boss sent me and three other of his "Krauts" to Gettysburg to work in the fields for two weeks. It is from this place that I am finally writing to you. Fifty or so years ago, there was a great battle around Gettysburg, during their Citizens War. We four are working for a man named Sheads, who was also an army officer I think, but he is not so disrespectful as my boss, though he lets us know that he has little use for Germans. He says they fought very poorly in the battle here.

I have found out that we Germans are the only ones who are willing to work into the night in these fields. The Americans are afraid, and I will tell you why. They are very superstitious people. On this property were hundreds of soldiers killed, and they were buried in big pits. They were from South America, and they were fighting against North Americans who lived here. They made an invasion, and came here and made the battle. We are told that the ghosts of those South Americans walk the fields at night, and the American workers are terrified of them. I laughed, because we Germans do not have such superstitions.

But last night, I was alone near the trees and saw a man standing there watching me. He wore an old clothing, with a wide-brimmed hat and I think some kind of military jacket because I could see shining buttons that looked gold or white in the moonlight. He didn't say

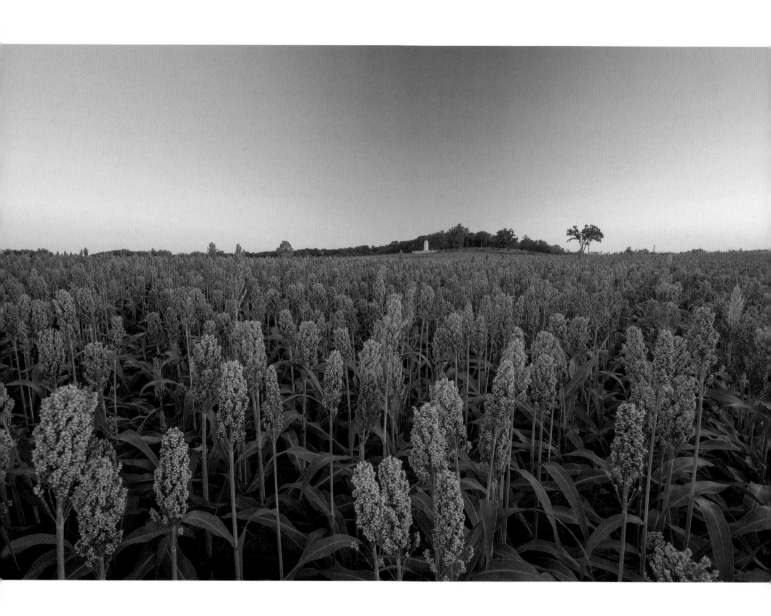

anything, or at least I didn't hear anything, but I felt a kind of electricity travel up my spine, and I am sure the hair on my neck stood up. I cannot describe the feeling, but I knew he was not alive, and the way he stared at me, or something that he somehow communicated towards me, let me know that he wanted me to go. I mean go away, go back to Europe. I didn't belong here. I could not move. I actually could not move, just as though I were a statue. I was frozen, and it went on I think for almost a minute. Then he was gone just as though he had never been there.

There is a German here named Emil Shaeffer, who is from Reutlingen—a fellow Swabian. He has a cousin in Milwaukee, where there are now many Germans and good jobs in factories. We will go there as soon as we can put together a little money. The next time I write to you, the letter will be coming from Milwaukee. I am afraid of their ghosts now, but there was no Citizens War in Milwaukee.

Tell young Willi that I will eat no apple pie on the train, because it made me work for apple growers and farmers here who hate Germans. I am a mechanic, and he should become one too, when he is old enough, and I will arrange a job for him in the factory where I work.

Greetings to Grandmother.

Yours most devotedly,
Kurt

[Kurt Koestzer and Emil Shaeffer moved to Milwaukee in 1928, finding factory jobs. Emil worked in the converted Schlitz Brewery during the Second World War, manufacturing munitions used against Nazi Germany. He was a line foreman by war's end. Kurt Koestzer was drafted in 1942 and served in George Patton's Third Army, receiving two purple hearts and rising to the rank of staff sergeant. Upon his return to the States, Koestzer cofounded and operated a small manufacturing company. He is buried in Valhalla Cemetery in Milwaukee.] ✖

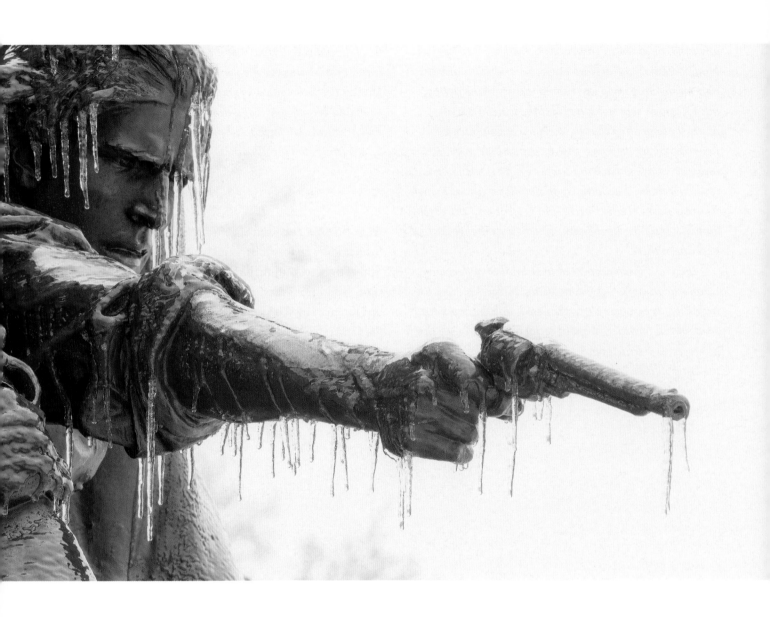

14. *COURAGE*

It don't give you courage. Well, maybe for some, but for me a long pull on a canteen full of strong whiskey only keeps me feeling tolerably good. I am scared all the time; just that a steady supply dulls the sharp edge. Sure, I say that boredom got me started on the bottle—boredom and cold winter quarters. But it was my other way of keeping off the cold and the dullness that led to the whiskey.

You know Burnside and Hooker, both of 'em, were plenty lax about sutlers and camp followers. I wish otherwise, of course, but the only thing can be done is buy plenty of whiskey from the sutlers, once you got the disease. A lot of us had the syphilis, but I got it bad, I was something special, and the thing really exercises me is that plenty of the boys got off with nothing at all.

A fellow wants justice. Where's the justice? You volunteer to put your life in hazard for your country, you do only what everybody else is doing, and you get a bad case, you get a fatal case. I have seen what it does. Fever, rash, and pustules in places where you hadn't ought to talk about; even the nose and face and everything deformed. I have seen it take fellows' minds, make a raving animal out of you, and then finally kills you when you're down to a skeleton. That's what I had waiting. I thought, there's nobody seeing to justice, nobody taking care of me; nobody, no God in heaven going to watch over me and protect me from the Rebs' bullets or cure me. I'm on my own, and I ask you, What the hell would you do? Wouldn't you drink a little? Find out there's nobody up there, nobody. You know any time now you're going to get the bullet or you're going to drool and lather and howl like a rabid animal. Sword of Damocles is what it is, hanging over my head every minute of every hour, every day and night. Any time, and I won't see it coming. So why the hell not? Why the hell not get drunk, and stay drunk, until it's all over, because no God is going to reward me for being a sober good soldier and it's no God at all going to punish me. If there was a God at all, he gave me this pox or allowed it, and if that's his idea of justice, then to hell with it all. How's that justice? Enlist to fight for your country . . . Well, if that's my reward, I'll collect it. There's no rewards and no punishments afterwards. This is all there is. Nothing makes one bit of difference. Ain't nobody back home to care one way or another, and the only friend you got's the canteen.

I'd borrow, beg, even steal to get the copper to buy this elixir. The sutlers don't care. I carry two, sometimes three canteens, whatever I can fill, to take care of myself, provide for dry times, because nobody else going to provide for me. So here's my courage, right here—this steel flask that through the ever-wise, all-seeing Providence of the Good Lord who don't exist, I picked off a dead Reb at Chancellorsville, or maybe it was one of our boys, because dead is dead and it don't make a difference.

I didn't look for a bullet. It just found me, you might say. I didn't walk out here in the pitch-black dark so some dirt-worth Reb could shoot away at a man on an errand of mercy. Sergeant told me, "Stay the hell back, you fool! The Rebs are shooting anybody goes out giving water." The wounded were crying piteously, you understand, disturbing one's peace of mind. I said, "It's all right, Sergeant; I ain't going out with water." Sure, the wounded boys was burning up with thirst, but they was going to die anyhow, water or no water, and they knew it. A good pull of whiskey would make it go down easier. So I went out.

And now I'm still out here and the boys are crazy, some of them, confused, don't know they're dead and think it's just like before, and the ones I go to, they're the animals out here, and they'll stay here that way forever unless somebody gets with them, and talks with them, and calms them down, and they settle down free to go their way. I know they go. Used to be hundreds out here; not many left now. When I get with them and tell them they ain't alone, I can talk to them. I can tell them the truth, that they are dead and have passed on, and's nothing to be afraid of, just go on. But no, I don't tell them the whole truth, that there's nowhere to go. They calm after a while and get some manner of hope, and that's what you might say lifts them away. I don't see them go, but I know they go. I feel them go. And I know it won't be long I'll go too, go nowhere of course—go to no heaven, no hell, no nothing or whatever, which is why I still hit the canteen like a nursing bottle. The Sword of Damocles hanging up there, but let it hang. I mean to get these poor boys out of here. No reason to; ain't going to be no commendation. I'm just drunk as hell and I don't care a damn for no reward. ❧

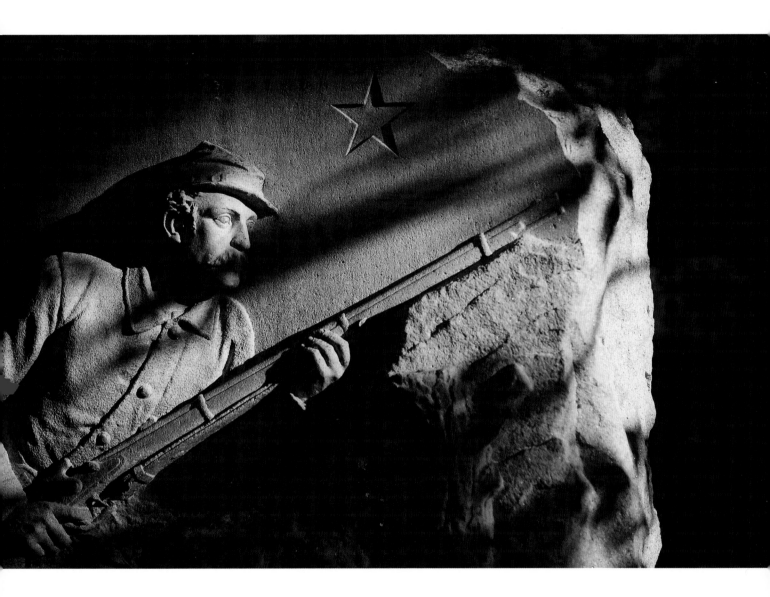

15. *THE MUSIC TEACHER*

Our regimental band was execrable.
The colonel took our instruments and gave
us Springfield rifle-muskets in their place.
But either way, we weren't much use in battle.
He made us teamsters then, with packs and saddles,
mules and canvas-roofed wagons. We were enslaved,
but half my trumpet section got away.
To an army's life, what does music matter?
My life was wasted teaching brass technique,
I know; but here's another thing I know:
that any art is made of frail belief
that finds its calling only as it goes.
A nation's inspiration comes to grief
when all a soldier does is what he's told. ❧

16. BARLOW'S KNOLL

We came back to Gettysburg when I retired. I grew up here, you know. So did my wife. We were married in Christ Church, on Chambersburg Street, in 1927. That was the year of the gin shootings. There used to be a speakeasy at the old garage, just a block from the church. My dad was a pastor, and he married us.

I never thought I'd be in an old folks' home. I'm ninety-two, you know. I wanted to be put in this one because you can see Barlow's Knoll from the window—there, see it? Past the trees; you can see the flagpole. May and I used to go up there, before we had the children. We'd walk up from the house, with a little picnic basket.

In those days, there weren't many tourists. We'd go up on a weekday, when there was nobody, and May would unfold a tablecloth, and we'd sit on it together. Nothing fancy, nothing romantic; no wine, you know. It was Prohibition. You could see a lot from there: Oak Hill, the college, town. In the woods behind, it was sprinkled with dogwoods in the spring. Gettysburg's a pretty town in the spring—lots of tulips and azaleas, and lilacs already by late April. Wisteria in the summer; we had a lot of that.

Up on the knoll, we'd sit for a long time. That was where General Barlow was almost killed, you know. That's why the name. He made a terrible mistake over there. He ordered all his troops forward to that knoll, when he should have obeyed orders and stayed with the main line. He put his men where they could be attacked from two sides, and they were. That's what unraveled the whole Union line and got thousands of men sent to Southern prisons, where most of them died, I suppose. Barlow was young. Like all you young fellas—think you know better. Well educated, rash, arrogant. Couldn't leave well enough alone, listen to his superiors. One thing I have to say for Barlow, though: he was right up there with his men. That's where he got wounded. Must have had pluck, that young man. Soldiers liked it when their officers stood up front with them. Higher percentage of generals were killed than common soldiers in the Civil War, you know.

First time we went up there, I said to May, "You know, a lot of men lay dead around where we're sitting." I didn't want to spoil our lunch, but I assumed she didn't know things. That assumption was always a mistake with May. She always knew better than I did. "There was a terrible amount of anger and pain here," she said. Sometimes she could almost feel their agony, she said—feel their presence. "Why don't we bring them a little love? They need it as much as we do."

She was a better preacher than my dad. If he'd have heard her, though, he would have been outraged. He would have thought she was talking about ghosts, and he didn't believe in them. He said the Bible said it's wrong to believe in ghosts. You know, since that movie *Gettysburg* came out a couple years ago, there are three times as many tourists as before, and I think half of them want to go on these new "ghost tours." Dad would have been furious. What I think is that people see what they see.

But May didn't mean that, exactly. She was as good-hearted as they come—a real kind, sensitive heart—and she could feel things. So I grew to love the battlefield,

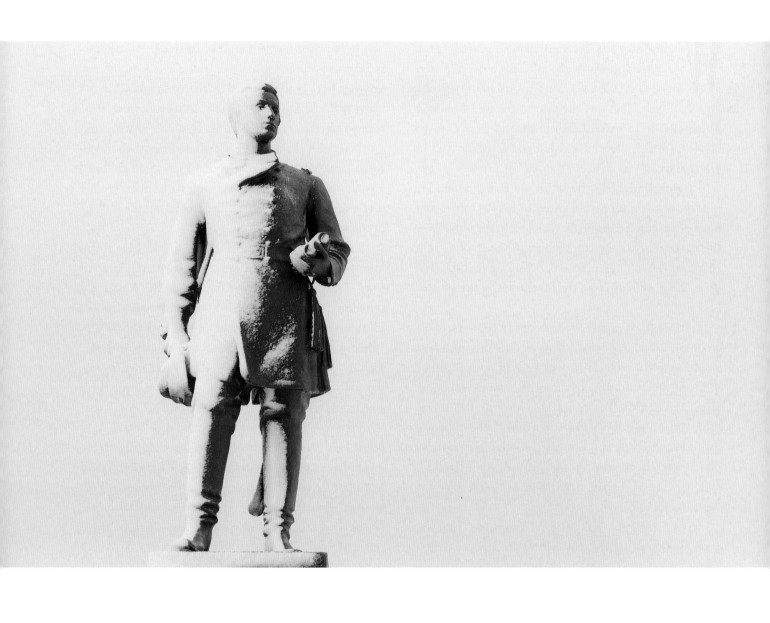

after that first time together on Barlow's Knoll. I know it sounds odd to love a place that was so awful. It was a kind of hell on earth, you know. But May made it different. She's with me every day, all the time. We sit here together, looking at the knoll over those dog-wood-sprinkled woods. Young Barlow was a fool, like most of us, and those men killed each other like demons. So why not give them a little love? They need it as much as we do. ✒

17. *ALMSHOUSE*

You see me kneeling here again because
my soul doth magnify the Lord.
The Lord has raised up those of low degree
and scattered on the fields the rich and proud.
The Kingdom came that afternoon. Right here
the rich men gathered, and they fought and died.
Arrayed in costly uniforms, their flags
of silk displayed, came the children of pride.
Their swords, their cannons, and their bayonets
shining in the sun like silver and gold:
God's thunder and His lightning slaughtered them
exactly as the prophets had foretold.
We saw their well-fed horses prance,
and lie down screaming in the midday sun.
The sun stood still, and bugles rent the air:
we said the final Judgment had begun.
We heard their yells, their agonized hurrahs,
while huddled in our rags beneath the floor.
The God of Battles, having heard our cries,
had come at last to vindicate his poor.
And then they brought their wounded to our beds,
and we were made to bring them food and water.
O, bow thy heavens, dear Lord, and come down!
Pity us! Why do the wicked prosper?
Surely that was a day of prophecy:
we saw the mighty and the wealthy burn.
Surely our God hath not forgotten us.
One day—hallelujah!—He will return. ❧

18. STAYIN' ALIVE

Welcome, stranger. Have a seat. Or should I say, have a folding chair. I ain't seen you here before. Oh yeah, that's what I thought. So what you doin' in a soup kitchen? Slummin'? That's what we used to call it back in the seventies. Gettysburg's got its slum, all right. I lived there, way back when. In a historic place, mind you. Was a Union officer hid out in the shed for three days during the battle. That should interest you, you bein' a history man.

Nawh! I don't live there now. But we used to be proud of our place once bein' where an officer took shelter—a "refuge, until these calamities be overpast," the Bible says. I've become a regular Bible thumper since I joined AA. See? Carry it with me everywhere. Ha! I carry everything I got, everywhere!

Yeah, think what it musta been like for that Yankee officer. For the whole town! Yeah. The town ain't yours anymore. Confederates running the place, might just shoot you for looking out a window and pointing your nose the wrong direction. They could do that and nobody'd say nothin', and you know it, and your whole family knows it. There's no law any more, just Confederate law. And for all you know, it's always gonna be that way, from now on. Sheltering a Union officer like they did could have put them in a world of hurt.

Yeah. Vietnam. That's where I became a man of substance, so to speak. Substance abuse. Then later on, it was alcohol. I'm clean and sober now. But do you think anybody'd hire me? Benefits? I ain't got any address.

I was a big man when I got back from Nam. Had a job, fast mover. *I'm a woman's man: no time to talk.* Every night was Saturday night fever. Not for long.

You know I lived in that shed. Where the officer hid. Felt like bein' home. The house long since wasn't my mom's anymore. I knew what that soldier felt like, hiding out—"until these calamities be overpast." Just one day at a time.

The story was, the family back then heard a quiet voice coming from the shed. "Help." *Somebody help me please.* I know how he felt. *Life ain't goin' nowhere.* Stayin' alive, just stayin' alive. That's what I been doin' for thirty-eight years.

Oh, here and there. I got no particular residence. I'm waitin' out the storm.

You kiddin'? Students up at the rich folks' college scared up money for this place? That's why you're here. I get it now. You want to see how the money's spent. Who gets it. No? Well, what brings you here, then?

You got *that* right. We're all in it together. No law anymore anywhere, pretty soon. Confederates everywhere, with guns, plenty of 'em. Do you think it'll pass? Could be a long wait. Almost forty years now, for me. I can keep waitin' it out. Be harder for folks like you, ain't used to it.

You oughta try the Bible. Puts it all into perspective. It's always been hell. Always will be, until the Lord comes again. "Mine eyes have seen the glory of the coming of the Lord." Well, not yet, they ain't. You just got to find your shed and wait it out. *I'll live to see another day.* All them songs still keep goin' through my head. Sometimes I think they're about all that kept me alive. Just jive talkin', maybe, but here I am. "This too shall pass." *Somebody help me. Life goin' nowhere.* ❧

19. PEACE LIGHT

My old mentor, Colonel Sheads, he got this call one Saturday. It was March 30, 1963. Out of the blue. It was Camp David, and then JFK himself comes on and says he and Jackie and Caroline would like to visit Gettysburg tomorrow. Imagine, a high school history teacher, and the president wants you to show him around. A couple of hours later, the Secret Service shows up, and the colonel takes them on a tour as a kind of dress rehearsal for the next day. This is during the Civil War Centennial, only a few months before the hundredth anniversary of the battle. JFK had been invited to speak on November 19, the anniversary of the Gettysburg Address, and I suppose when he came in March, he expected to be back in eight months. But of course he went to Dallas instead.

The Kennedys were intellectuals, and most people don't know that. They remember the glamour, and that's all. But JFK knew American history like you and I know the insides of our houses, and he was such a Civil War buff that Jacqueline took a Civil War class at Georgetown just to keep up with him on the topic. There's a book by the friend who came here with the Kennedys, Paul Fay. He says the president described some events of the battle so well that you thought you were there.

One time, Fay remarked that he was surprised that Robert E. Lee was held in such high esteem by Southerners, because he made such a huge and horrible mistake here. The president told him that historians probably don't know everything that went into the decisions Lee had to make, and that Lee was tired from a long campaign. And then he said, defending the chief Confederate general, that he was more than a military leader.

I think he meant that Lee held the whole Confederacy together. The means was hope. See, that's why Kennedy was more than a commander in chief himself. I traveled to India when I was a student here at the college, and I saw pictures of JFK in the poorest people's houses. A picture of Lincoln, maybe one of Gandhi or Martin Luther King, and one of JFK.

But my grandmother! She told me that after JFK left, someone asked her, didn't she wish she had seen him. "That man? No!" she told me. "He was a secret communist, and he was out to destroy Christianity. He almost wrecked our country!" Well, you know Adams County has always been conservative, and some folks thought Kennedy was a prince of darkness. But more saw him as a bringer of light. "What did that man ever do that was good?" Grandmother asked me once. "You tell me one thing, and I'll tell you a dozen bad." Well, all I could say—and I didn't really want to say anything to my dear old Gran at all, but I was young—was "Hope."

She said, "Hope for what?"

"Just hope" was all I could think to say, but later I wished I'd said, *For the future.* It's hard to say that to an elderly person, so I guess I'm glad I didn't say it. My mother disagreed with Gran, her mom. She loved the Kennedys, mostly because of Jackie I think. Women dressed like Jackie. And you know, men didn't wear hats again for decades because JFK didn't wear them.

"Hope for what?" It's a good question. Today being Presidents' Day, I thought it would be fitting and proper to stop here at the Eternal Light Peace Memorial, which Franklin Roosevelt dedicated on the seventy-fifth anniversary of the Battle of Gettysburg. Paul Fay wrote that Mrs. Kennedy remembered the Eternal Flame here,

and that's what inspired her to put an eternal flame on the president's grave at Arlington. A light right at the darkest place.

My mother was a high school teacher, and I will always remember her coming home crying on November 22nd. I was a schoolboy back then, and the announcement was made over the intercom. The world changed. My mother said she cried in front of her class, and she never was ashamed of that. If I cried in front of one of my classes today, well, it would be political, I suppose. You want history teachers to stick to the facts and leave emotion and politics out. But I think hope is always political. Some say that it's different hopes that make enemies. That might be true, but I think different hopes can get along. It's the fears that make enemies. It's fears that start wars.

If I could answer my grandmother's question today, I'd say that I hope for a world where hope is no longer necessary. Maybe that's the same as hoping for peace. I think hope starts when we abandon fear. We won't see a peaceful world in my lifetime, and you probably won't see it in yours, either. But why not begin? ❧

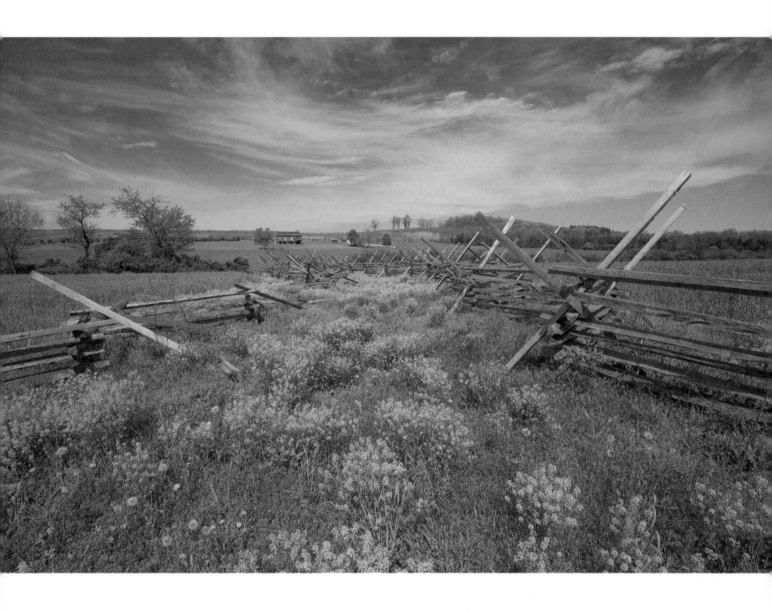

20. *ORPHAN*

My pa was Sergeant Amos Humiston.
You've seen the photographs of him and us.
Mother took us to Gettysburg to make
the orphanage for children of the dead.
We're all dead, now, but I am waiting here.
I was discovered once; could be again.
It's you out there, the living, who go past
my window without looking in, who pray
for us I think on Sundays in your churches—
it's you I want to be again someday,
because this is a house with many rooms
as Jesus said, but Mother works so hard,
you see, she has no time for us, her own,
and room by room they're sending us away.
I wish I could be wondering again
where Pa is now, instead of knowing he's
in heaven, in a bigger house with many
rooms. There's so much that I don't want to know.
I'd like to be a younger child who must
grow up over again, without a war
but with my dog to keep me company.
They wouldn't let me bring him here because
someone might be afraid that he would bite.
But every little child would like a dog.
The grown-up people think they know so much,
and I'm afraid they do. But couldn't we
forget? And couldn't we begin again? ❧

II. THE SECOND DAY

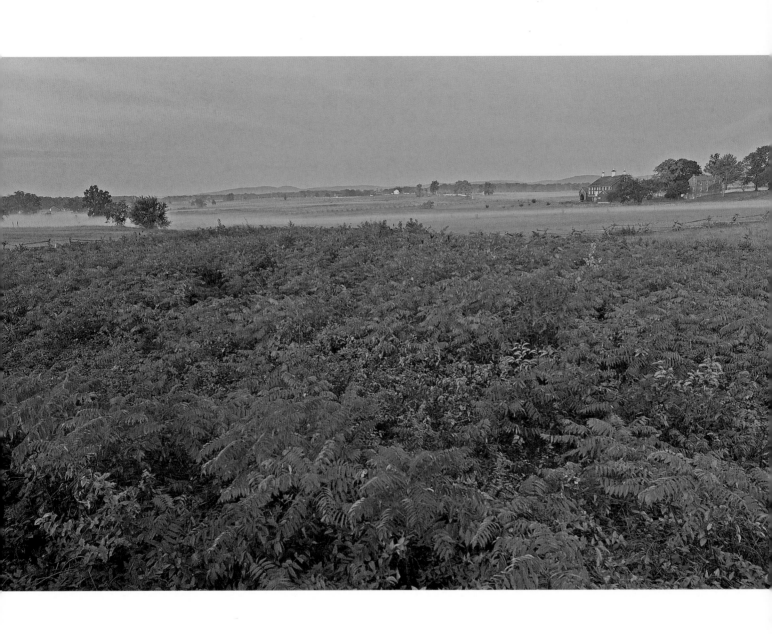

21. *BLOOD AND WATER*

When the Third Corps moved out alone to the Emmitsburg Road, I thought they were the bravest men in the army. Had Clemens been with me, he would have pointed out that what looked like valor was the rash order of a murderously incompetent fool—meaning General Dan Sickles. And of course, he would have been right: Sickles almost cost us the battle and the war by disobeying orders and advancing off the army's line on his own. He did cost hundreds of men their lives—there is no "almost" about that.

Yes, I mean Samuel L. Clemens, whom you would know—whom all America knows—as Mark Twain. I am the traveling sidekick he calls "Harris" in A Tramp Abroad. I was chaplain, in effect, to the Clemens family, a group of wounded nonbelievers who never quite accepted their unbelief. I had the sad honor and duty of conducting those heartbreaking funeral services for his daughters, his wife, and finally for my good and noble friend as well. The public knew his humor and his intellect, but very few knew his heart.

He saw war for what it was: folly that makes us kill strangers to whom we would otherwise lend any aid they needed. What Saint Augustine called massa damnata—meaning that all of us suffer the consequences of each other's sins—Clemens thought of simply as "the damned human race." He loved people as individuals but despised them in the aggregate.

The Third Corps I so admired was an example of massa damnata. A man with no right, except a legal one, to command an army corps issues a bad order, and a thousand good men are shot. The world runs by trial and error; one man's mistake is another man's death and a family's grief.

If you had heard the cries for water that night, you would know why I come back to this battlefield from time to time. I didn't die here, of course, and I do not haunt the place as you do. But the suffering of those men haunts me. I return to look, I suppose, for answers that either do not exist or the human mind cannot absorb. Clemens thought the former; I still hold out for the latter.

Clemens's greatest work, and the work he loved most, came from water—the Mississippi River. What those poor fellows burning with thirst that pitiless night would have given for a cup of that muddy water! Clemens used to say that the works of the great authors were like fine wine, and his were like water. Then he would add with a thin smile, "But everybody drinks water." Not the night of July 2, 1863. If you went out to those agonized men with a shoulder slung with canteens, you stood a good chance of getting shot. As a chaplain, I prayed for them. I can almost see Clemens smile.

It would be a sympathetic smile but also a hopeless one. Since Gettysburg, I have devoted my inner life to the question "Why?" And as you see, I am still seeking the answer. It seems to me that the question has a function. I do not know that answers have anything to do with that function.

Clemens's prodigious intellect gave up on finding answers to heal his even greater heart. So who am I to keep on searching? But where he saw water, I see blood. On this field, we were afloat upon a sea of blood. I was not a pilot; I was a mere passenger. I trusted that there was a pilot, though there seemed little evidence of it. Clemens said that he would have been a steamboat pilot all his days and died happily at the wheel had not the

war intervened. I think he knew, though, that even a riverboat pilot—the most free and unfettered of human beings, he said—even that pilot must go where the river goes. He must learn the river, its moods and changes, and not climb its banks. He knew its beauties, too, and the dangers that they masked, all written upon the water. And so I tried to learn the wisdom that is written in blood.

Clemens was patient with me, though I disappointed him. I hung on to my primitive religion, while he had the courage to abandon it. Still, he thought me brave, perhaps the way I thought the doomed and gallant men of the Third Corps were brave. His humor came from grief and burning indignation, and I never had to take the losses that he took. Courage is a different thing from bravery. You can be born with bravery, and its spark is ignorance. But courage is made, not born. You know what should be feared, and you do feel fear—which the brave man might not—but you go despite your fear.

The Savior knew what they would to do him; he understood the agony, and he was afraid. But for some purpose I will never understand, he went ahead. He suffered at the hands of human folly, murderous human folly. On the cross he thirsted, but they gave him only vinegar on a sponge. When they speared his tortured body, blood and water issued forth. ❧

22. EXCELSIOR

See the diamond on my cap? That means Third Corps. Aren't many reenactors interested in the Third Corps, but that's my passion. I had an ancestor in the Seventy-Third New York, also called the Excelsior Zouaves. Notice the brass letters "E Z" on the band of this kepi. We didn't wear fezzes at Gettysburg, or the baggy red pants you normally think of when you hear the term Zouaves, whose uniforms typically were modeled on French North African uniforms. Most of the men in the Excelsior Zouaves were volunteer firemen, and their tradition of heroic bravery and disregard for their own safety endures to this day. I'm talking about the New York Fire and Police on 9/11.

Now, for any of you who don't know, this regiment's brigade, the Excelsior Brigade, was named for the state's motto, Excelsior, meaning "higher." The man who raised the brigade was a Tammany Hall politician named Daniel Sickles. He was utterly without military training, but he was one of the best-known, perhaps most infamous, politicians in America. He had murdered the nephew of Francis Scott Key, the composer of "The Star-Spangled Banner," for dallying with his wife. Well, presumably they hadn't dallied much: they went right at it.

Anyway, Sickles's defense was temporary insanity, the first successful such defense in American jurisprudence. But after the trial, Sickles bragged to a friend, "I knew what I was doing. I meant to kill him." It became Sickles's practice to defend himself by simply asserting the exact opposite of the truth. That was the case here at Gettysburg.

Note the two monuments to your front left. One shows a man in a fireman's hat next to a soldier of the Seventy-Third, my ancestor's regiment. Notice that the small monument closer to us appears to have an empty space in the middle. That space was intended for a bust of good old Dan Sickles. But when it came down to it, nobody could stomach putting it in. Why? Because Sickles's egotistical incompetence nearly lost the battle, which would have resulted in the breakup of the United States as we know it. But he claimed the exact opposite: that his actions had saved the Army of the Potomac. When asked why there was no monument to him here on the battlefield that his own bill in Congress had made a national park, he replied, "Hell, the whole damn battlefield is my monument!"

So let's back up a little. Sickles became a brigadier general as the reward for raising a brigade, though Congress, which knew Sickles for the unsavory liar that he was, delayed the actual commissioning as long as they could. But the average guy in his brigade liked Sickles. He was personable. A lot of people liked him, including Abraham Lincoln. But the man who mattered was General Joe Hooker, who promoted Sickles to divisional command before the Battle of Chancellorsville. By a freak circumstance, Sickles was then the senior division general when the Third Corps needed a commander shortly before this battle.

Are you following me? That meant that here at Gettysburg, possibly the war's decisive battle, a man with no military training or competence, of bad character, and probably not of sound mind was in command not of a mere company or regiment, but of an entire army corps. The corps that happened to be where General Lee decided to attack on the afternoon of July 2.

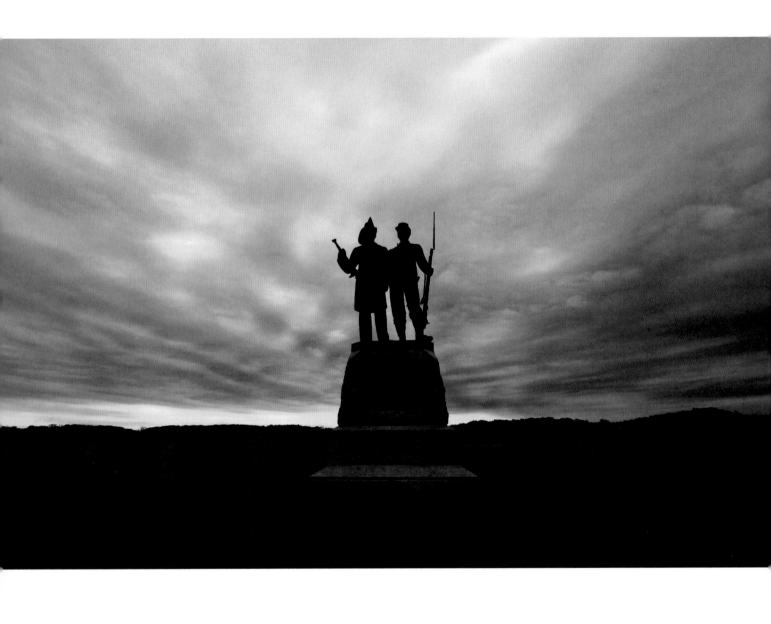

Now, General Meade had ordered Sickles to post his corps on a three-quarter-mile line connecting to Hancock's Second Corps on the right, with Sickles's left covering the vital Little Round Top, over there to your rear on your left. Sickles blatantly disobeyed orders. Why? He wanted the higher ground of the Peach Orchard—to your left. Remember, the word excelsior is Latin for "higher." You know what? I bet if Sickles had been alive when they built the so-called National Tower here, he would have demanded that they call it the Sickles Tower! And he would have made it higher, of course: excelsior! Who here remembers the National Tower? Good! Remember what an eyesore it was, which you could see from everywhere on the battlefield? A gross commercial venture that the Civil War community hated and finally succeeded in having demolished. I was here the day it came down. People from all over the country came to cheer. You're nodding. You were here, too!

OK, so Sickles moved his entire corps forward, impossibly trying to cover a mile-and-a-half front with enough infantry and artillery for only half that length. The troops moved forward off their Cemetery Ridge line, behind you there, in beautiful formation, as regular as if on dress parade. Flags flying. Chaplain Joe Twichell of the Seventy-First New York, who became Mark Twain's friend after the war, called them "the bravest men in the army." Actually, Mark Twain is part of our story today, because he knew Sickles thirty years after the war; visited the old general in his Manhattan apartment. He said that Sickles was appealing and likable in a five-year-old sort of way. His apartment was full of war memorabilia, all related to himself. Twain said that Sickles would talk for hours, all about himself. Did you know that he had his leg bone that was amputated here not only saved but preserved and put on display? You can still see it, at the Smithsonian now, I believe.

So anyway, General Meade rides up in furious dismay and asks something like "What the hell are you doing out here?" But Sickles was his own publicist, writing under the name Historicus—ironic because what he wrote was anything but historical. He wrote that Meade had approved of his move! Again, the exact opposite of the truth.

But wait, the lie gets worse—and bigger. So as many of you know, Longstreet's attack chewed up not only Sickles's Third Corps but also brigades of the Fifth and Second Corps that Meade and Hancock were forced to send in piecemeal. Longstreet's assault almost succeeded. A thousand men died who didn't need to die. That's over ten thousand in today's terms. Three times 9/11. But if Sickles had been in place according to orders, Longstreet's men would have had to attack over open ground, against a numerically superior line posted advantageously. It would have been Pickett's Charge, a day earlier, with similar results.

But Sickles claimed the exact opposite. You would never guess what his claim was, it is so ridiculous, insulting, and absurd. Who knows what it was? Yes? Right! That his corps absorbed and wore out Longstreet's attack. And saved the army! So the man who nearly destroyed the United States turns out, by his own claim, to be the one person who saved it. If you're going to lie, make it grandiose. Don't you wonder if

Hitler studied Sickles before he came up with his "big lie" technique? Tell a lie that's big enough, loud enough, and long enough, and people will believe it.

Yes, you're right. I am a little down on Sickles. Why? Well, remember my ancestor in the Seventy-Third New York? He didn't make it. Up there, in that Peach Orchard, his blood is in the soil. I would have a lot of second and third cousins today if it hadn't been for Daniel Sickles. History is personal, folks. History is today. ❧

23. CAROLINA HELL

Rush them, boys! We got them on the run! Damn the Yankees—give 'em Southern hell! You there—see—I'm hit—it's canister balls hot as hell, and knocked me over backwards. See the way we charged that battery, sir? Look at how we came across that farm-yard right into the muzzles of twelve-pounder smooth-bores double maybe triple loaded—gave them Palmetto hell, we did, and see them pull their prolonges—never mind limber up—Hoo! My boys! You got them damn Yanks whipped good! Just look at them blue-bellied gunners work like monkeys rolling back them cannons. I could watch this for a thousand summers. Course I'm hit, you fool! I didn't come to sit behind our lines like some damn chaplain. The song says, "South Ca'lina gives 'em Hell, boys, root, hog, or die."

What side you on?—no uniform. Must be some ol' newspaperman, I reckon. Well, you write this down. You Northerners wonder why we come out here to fight you all? We lost the 'lection fair and square—you think so? Wasn't nothing fair about it! Rigged from first to last. You just think, sir, if I may ask: Why was it where no Yankees messed with voting, Lincoln tallied nary any 'lectoral votes at all? Now what was that, sir? Anywhere Yankee lawyers reached, he won that state. But not within our borders, sir. You didn't read that in the papers. Why, because the press are liars. All lies.

Can't trust one on 'em, except the Mercury. Lincoln, Dishonest Abe, stole the 'lection. Fraud does not deserve our acquiescence, sir. No self-respecting white man voted Black Republican, no sir. Abe Lincoln keeps a black mistress—everybody knows that, sir. White House ain't exactly white no more, with his mulatto children run-ning wild, like as they was just down from the trees. Fat Mrs. Lincoln, she don't care, as long as she can line the Lincoln purse. At Southern cost, I hasten to add. They plan to tariff us to death, disarm the South, and put us all in factories to make their big bugs richer than they are already.

You say Mister Lincoln, as you call him, has no such intent? You naïve dupe. What Lincoln tells you, you believe. He means to conquer, subjugate the South. Just look at what we're fighting out here: immigrants, mudsills, offscourings from the slums of Europe's cities. "We are a band of brothers, and native to the soil." That's what the song says, "The Bonnie Blue Flag." Lin-coln! Known and published liar. Don't tread on us! We will hang Abe Lincoln after we whip these damnyankee hirelings in front of us, no matter that we pay for victory with Southern blood. Brothers "fighting for the property we gained by honest toil." Hurrah!"—sing it, newsboy! "Southern rights, hurrah! Hurrah for the Bonnie Blue Flag that bears a single star!" ❧

24. *THE OLD COUNTRY*

It is you again. You would think the war belonged to you instead of us. I think you understand me when I talk Norwegian: you grew up with it too. But I was born in Norway, long ago. Yes, long ago and far away from here; it couldn't be more far away. If I had known I'd get into a war, I never would have left. I came for work, you know. I was a carpenter—just like the Lord Jesus. Yes, but that's where resemblance ends. I don't think Jesus was a Lutheran. My father was a carpenter, but mother was no virgin, I tell you, by the time she had me: I was sixth. Both brothers were carpenters ahead of me, and if I wanted work, I had to find another town that didn't have already three good carpenters. I said, I might just as well go to America as go up north. Americans were building everything. That sounded pretty good. I took the first ship from Bergen, and it went to Boston. It was a good place for me, and I sent good drafts of money home.

Then the Southern gentlemen began this war over slaves, and I tell you, I was angry enough to fight them all. If you want to know what freedom is, just go to Europe and live there for a while, and when you come back here you will know what you have. No king, no Church, no "This is how we always have done it and how we always must, alpha omega amen." It is a new world we make here, with the hammer and nails of justice. Where there is no justice, there is no freedom: there you have the old world again, the same Old World of Europe, where no two men stand alike. In Europe, one man is always higher than the other. In the South, they are the Old Country, but even worse. Let them get away with it—let them break up the country when an election doesn't go as they like! But in the United States, the only

one higher than any one person is the majority. There is your ruler: the majority of the people—not a king, and not a priest, and not a rich man with his slaves. That I will obey. There is justice; there is freedom. Otherwise, you only go back to what we all left behind when we came over here.

But to die for it? Maybe I wouldn't have if I had known that I would have to die in all that smoke and dust—on some little farm. Norway is beautiful. I would have liked to die there.

When I was shot through the chest, I stayed up in the saddle. Norwegians are tough, I tell you. But the captain says, "Lieutenant, get out of here! Go and find a doctor!" Well, I rode back toward the ridge but didn't see a doctor, and the farther I rode, with the blood in my mouth, the angrier I got to be dying anyway, so I turned the horse around. I had two guns under my orders, two brass twelve-pounders, and as long as I could sit a horse, I would see to it that the men stuck to their work and gave the Rebels what they had coming. Right there the guns stood, and the boys with them.

The slavers came from the woods over there, and from the field in front, and from across the road. They had us on three sides, but we gave it to them; we gave it to them good, I tell you. From horseback, I can see where the Rebels come up close, and I ordered the lanyards held until the time was right. But they were all around us, even behind. I think they shot me from our ammunition chests, shot me in the back first, and before I fell, they shot me five times more. I lay with our dead horses, and I felt I was raised up in the air and saw myself lying there, saw the captain shot and the sergeant hold him in the saddle, and our men run with them, and the Rebels

stop and try to turn our guns, and then I'm not so sure what I saw.

But I am here now. It must be a long time that I am here, but there is no real time. The carcasses were almost at the front door of that house—our animals, horses to pull the guns and limber chests and caissons—poor beasts, who came here from some lovely pasture, not knowing why, not speaking the language of those who drove them, lying uncomplaining in blood and smoke and noise. Who sends us where we go? I wonder if the horses thought they came by choice.

I ask you, if you go to Norway one day, you be the bird who brings my greetings to my father and mother. I have no wings. I cannot move from here until the one who pushed me here relents—or maybe until I understand. You find them there for me: Min far, min mor. Hils fra mig, fra mig! 🕊

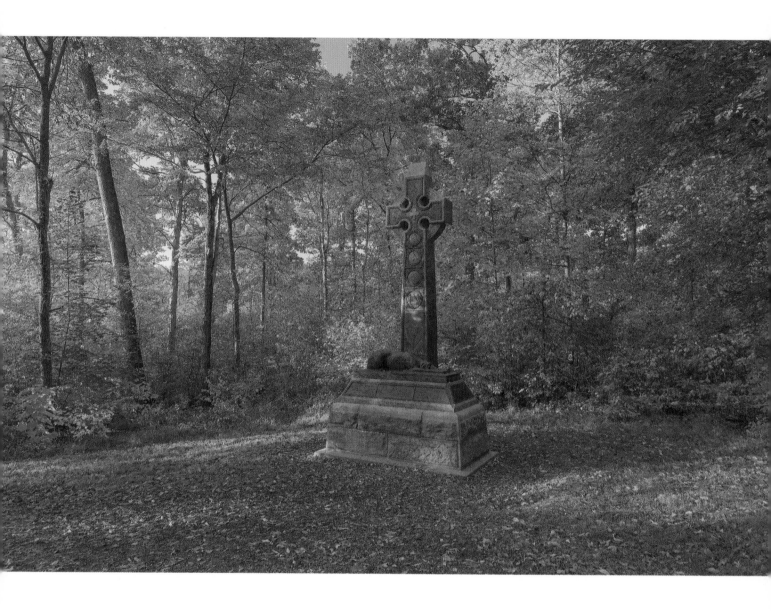

25. SLÁINTE *FOREVER*

I'm Irish now, I'll have you know. Keep that
in mind. Was born and bred in County Cork
and sailed from Galway on the old Saint Pat
in '48, starving and sharp for work.
So when I saw you pausing here beneath
our monument, and seem to shed a tear,
and place that lovely, leafy little wreath,
I said, "Here's one who loves the Irish, sure."
But best of all's the little note you fixed
between the Wolfhound's rough and ready feet:
Sláinte *Forever. Let us raise a drink*
of Irish whiskey, simple, pure, and neat.
Sláinte! *It's life that makes a fellow think,*
but it's death that makes a fellow drink. ❧

[*Sláinte* is a Gaelic toast.]

26. *BROTHERS (1863)*

I did it for the state of Mississippi, which I loved the way you'd love a daughter who has set her mind to marry some charmer bound to break her heart. You move in with them to look after her and be there to help when the wreckage comes, maybe take care of some poor little one born of that foolish confederacy. I knew secession was a rash and foolish act, but I loved our lazy summertimes, slow like the river, going nowhere but to the Infinite.

But mainly, who would care for Daniel? He was my twin, you see, but not in mind—a man, and more than old enough to join a whooping bunch of boys set to enlist. He'd always be a boy himself, and they would play him like a kitten, which is also what he was—no war in him anywhere, but just a wish to please his friends, or whom he thought to be his friends. When he came home and told us he'd signed on, I saddled up our nag and rode to town dressed like a man, for someone had to care for him, and I was full of war. I'd looked after Daniel from the day we both were born, I think, but how could I complain? He was so good-hearted in his kindly, simple way. He couldn't tie up a pair of shoes till he was twelve, went barefoot like all the little boys did, way past when he was small, and I tied them before we went to church and no one knew—except for Pap and Ma'am, and they would dote on him morning, noon, and night like servants.

When he was twenty, all the folks believed that Daniel had been kicked in the head sometime when he was small, and we sat right with that—or I did, anyhow, because I'd not be thought an imbecile because I was his twin. Over time, it was quite a story people made, how he had saved his sister from a maddened horse when we were four, had stood in front of me and waved his arms and Lord knows what—even made up what he shouted, "Go back to the devil! Go back to hell!" though I alone could have told them what he said. I don't remember such a thing, of course. People will believe what they want. And I say, let them. I learned to do a boy's chores, and then a man's. I taught myself reading and writing, and could do sums when I was eight, because I was not going to be helpless, and would die before I was called Simple.

So Simple Daniel and his brother "Jake" went off to war for old Mississippi. He stuck right with me and did what I did, and I declined promotion—could have been a corporal at least, and maybe a lot more—because I was a brother who stood beside his brother. Drilled with him, even would load for him when we were in a fight. I got creased along the head at Sharpsburg, and the boys said he sat beside me all night like a dog, and the rag around my head he'd torn off a dead man's underclothes—and he was mortal scared of the dead. Who'd hate such a boy? All night, until two younger boys from our company drug me off, him cradling my head like a baby.

We came through Fredericksburg and Chancellorsville all right, not much worse for wear. For him, the way up here was one long holiday of chickens, eggs, buttermilk, and farmers' bread. Blissful as a boy rolling a hoop, my brother marched along just happy to be alive, no thought of Yankees troubling his sweet mind. But I knew there'd be some reckoning, one day, because the reasonable damnyankee willing to give up and let well enough alone has yet to be given birth.

Sure enough, we got word of a big fight up the road a half day's march. The second of July, we swept across that field just there, as glorious as anything, flags forward, the

general bareheaded, white hair streaming—across this farm, Rebel yell high in the afternoon, yipping, whooping like it was anything but what it was: Yank artillery pulling the lanyards over on that rise yonder. All that war, but not the anger, shot out of me; hit by some iron canister ball, I expect. Reckon Daniel went on some ways before—before he fell.

I am looking for him still. Might be he got out of it alive, but if he did, I know he'd come back here seeking me, somehow, whether he was dead or in his body yet. But I ain't seen him.

The Yankees buried us, me and half our company, it seemed; so the boys never found out I was a woman, unless old Daniel came out alive and told them like a fool. Don't matter, I suppose, except it was our secret. At home they grieved, the mother and the father, but just a little, I expect. Enough to be respectable. They never had much time for their firstborn, what with the other ones that came along. I never knew the others like I knew Daniel. I guess you might say he was my life and death. I wish these fields would give up his ghost, so that him and me can go home. ❧

27. *SEMPER FI*

You ask me where to place your men? Remain
upon the line you occupy, Colonel!
We shall have no falling back today.
You'll stand your ground here, sir, and give them hell!
Half-hearted officers won't last in this
brigade, sir! Get your men out from behind
those trees, or by God, you'll be an enlisted
man! Collect what cartridges you can find
from the dead. We'll all be among the dead
if we don't hold this line. You're on your own.
Don't send for help from other regiments.

Well done. I'll get a surgeon for that wound.
You earned those shoulder straps this afternoon.
Yes, Colonel, I will have your effects sent. ✎

28. *ADAMS COUNTY*

You know I been leaning on this tree watching you, Yank, for, I don't know, about a quarter hour now, I suppose, and you almost alarm me, the way you been looking, stepping first here then there then back, as if you're trying to remember something. And then I been thinking, maybe you ain't a Yank at all, come to think on it. I believe you look familiar. One of Kershaw's boys, maybe—lined up over there on our right?

Seems I recollect a new recruit run up to catch the skirmishers, a farm boy, from the looks of it, new shirt and homespun trousers—about as much uniform as most of us had by then, except yours was unsoiled and not tipping toward the category of rags, and you stood out with that bright plain shirt, which might be why some Yank sharpshooter picked you out. You crossed the road with the boys knew what they was doing, just kind of watching them, toting that musket like it was a alligator or something, and when they fanned into that orchard field yonder and lay down, you saw some stone set for a little rivulet, or was it the remainders of an old wall, ten inches at best, which was all right to aim behind, except even from where I was, I saw you hadn't ought to lifted your head just then.

I can't help wonder if that wasn't you, and you're looking for the spot. We all want to see the spot again. As if seen, it could be understood. Might be you don't recognize the place, quite, because, you know, the barn is gone except the foundation, the barn some of them Yank sharpshooters run from when you boys crossed the road. Was plenty more of them in the woods, though. I expect you know the stone house, because it ain't changed. But even if you do, I'd lay money on you don't believe it. You

can't be sure. Any more than I can know for certain it was you.

Hell, you looked to be only eighteen or thereabouts, and now I see a gray head. Finally in uniform, after a fashion, you might say. Maybe you are just a Yank, some damnyankee tourist here to look around, maybe had a great-granddaddy in them woods shooting down our boys. I see you got the soul of a Yank, brother, but I can tell the heart of a Rebel pretty far off. And I been watching you close, like that sharpshooter, but with no evil intent. You are one confused specimen.

It comes to me now that you belong more to your time now, as much as to ours then, two sides playing hate with each other, heart and mind at war like every man in every time since Adam. And like the country then and now, you wonder who the hell you are and who you ought to be. Yes, I think every man since Adam, and my brother, you have come to the right place because this is Adam's County. If any place belongs to him, this does.

Well why don't you pray for Adam, then, instead of us. You can't hallow us, Brother. Can't hallow a field of dead men fought to save their rights. Ain't nothing holy in that, and you can't make it so with words, like the Black Republican made the Yanks holy by saying so. Well, Old Abe did say he couldn't hallow this unholy ground, but the Yank sharpshooters had done it, somehow, by shooting you down, you poor simple son of Adam, just paying your wages, shot to death for being Southern. Why don't you pray for yourself, 'stead of us? You're the one confused. They birthed a country out of this hash we made, those that wasn't killed. Maybe you can do it again. ✺

29. *THE FACE OF BATTLE*

We shot them down in rows, but what for? Look!—the hairy lunatics are still here. See them in that field, staring at us.

And you! Your fear insults me like an impertinence. Can you not reason it out, that we can do you no harm that you do not inflict yourself? And your reverence exasperates me even more. Look at me when I speak to you!

What do you see? I know you see a Yankee officer in uniform, with his accoutrements, sword and pistol. Does it not strike you as an oddity that I should stand in uniform, when decades ago my clothing must have crumbled into desiccated threads?

You perceive the nighttime trees behind me, do you not? They appear in full, as though no figure intervenes between. You see me fully, yet you also see everything behind me. Peculiar, is it not? Singular, do you not think? I am present, and not present, at once. Perhaps that explains your fear.

You flatter yourself in thinking that you are now looking steadily at Death. Perhaps you are staring Life full in the face, as much as Death. Cast your gaze into that field, where the Rebel dead stand regarding us. They are alive, are they not? Their feeble minds were full of heart-stirring vocalisms like Duty, Honor, and Valor, and those words were useful. Consider also the gods of Olympus, who do not die mere human death. And look again.

So here we are, with our worthless Rebel friends who drool their incomprehension at this Yankee officer having concourse with a breathing citizen some generations hence. To them, you are present and not present, both at once. It is too much for them to take in, poor chaps. But do not the gods confuse and appall with their presence, as with their absence?

Why do the living consult the dead? Do you imagine that having crossed the Mystery, and looked back on our actions, we have acquired not only knowledge but judgment? But why should we know the future, who are all-consumed with the past? Have you no powers of reason? Have you no Bibles? Have you not one another to consult, no experience, no History, no intuition or imagination? Experience is not a teacher, but a judge. What can be learned but to endure and wait for the wrath to pass? What can be predicted but wrath to come?

Look at the morons now. Had they respiration, they would be breathing through their mouths. Still battle-crazed, they think their Cause lives on. I see their presence unsettles you. They stand like wraiths, regarding you, silent as stalking wolves. Perhaps you terrify them, a living specter of the unlearned.

How shall we honor them? A "brotherhood of valor," "comrades in arms," sharers of a knowledge hidden from you later generations? It is a bitter knowledge they have. Their ideas of honor and valor and duty shall receive their due from the laughing hyena that governs their affairs, or from the Fates: they were but weasels fighting in a hole. Fortunately, the weasels fighting for injustice and stupidity lost out—this time. But all of you belong to me.

For you, I have but base contempt—the same for all the living. What else are you reasoning, deluded fools but slaves of folly, slaves of wrath, who are so finely made? What miracles you are, each tendon wrought of finest filament yet smooth and strong as marble! Your heart, the seat of heaven, that can lead you to this hell,

untiring and indomitable! The eye, how beautiful itself—an ocean and a jewel—that will not see what it is made to see! The breast, its curve the fell of falcons; and the hand, how intricate, to work the works of darkness and to lift the fallen! What miracles you are! What noble sacrifices! What miraculous fools. I hate your reverence. Its insulting incomprehension whets my appetite. You might honor each other, yet you honor me. You kindle my red rage.

You see why I am here. They have their confusion and perplexity to fix them onto these fields; I have my rage and animosity. You are looking at the face of War, and when my time comes around again, I shall come for you. ❧

30. TOUR GUIDE

OK, everybody got their water bottle? Let's make sure we all stay hydrated. Hey, is that an L.L.Bean shirt? Got one just like it at home. Don't know why I didn't wear it today. Perfect for Gettysburg in July: wicks moisture, stays aerated, blocks UV rays, repels the biting nasties. The whole enchilada. Too bad Johnny Reb and Billy Yank didn't have 'em! Do you know they wore wool uniforms, in summer? Course, they got a break: their long johns under the uniforms were cotton! How'd you like to be wearing a full suit of long johns right about now, with wool trousers and jacket on top? Well, they had worse things to think about. Right here was some of the most intense fighting of the battle. Right where we're standing, a lot of boys in blue and boys in gray *met their Maker!*—as one of my favorite colleagues likes to put it. But hey, we're not going to be heavy today. I know you've been listening to some pretty serious lectures. So today I'm going to share some of the amusing stories and incidents of the battle. We're going to enjoy ourselves this afternoon. We're going to have some fun! ✒

31. *WAR MEANS FIGHTING*

*W*e Georgians took that stone wall yonder, declined to give it up. Them New York boys, they druv us off, but we returned directly and give 'em all the taste of Georgia hell they'd ever want, I expect. Oh mercy, it was fun! We whooped and hollered them off, and you could almost see their white tails bouncing—they showed us their hinder parts, I reckon—couldn't get away fast enough to suit themselves, and if anybody saw fit to dispute that we were the fightingest wildcats on this earth, it wouldn't be them damnyankees from New York. We shot them all to hell, we did; left that 'ere field up front of the wall just strewed with plugged bluebellies like the ground under a old pecan tree. So if anybody ever told you that war is hell, it must have been some Yank who'd had his fill of Georgia hell.

We played them Yanks some tricks, sure. I laughed like a monkey to watch them bluebelly burial parties come dig their comrades in, faces covered with kerchiefs against the smell, blubbering over their dead friends and puking like cats over sour milk. Well, what did you expect, Yankee boys? This is what war is for, boys! You come mess with us, we gon' to show you a thing or two! You expect a Sunday school picnic? Let me educate you mudsills: war is fightin', yes sir, fightin' with guns and bayonets and red-hot canister.

War means fightin', and fightin' means killin'. If you didn't want any, why did you sign up to fight us for, Yanks? You think we'd run off like you did from this here wall, say? You thought we'd concede the point and swallow our dispute and politely ask permission to come back into your filthy Union, rub shoulders like before with you shopkeepers, machine oilers, free niggers, and cutpurses? Pretend to be brothers and love each other after what you done to us all those years?

I beg to differ. You can live whatever way you please amongst yourselves; you can live like pigs in shit for all we care. But keep to yourselves or be prepared to die like fattened hogs. And look how some of them New York hirelings dressed up in French outfits, red pantaloons like ladies of the evening—which is exactly what they were, selling themselves soul and body for the big bugs who run New York and want to run the country. Fun to shoot them full of holes? I reckon it is. Charity and do unto others be damned; we have grievances, and Georgia fights a fight, boy, root hog or die! You can't fight proper without you hate proper; can't do justice to the thing unless you love to shoot 'em down like wild hogs. What did you think war is, boy? Patriotic duty? War is fightin', and fightin' is killin'! ✒

32. *BLUEBIRD*

Why Union's blue, I couldn't rightly say. I never thought on it till now, while looking yonder at the bird. It's New York's state bird, you know. My mother used to love them so.

We'd sit outside in summertime like this when chores were done and watch them flit and hover out there beyond the garden by the fence. Their call is quicker than the other thrushes; a little hurried, I would say. The light would fall just right, late afternoon, to give that pretty blue a kind of sheen like angel wings.

Oh yes, I know whereof I speak, sir. We saw them once together, past the roses just before the trees, in a kind of shimmer of white, and then gone, but we both saw it, and the bluebird sitting on the fence post like a pin—angels and a pin. My mother was well educated in the Old Country, as she called it. She told me how philosophers would discuss if angels had bulk, like earthly substance. If not, then a dozen of them could sit together in the evening in no space at all—or a thousand; however many might please them, or please God, rather, because they're doers of His business and don't have business of their own. Though why they'd just sit together, I don't know. Unless that's God's business just as much as flying here and there.

So where the angels were, three bluebirds sat along the fence, but barely for an instant and then they were off. They flock together, bluebirds do, but in little flocks like three or four. Maybe angels do the same. It would be lonely, going about God's business by yourself. I bet they go in pairs or triplets most of the time, for sociability and Jesus' sake. Like bluebirds.

We wondered, had the angels gone to bluebirds somehow, for modesty?

The bluebird is a perfect bird, as colors go. Wherever there is blue, there should be orange, and the other way around. That's what a great Dutch painter said. Oh yes, I went to college for a while but came back home to be with Mother when her health grew worse. I think he had the bluebird's orange breast in mind, under that perfect blue, that bit of sky. An angel is a bit of sky come down with messages for us to see.

They bring the light. Sometimes that is enough.

That's why the bluebird yonder sits so still. She doesn't flit away; she sits with me. It's Mother who's an angel now. I know my mind is wandering. They gave me something—it's laudanum, I think—to ease the pain.

But is the bluebird there or not? I think all heaven's there. Now you must bear the light for me, my boys—for old New York, for Liberty and Truth! "You are the light of the world," our Savior said. Maybe there is no other light on earth. Except when bluebirds come. Oh, the bright wings! ❧

33. REVENANTS

My friends fly away no matter what I do. They penetrate the air like startled prayer, like bursts of sparrows blown to memory! Brown to blue they go, a disappearing canister of souls. And you are left on this sun-beaten field alone—the part of you that a body could recognize, your name Unknown, decomposing into the unknown, into the cloudless, unending, and ice-cold sky—that whatever cause you blew up for might live on, making the young ladies now and forever glad and thankful for your sacrifice each dusk and dawn for a while, and commend your memory to God, for a while. But you didn't know what you were doing or the reason for this universal rot, this mash and ruin. I do not pray for anybody's soul, as I am sick of souls. I want the bodies back: shy Clement, whose mercy was to die gut shot with Yankee lead poisoning his entrails; my cousin James, a nuisance who embarrassed me continuously by looking up to me, like these boys looking into the sun with empty eyes. I sort of loved him anyhow, would like to see him whole again and with legs on him, to have them all again as we were, not some angel choir of souls you can see through, standing cloudy and cool—indifferent saints looking on like mules.

In point of fact, I don't mean to pray at all. Honest prayer is not for cowards, and while I did not run from the enemy, I ran from prayer all my life. Only now, when I look back in my mind and see the dead on this field, the time between is gone and I am horrified to God. Angry, too. God is not to blame, and He can't help, but He's the only one I have—only one to talk to. Only one who doesn't talk back. The others all squeak and gibber in my fancy. Or is it only gas escaping from their bloated poor, poor bodies—or demons wearing butternut and blue?

I beg to Jesus to be freed from here. Won't you let me go?—go to where my mammy used to gather us up like the Spirit of God that brooded on the waters before everything here was made, gathered and held us with hands strong and gentle like the hearts of angels, gathered us all the same together, one brood to brood over. But didn't we go our own ways? And didn't we have it out on each other? The fields of Gettysburg rotting in the sun like a stinking heartbreak, one end to the other, rocks and cornfields and trampled wheat and creeks red with our blood. Horses blowing up like bags and vultures gathering! My mind is sick to death. What happened to the afterlife? What is this heaven for, if all I do is smell the spinning death and stupidity and heartbreaking bravery of us all?

Those Massachusetts gunners discharged their twelve-pounders into our faces before we got to them and made a steam of us, a bursting drizzle of hot blood, clothing, hair, bent split pieces of musket. And what was left, wild hogs found that night. We were hummingbirds drawn to the nectar of surprise but mad as yellow jackets, drunk on rage and righteous indignation. You who sift the air for us, have you found that we were right? Or is your present judgment that we were unjustified and at fault for everything that happened here? Because it doesn't matter, does it, anymore. You'll make your own foolish choices, which we gave you all the fixings for. History has nothing to teach when you don't study it, and those dutiful gunners did not leave enough of us to study properly. We would have told you, "Damnation! We shouldn't have done this," the instant we were hit, but we were busy. We had concentrated for that instant, but then our attention was scattered in all directions.

Except here I am in some godforsaken sense, to squeak and gibber as the Bible says of ghosts and those who call them up and claim to speak for them. How do you know this talk is not your own rage and your own horror speaking? You don't, but you have heard the dead—not in words, but somehow—and you have been told we congregate and walk about and visit the living in places like this where we were sudden in our departure, where we were taken off by violence, and after all these years by your count still can't get it into our nonexistent heads that we are gone. Not only gone, but forgotten—all who knew us dead, forgotten themselves. And you want to know us. What for? To honor us, I suppose you'd say, but think twice, twice about honor. You don't know what it means, and I haven't the brains to tell you. They were blown into the air when that Yank pulled the lanyard, and what remains of them, if anything at all, is a little too refined and rarefied for this soldier.

I haunt the place—that's right, I haunt this place—because I haven't yet learned of anywhere to go, haven't got the legs to carry me. But as matters stand, I am not interested in moving on even if I could. These fields suit me. By day they are beautiful, soft and green and butternut, and by night I see what you can't see, by different light—memory—a hard sun that never goes out and does not sleep. I say, Why move on, when all I'd do is be born again, and again, just to come back here? Like you. You know, I think between the two of us, it's you who are the spook, the revenant—you and some of these others walking back and forth as if you'll never get enough. It's you who can't leave, born to come here, born to come here, time after time. Yes, I wonder about you, why you can't get rid of whatever's in your head, some rage you got, some sorrow won't let you go or you won't let go. Oh, you can pray for me, Yank, sure, but I think I am your prayer. Send me to God if you can. ❧

34. *DEEP RIVER*

My Mammy said that sin's a river,
for you get on some place you want,
but it will take you where it wants to go,
not where you thought you'd end.
I see how many ways she's right.
She said I hadn't ought to come up here.
You see, she didn't understand about no draft,
how guv'ment, which is white folk, reaches down
and takes up other white folk
no matter if they want or not.
Sin, she called it; thought that only colored folk
ought have to go and do as they was told.
But now I see her drift.

My mother died when I was born, so Pap,
he took a servant 'cause he couldn't raise no boy hisself.
How Pap afforded her, I'll never know,
except that she was halt,
which must have dropped the price down
to a sack of corn and promises.
You don't inquire close after matters suchlike.
Nobody really has a price; it's but an economic thing.
I was her boy,
and that is why I fought and laid it down.
I know, I know, you'd call it Sin. But you don't have no choice
when's one thing bad and t'other worse.
They drafted me, but I agreed to fight.
The Yankees come and get my Mam?

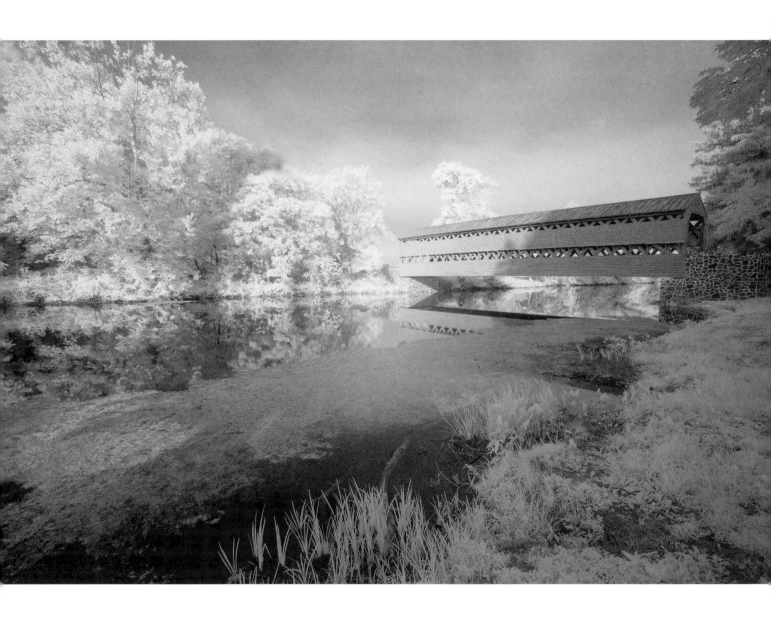

And she's free, and who knows where
she'd go and how she'd live without her boy
and Pap to look after, and to look after her?

You abolitionists don't understand: it ain't
a simple right and wrong. Aw hell,
I know it's wrong.
There ain't no argument
about it's wrong or right. I wouldn't want
to be no slave, no more than you—and that's
the Golden Rule,
no matter what the grandees on plantations say.
See, we ain't ignorant. Because we talk like folk
and not like some wound-up device, don't mean—
well, see, that's what you think and I know it.
I read. I read how abolitionists despise us Southerners,
look down the nose at us, and smile
at how we talk,
and all the while afraid of us
like rattlesnakes and devils.
The choice you give us was to free four million
colored folk and fight it out with them till they or us
is mostly dead—not out here on battlefields
but in our beds at night, and in our churches,
men and women all alike, and children too. Or
fight it out with you the decent way, and orderly,
and when it's done it's done.
Sin don't let go of you
until you pay its price. Our fathers sinned,

just as the Bible says, and children's teeth
are set on edge, and generation after generation
pay the price. I sinned
against my Mam, fighting to keep her,
but I'd sinned still more to let her go.
Fathers put us on the River, and this
is where the River ends for me.
I'd say you've got a longer way to go, and who knows where
the River's going to take your generation.
A sin is something you can't hold, and can't let go.
And sin ain't death:
death ain't nothing side by side with sin, 'cause death
 is short
and sin is long.
Sin outlasts death—generation after generation,
so deep you never find its muddy bottom.
No, death is not the River, sir, for if it was,
I would be long away from here. ✒

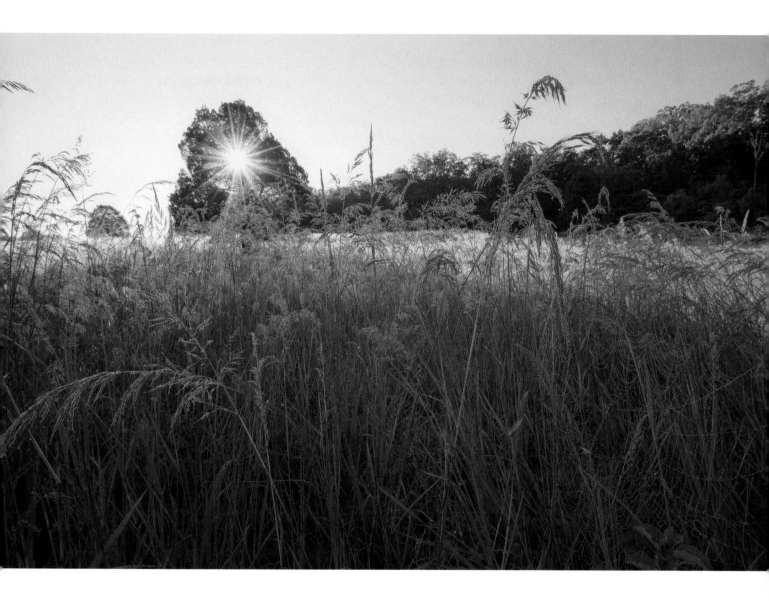

35. SURGEON

You there, move out of my light! Can't you see we've pulled these fellows out of the sun but I still need that shaft of light you're blocking? Civilians shouldn't be here. What's the matter with you? You look like you've seen ghosts. You're paralyzed with fear! Don't come out here if you can't stand it. But I suggest that you address your fear of death by looking at it: you see the dying all around me here.

I have no chloroform here, I have no nurses to assist me, I have no table; there's insufficient water, bandages, lint! Where are the stretcher bearers to take these fellows beyond the range of balls and shells? We're only fifty yards behind the line of battle! The air is foul with smoke. The dead are better off than these poor men: listen to their moans, their prayers! And the poor fellows who must scream—they don't even know it is themselves who release the noises that torment their ears. Their blood, their precious blood, soaks my apron! This sick, sweet, steely smell revolts my helpers; I know the odor will lie in my stomach for all time. And you're afraid of death, you fool! Help me move these men.

Why do you stand there like a ghost? Swallow your fear and do your duty! Look: I put my hand to my head to stop the spinning and mark my forehead like Cain forever. See these hands? And you fear death. I would welcome it—a gift my hands are too besmirched to grasp. I reach them toward God, and he turns his face away! What have I done? What have we all done here? No death is granted those whose hands drip with Abel's blood. The one great blessing, we are denied! The guilty are condemned to live forever upon this charnel house of Earth, this mad battlefield, firing on each other, nursing each other, swooning in smoke, and half mad inside this pandemonium.

Give me some alcohol, some chloroform, cotton bandages! Stiff with fear, you're no good to anybody here. I'll tell you about the dead: I've seen them rise like second selves from these mangled bodies and go—God knows where, but away from here. You don't know the half of it, what happens out here. All you have been told is true: the soul lives after death. I see them all around, and then they are gone, while we stay here. The other surgeon was shot through the body next to me, there, exactly there, with a face like mine. All we do is help the wounded here, and we are shot and torn up by shells. It's you— you the living, whom you ought to fear. The dead and dying have made peace with whatever is to come, but the living are always at war with the future and always fighting death.

Some fool has left my surgeon's kit back inside the supply wagon. What can I do with two bare hands— two bloody bare hands? Go fetch my kit! Get out of here; I don't want you to watch this. Go on, go. You will go mad; you will lose your senses, looking on these poor wounded fellows. Look what you living have done to them! Go on now—go to the rear. Tell someone to send my kit! ❧

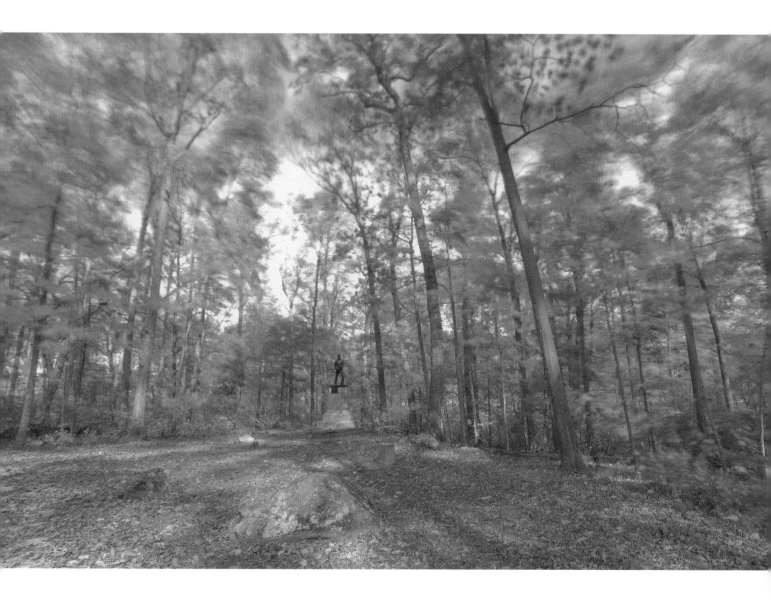

36. UNREST

Why do you follow me? You always follow ten steps behind. But you can't see what I am doing when I turn my back. The others follow me on days that you don't come here, but at night—at night I am alone with them, the other ones, the Dead. I bury them. And then at night they walk. See, the woods have grown up toward the Dead. With time the trees begin to walk, and they come toward these rows to cover them, to shade them from the sun. And so I must work fast, so they can lie in the sun. I don't want them in the dark. The Dead who must walk in the woods become unholy. They frighten me. But these Dead out here, they will be grateful. They will be my friends.

After we had buried our own, the captain ordered all of us out here to bury these, the Rebel dead, eleven of us. One odd, you see; one too many. And so the others went back and left me to do the rest. At first we wore kerchiefs over nose and mouth, but I don't smell them anymore. I'm used to them, I suppose—used to you.

I know who you are. You're one of them. You're a Rebel. You're dead up there. You follow me; you think I'll show you where you lie. But I won't let you see me shovel dirt onto your face. That's why all of you follow me: to see the place they laid you out, your Rebel friends who dragged you into rows and then left you swelling up and blackening in the sun. You want to be laid to rest.

But I won't let you see. A man shouldn't see himself buried. I can tell you that. I'll wander along the woods' edge forever, if I need to, until you fly away to heaven, or the other place. There God will give you rest. I'm not God. There is no rest in me. I shot you down.

See, from that little hill back there, I shot, or you would have shot my friends. I shot you, might be. We fired at the line of you. We did it to save the Country, you must know. The orders were to fire, then fire at will. To fire at will. Ha! Was your name Will? The captain ordered us to shoot you down, and then he ordered us to bury you. Hello, Will. Someone needs to pray for us. ❧

37. *COLONEL CROSS*

The Rebel bastard shot me from that rock—a vicious, futile act that earned him a body full of bullets from my men. To shoot an unarmed officer, even amid the rage of battle, is nothing but brute stupidity. I always told my boys to kill the ones who carry muskets; the officers will be replaced, perhaps by better ones who've learned from their commanders' mistakes. I had a higher opinion of Rebel infantrymen than of their officers, who had at least some pretense of education and should have known better than to fight for what they were fighting for.

But it is my considered judgment now that the whole lot of them are imbeciles with little more claim to being human than possessing facial hair and Bibles. The uniformed dog on that rock might have believed he did God's will by shooting Yankee officers. They could not be doing what they are doing, fighting to keep an entire race in chains, without their Bible-thumping preachers shouting God's approval—no, His outright favor, and His holy desire to see as many Yankee Philistines murdered on His altar as could be effected by those Christian gentlemen—illiterate, armpit-scratching gentlemen. In them, Christianity is an obscenity—hypocrisy drawled in a ridiculous fog of whiskey. Without their preachers, they could not rush in and die like lunatics in front of my men, line after line coming at us with that childish yell of theirs, swarming forward in the hope of everlasting bliss in a non-Yankee heaven, where black angels, no doubt, light up their seegars and serve them juleps for ever and ever amen, hallelujah! And the Good Lord sending all of us mudsills to the place of sulphur, fire, and brimstone. We'll see. We'll see if there's a heaven or a hell, and if there is, we'll see what Jesus thinks of gentlemen who whip mere children and women to do their work for them. We might not be gentlemen, but we do our own work!

I can sense that you are the reconciling sort, but even you can see that all this mayhem came about because the South would not suffer themselves to lose an election, and for their own self-interest, therefore, they tore at the very principle of democratic government so they could keep their so-called property. We Northerners entered the war too kindly. The Rebels hated us right off, and won the battles, because war is not Sunday school. We didn't understand that when you take up the cross of war, you must carry it to Calvary. You must abandon your delights and your beliefs, and descend into hell, with no angels to comfort you except your musket and bayonet. I taught my men to hate the gentlemen—"The Prince of Darkness is a gentleman," you read in Shakespeare. And the war itself taught my soldiers to hate. If the Rebels yelled like banshees, then we would yell like Indians! The Rebels fix bayonets; then we fix bayonets and charge first. You may start a war with prayer books, but you must finish it with steel.

I knew that I would die out here. "He who lives by the sword shall die by the sword." Always before battle I would wrap a red kerchief around my bald head to tell my men to be about their business. This time I asked my orderly if he had a black bandanna, and I tied it tight around my head, as if to tell my boys, Don't be dismayed. We are going to die, quite a few of us, but we will give them hell first, and after we are gone, you rest must drive it home. If war begins in church, it ends in

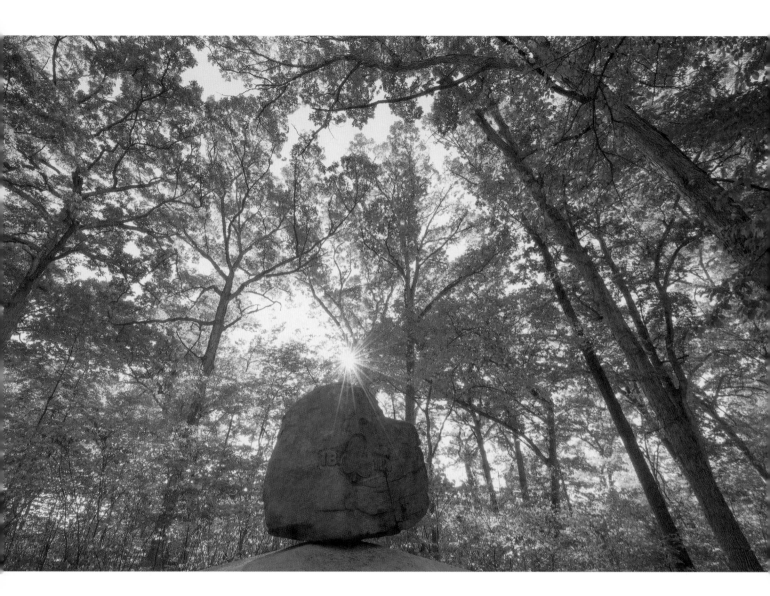

the graveyard. It ends out here, with nothing in between but rage. Give it to them! Give them the bayonet! Let them come on. Shoot the bastards down, and keep your prayers to yourselves until afterwards. Come on, men! Give them some New Hampshire hell! This time we've got them on the run! After them! ❧

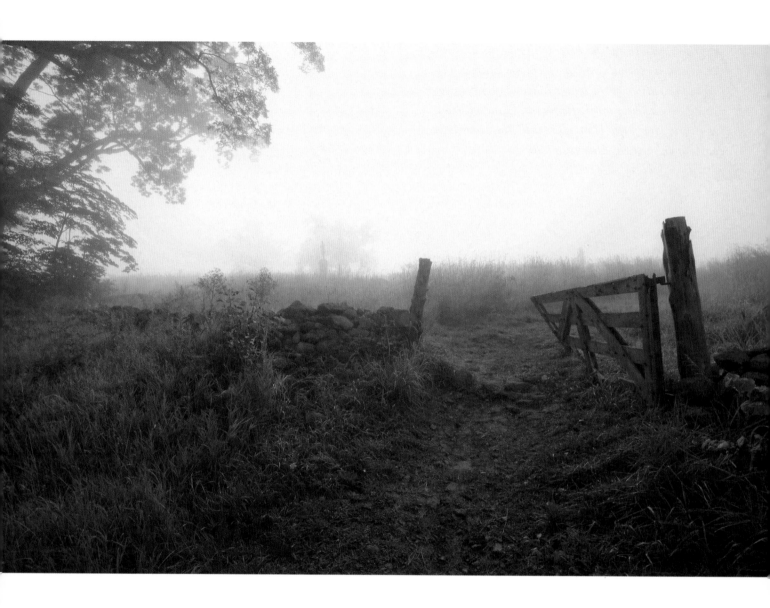

38. THE GATE

Funny things happen that you can't explain. There's this time my wife was working weekdays half across the state, in a pretty remote corner. She'd drive the four hours home every Friday evening. One Friday about seven o'clock, I just got the terrific urge to drive out the way she was coming in. About halfway, there she was at the side of the road. Her engine had failed, thrown a rod, and this was before cell phones. Wasn't any traffic at all on the highway. This was out in west Texas, you see. She would have been there in November weather all night. She hadn't been waiting more than twenty minutes when she saw me. What's the explanation? An act of God? Intuition or telepathy between two people who love one another? Neither? Both? The one thing I won't believe is coincidence. We load too much on that poor ol' word.

So when somebody tells me there's something uncanny about this Triangular Field, I listen. Doesn't mean I believe without evidence. But I'll listen. Some say photographic film won't develop if shot here, but I have my doubts about that one. I've taken pictures here, in the days when you still used regular Kodak. I don't know whether people have that supposed problem with digital. I suppose they would, if it were true.

You've told me you don't hear voices here, and you haven't seen ghosts except maybe one. Well, it's that "maybe one" that's the gate to somewhere. I never had another hunch about my wife driving, or anything comparable. A person gets only just so much heaven here on earth. But there was that once. Just that once. Since then, I think differently about things.

I'm interested because it was the First Texas boys that came through here. The 124th New York bayonet-charged them downhill, and's no way you can stand to a downhill bayonet charge. Witness the Twentieth Maine up over there on the back side of Little Round Top. Same thing. Oh, I suppose there's some Texas pride in what I'm saying, but I'm not one of those "Don't Mess with Texas" fellas. The New York regiment hadn't ought to have done that anyway; ought to have let our boys keep coming uphill frontally, because the New Yorkers lost a lot of men, including Colonel Ellis, for nothing. A Georgia regiment came up with the angry Texans and overran the New Yorkers and the battery they were defending.

And angry they must have been! Texans didn't take too well to being run off by Yankees, especially New Yorkers. Still don't. But the point is, there was an unusual amount of fury on this little field, and I wouldn't be surprised but what some of it's still here. You know I've heard it said that you become what you don't forgive. I saw this documentary about civil wars in Rwanda and other places. People had their whole families murdered by their own neighbors. That's how most civil wars work, not like ours where there's two geographical sections, proper uniforms and all. No, it's usually like Kosovo or Rwanda, and I expect if we ever have another one in this country, it'll be like that. Won't be any Abraham Lincoln in charge, but some dictator who doesn't care about human life except his own. Oh, it could happen here. It happens a little all the time. We aren't anything special in this country; we're human. We were lucky last time, but maybe not next time. Only way we'll get past it is to keep the gate open. Another person is a whole nother world. Like you and me here. I'm a Texan, and you—well, you sure aren't!

You know, some young girls saw the Virgin Mary before the civil war in Yugoslavia. I went to Medjugorje; I did. Me and my wife. We're devout Catholics. So a number of times, the Holy Mother warned the girls about the civil war to come. People go on pilgrimages there. We met several couples from all over the United States. A few people said you could just *feel* something there, where we visited the spot of the appearance of the Blessed Virgin. Well, I believe it, but I didn't feel anything. Nothing at all, and neither did Joyce.

It was while we were in Medjugorje that I finally asked her why she had waited for me so calm, those few years back when I found her stalled beside the highway. "Oh, I knew you'd come," she said, just matter-of-fact. Whew!

So you see, if these spirits are still here, that haven't forgiven each other, and they start warning us, we better listen. I expect it'll happen with or without warnings, just like over in Yugoslavia. Here, look at this. It's a Cro-atian coin that I got over there. I keep it in my pocket all the time, to remind myself.

Well, I'm not sure what of. That there's another dimension, maybe. I grew up near Amarillo, and me and my brother used to go out hunting rattlesnakes. I'd be stepping along careful, and all of a sudden Eddie would *hist* and sign me to stop. He'd point and say, "There's one under there!" Like somebody telling him, *Watch out!* Happened right along, time after time. I wouldn't see anything, and neither did he. He would just *know.* Says he can't do it anymore; what's more, he wouldn't try. See, the gate opens for only some, and I expect even for that some, it doesn't stay open forever.

Well, Joyce isn't with us anymore. But I don't feel she's gone. Any more than I am gone. Some day, some way, she'll come through that gate. I just know it, like she knew. I can't say exactly where or when, or how. But whatever the gate is, even if she doesn't come through, I'll stumble acrost it eventually. And I'll go through. ☙

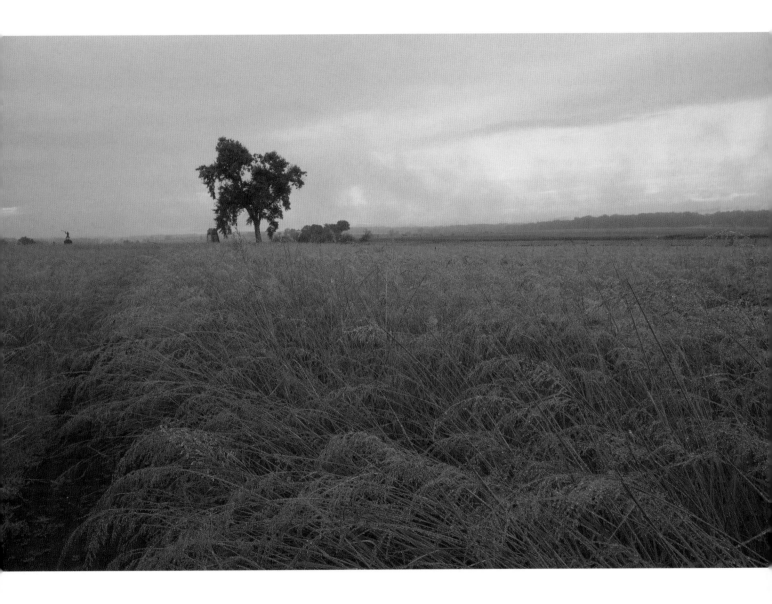

39. BROTHERS (FALL OF 1968)

My brother told me I should come here sometime. The day he left and handed me the keys to that big Oldsmobile of his, I promised I would. I drove that car until the day I died: rebuilt the engine twice, transmissions came and went like going out of style; the thing ate carburetors like a dog. But thirty years, four hundred thousand miles: not bad. Can't bear to think of it as rust in some junkyard or buried in the ground. He said to drive it till he came back.

We two never felt like twins. We didn't look alike, and we couldn't have been more different in the ways we thought. The Civil War hooked him in fifth grade. From then on, all he thought about was Union and Confederate. Read all the books. But I was interested in sports, played every shape of ball there is, in fall went deer hunting or lion hunting up on Nittany and through the Laurel Highlands. Our mom and dad thought he would be the first in our whole family to go to college. But that was not for him. He got a job and didn't even graduate from high school. He bought that car first thing, and then moved out. And so they drafted him, not me, that September.

I came here with a girl I met at State, a long-haired, quiet girl with nice brown eyes. Her family kept horses, and she rode so naturally you'd think the grace of the summer wind was in her soul. "So this is where we start?" she said at Pickett's Charge, the first place we got out and walked. "Do you know where we are?" she asked. You see, I didn't know. The hope had left us back in early June, and there was no place left to start. My heroes all were dead. We drove around an hour or two, and then went home.

I came back many times to these old fields. I never learned the battle much, but springs I'd come for the magnolias and dogwood blossoms in the woods; in fall, all the colors were out, and in the Soldiers' Cemetery the great old American trees from all the states were really pretty. Glorious. Before they shot the deer by the hundreds, I used to love to watch for them, without my gun. (I stopped hunting, back about then.) In summer, the bluebirds sat on fence posts, as beautiful as if the sky had come together in one lovely living thing. But winter was my favorite. Alone, I tramped the snowy fields when icicles hung transparent, glittering on bony twigs where once there was nothing but green life. My brother would have married her, you know; he never would have wandered off alone the way I did. I don't know why I did. Why we do the things we do sometimes, I'll never know.

I couldn't stand the darkness anymore. I drove back here and parked the Oldsmobile beside the road just over there, where the rangers would notice it had been left overnight and would find the body without much trouble, before any tourists came. I went up there with a couple bottles and drank them both—drank to my brother, drank to Bobby, drank to all the soldiers here and to the loved ones they left behind. I never learned the battle, no, but I learned what happened here— happened and never came right again. A hundred thousand lost what might have been. ❦

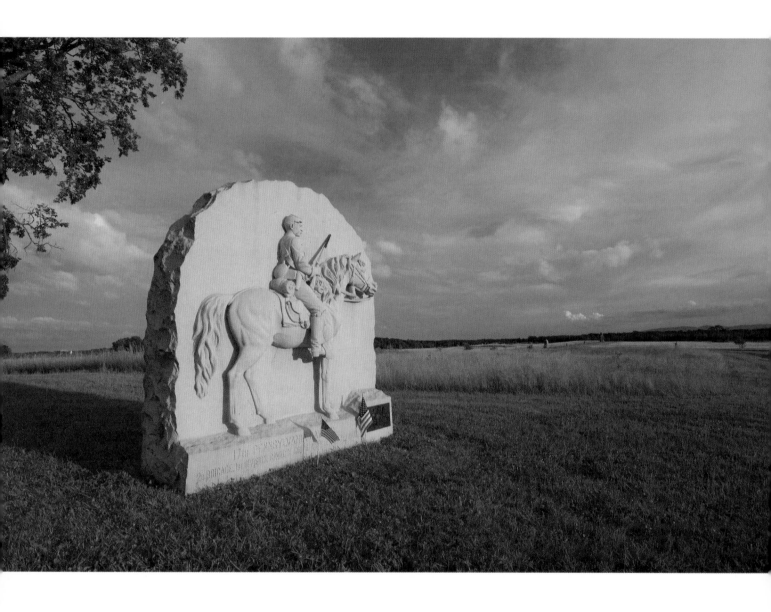

40. *STONE HORSES*

We had to burn their putrid, mushy corpses—
the horses that drew our artillery
and then stood in their traces while shells exploded
in their faces. We used mules to pull bodies
onto fence rails, and the oily smoke rose,
stifling and unbearable, darkening
the sun like a plague of Moses' locusts.
I see them return on leathery wings;
their long, yellow teeth seize our soldier souls.
In daylight, they stand on these peaceful fields
motionless as stone but with wide, white eyes.
They are the Earth itself, that we have sealed
with heat. At night, red as fire, War arises;
then Pestilence in shrouding clouds of flies;
black Oppression, on heavy iron heels;
and in the flames' hollow and endless draft,
ashen Death, with hell following after. ❧

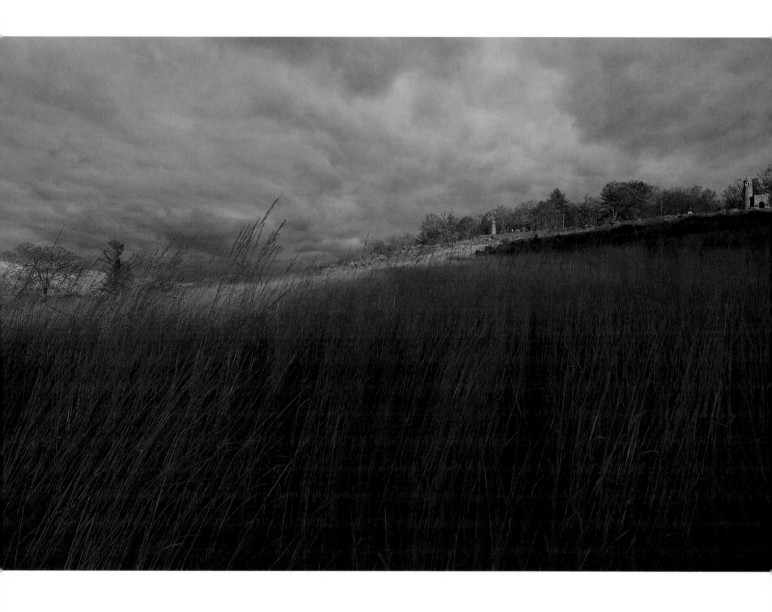

41. SLEEPWALKING

hat have you living done? We none of us proposed to vote or fight away the old Republic, but to purify it, make it agree with liberty a little more. That's why we left our homes and families, enlisted in the Cause to save our rights. You blind living inheritors spend our fortune like drunken sailors with someone else's money in their pockets. I see what's in your country now. I call it yours because I hardly recognize the place you've made of ours, both North and South. You ought to be ashamed!

Now wait, stand still; I'm vilifying you for your own good, and you can like it if you please, or not, but you shall hear me out. I died out here for liberty, and never mind that I denied that right to others. I will answer for that. But what I see you living do—spending and voting away that right of governing yourselves—I wonder what we did this for. My curse must be to look into the future as you look at the past, and what I see is self-important fools who can't or won't remember what those scraps of parchment represent—the Constitution, Declaration, Bill of Rights. Those words are who the country is, or was, no matter how we argued over what they meant, or what they ought to mean.

But never would we vote ourselves away from them, of our free will, like walking blindfold, tied on by ourselves, toward some cliff whose edge the Europeans toppled over years ago, and my time's grandchildren had to set to rights again at a cost you don't seem to understand. Look at this ground here. Can you see it covered with our dead, and their dead?—and the crawling wounded mingled together on this grass and up against those rocks yonder, gut-shot boys tearing at their jacket buttons to see their wounds. Can you hear the weak but constant murmuring of those alive enough under the hot sun, tortured by thirst that comes with loss of precious blood?

The ground you're standing on was fertilized by your ancestors' lifeblood. I think you living forget what you have inherited. I think you ought to, maybe, step out of your vehicles, put your feet on this old ground, and try to see yourselves with the eyes of the dead. You are walking this green parchment of our old forgotten field in a careless trance, and I have reprimanded you harshly in an endeavor to wake you up. You are sleepwalking, my neglectful great-grandchild. I want you dead to awaken before you sell your birthright to big-mouthed men who will make slaves of you all. Do you know what I mean? I didn't think so. ❧

42. *CHAPLAIN*

And I say, "Blessed are the pure of heart: for they shall see God." I knew these men. Not one came here pure in heart or in anything else. "No, not one," the psalmist wrote: not one is pure, but all have sinned and turned aside. Soldiers least of all are pure. Chaplains see it all: soldiers gamble, whore, and curse with every sacred name they heard in their Sunday schools; they're vulgar past description—I will spare you what they say about each other and their comrades' mothers. But none of these boys' pursuits and consolations rank as mortal sins according to my gospel. The soldiers' universal sins are rage and killing.

We know the Sixth Commandment strictly speaking prohibits murder, but the soldier, some maintain, kills out of duty only, and in self-defense. But I say, What is war, if it isn't murder on a grand design? One army tries to kill the other, premeditatedly, deliberately, with every engine of the devil man invents. To this grand murder, each soldier—no matter that he shoot an enemy in self-defense—each man is an accessory. Each shoulders his spoke of the wheel; each man provides himself as one cog in the gear. If war is not sin, then nothing is.

And yet I speak for them, the pure in heart. I speak for them because they are not here.

The ones who haunt the battlefield, including me, including you, are soured by war's poison—soured to our souls. But there are some who fought right here where you are standing, who are free and nowhere we can hear them—gone to God, or gone higher somewhere—are perhaps bathed in light and living in Eternal Beauty. "How can this be?" you want to know, as well you should. How could these sinners drenched in the sin of war translate to spirit and not be cloudy ghosts? What burned the sin off—refined them? What fire transformed them incorruptible, while we labor one hatred at a time, one world at a time, desire by desire?

Why, nothing could be simpler: they forgot themselves. Artists—even your half-hearted ones—know what I mean. They get lost in their work. You don't find who you are until you lose yourself, just as the Master said. I saw some of those Maine and Pennsylvania boys forget what they had figured out for their lives and stand by their friends, would not move, forgot to be afraid. And once forgotten, death assumes a modesty hitherto unimaginable. They loved each other in the final, Christian way and turned from boys and angry men into tall attendants in the Presence of the Single Beauty who made and animates the universe. They have realized themselves.

O! I feel their loss, but I will see them again, aeons hence perhaps, by the grace of God, when I can do what they did, give all to love, give without knowing it, and forget myself—forget this educated professor I became years after the war, forget the Harvard chair I occupied, distinguished as frost on a windowpane. Yet the greatest man I ever saw was Harvard bred—he whose statue stands there marking us. Colonel, no, General Strong Vincent. And with him Patrick O'Rorke.

Perceive: there's a mystery in it. High and low are taken. We are nothing as we are, and yet everything. You'll not find those two men here, our Vincent and O'Rorke. They have no need to tarry here. A higher heroism awaits them in the Presence of God, they who were in that instant pure—they and all those men who forgot themselves. For they see God. &

43. WARREN

I saw them in my mind before I saw the light
Reflected by their "burnished rows of steel." I was right:
They were coming. I saw the marching thousands,
Their line extending to the bloody, bitter end—
A faithful, brave procession to their heroes' graves.
For better or worse I saved this hill, and the day.
(A battlefield becomes a "vision-place of souls"
By making souls of men, by desolating homes,
By feeding the Beast meat. The New Jerusalem
Is built of stones inscribed with names and regiments.)
But star-spurred lords of war have no patience for saviors:
The funeral procession must proceed apace.
The Wilderness and Cold Harbor are what I saved
When I saved this hill. The only thing that is worse
Than such a victory is—I know not what. Curse
The need for death, the need for endless sacrifice,
And curse the bridegroom that devours the holy bride!
When Zion hears the watchmen's voices, be prepared
For Hamlet's feast: draw down your blinds and say your prayers.
We watchers tell of what we see; let others judge
If what we see is true, and if we see too much. 🙠

44. *VALLEY OF DEATH*

*T*he Plum Run Valley, a narrow, shallow, and open low place between Little Round Top and Houck's Ridge, received the name Valley of Death—and the little creek became Bloody Run—when the rear section of Captain James E. Smith's Fourth New York Light Artillery battery, consisting of two twelve-pounder Parrots (rifled cannons), fired canister into the Second Georgia and Forty-Fourth Alabama regiments, which were attempting to outflank and attack Ward's Brigade and the four other guns of Smith's Battery posted above Devil's Den.

I began my quarter-mile walk at the Slaughter Pen, where the Southern bodies were photographed after the battle. It was a fine spring morning. In my youthful enthusiasm, I had determined to recite the Twenty-Third Psalm as I walked, beginning with "The Lord is my shepherd." I noticed that the bodies had not yet been buried or removed. Several of the poor boys lay with jackets pulled open—apparently, in some cases, without the formality of unbuttoning. After the heavy rains of July 4, those uniforms had become dank and musty, so that now, on the sixth, the heavy, putrid stench was mixed with odors of deteriorating cotton and wool. Open jackets and exposed pale underwear underscored the bloated nature of the ashen cadavers. I speculated that either the men had torn their jackets open in anxiety and agony while feeling for their wounds, as wounded men are wont to do, or Union burial details about their sad and revolting task of interring their own comrades' bodies had rifled the Rebels' pockets, searching, as is commonly done, for mementos such as photographs and letters or for valuables such as gold coins and watches. "I shall not want," I recited as I reflected on the dead

soldiers no longer needing such so-called valuables yet the live ones craving them.

To many natives of this continent, as well as to residents of the country south of our border, I mused, the motto of the United States might appear to be "I shall want," as we are currently in the process of claiming, mining, and settling our vast western frontier and utilizing what was seized from Mexico as a result of our war with that country. As I strolled out from under the looming rocks of Devil's Den into the open space between the stony ridge and Little Round Top, I contemplated the growing national craving for money and material goods. The welcome openness of my immediate surroundings felt appropriate to the words "He maketh me to lie down in green pastures: he leadeth me beside the still waters."

Plum Run, a mere trickle as this nation's mighty waters go, was still tinged with the blood of wounded soldiers suffering raging dehydration, who crawled to put their faces in the stagnant liquid. Though these small waters are still again, I reflected upon how the burgeoning majesty of Northern industry, manufacturing cannons, rails, rolling stock, locomotives, and all the imposing evidence of postwar enterprise and prosperity, is surely troubling the virgin waters of our land, with mills that once produced uniforms now turning to the awakened desires and capital of an increasing—and increasingly demanding—populace.

"He restoreth my soul," I said aloud as I walked toward the two cannons representing the section of Smith's Battery that ploughed this vale of human flesh. Though it had grown warm and humid, gathering thunderclouds overhead caused me to turn up my collar in anticipation of disagreeable weather. The guns of

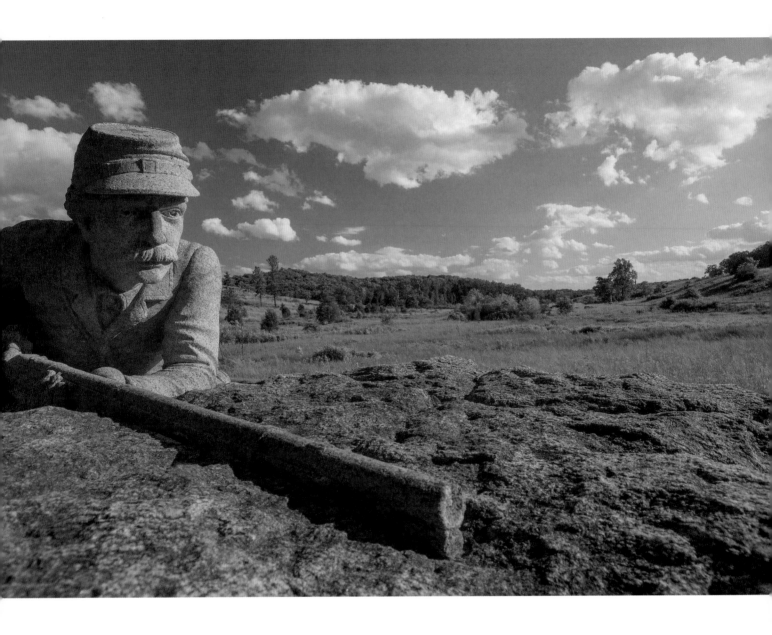

this section were iron, and coal black, but as I recited, "He restoreth my soul," I thought of the gleaming gold of the more common twelve-pounder brass Napoleons favored by cannoneers of both sides during the late war. They portended the era of greed and excess now upon us, which Mr. Clemens has so aptly dubbed the Gilded Age. Can our souls be restored? I questioned, as I pondered the ignominious war we are waging not only upon the Beatitudes, but also upon the Spanish in Cuba and the Philippines, and the one finally concluded upon our Great Plains. A brief but vigorous shower of rain having passed, I welcomed the high sun, though the temperature seemed to be descending toward the autumnal. I was thankful to have brought a jacket.

As I passed the two iron guns and approached the midpoint of my small journey, I glanced up at the stony ridge, marking that the trees were already turning and the delicate hues of red, yellow, and orange were observable over the monuments, and that the battlefield road seemed adrift in the sere, brown remnants of high summer.

"Yea, though I walk through the valley of the shadow of death," I murmured, "I will fear no evil: for thou art with me." Certainly that is the national temper and conception now, as we have brought Europe out of a stupefyingly cataclysmic war and have emerged as a first-rate power, our prosperity apparently having no limit other than our initiative, drive, and "can do" attitude. The young people these days are exuberant almost to a fault, and to a degree that those of our generation never could have imagined: jazz, speakeasies, and even recorded music that one can replay at home, amid the ubiquitous glare of electric lighting.

Surely "thou preparest a table before" us! But as I muse on this theme and walk slowly toward the battle-field road that bridges what for me will be the terminus of my sojourn, the aggravating arthritis makes itself felt again, and I pause briefly to recover my wind. How we doubted, some of us did, that we would come through our economic disaster. "In the presence of mine enemies" indeed: the Axis of darkness threatened to engulf the world and sent the ashes of millions into the offended face of heaven. The lowering skies blow cold as I grip my jacket collar around my throat. Looking up, I see geese flying south from the direction of Cemetery Hill, on their way overhead behind me. I hear them more than see them, as even with these glasses I have become increasingly nearsighted. I taste the first snowflakes of the season on my lips. "My cup runneth over," I recite with more than a touch of irony.

But the confusion I feel! Snow in every direction around me, I can't get my bearings to finish this pointless walk. Which way? The whole whited countryside is confused now as the sun sets. Our cities must be howling in violent factions as I stand here trying to remember why I am here, what I came here for. What direction to walk, even if I could? I will move, somehow, toward the light. "Whence we came, where we are, and whither we are tending," Mr. Lincoln said. Surely there is goodness and mercy somewhere! Surely there will be light, and we "will dwell in the house of the Lord forever"! ❧

45. *OVERHEARD*

Go back to Alabama, why don't you?

(I'm stayin' till we take that goddam hill. Go back to Maine, where you belong, Bluebelly.)

Decline, with thanks. Might want to try again?

(You know we marched to hell and back today. The Old Man marched us half the night before.)

How arduous for you. Want to lie down? I've got a rifle-musket here can help.

(I relate our difficulties to show that under normal circumstances, we would have run up over you on the first try. Give us some rest, and we'll fry your bacon.)

Why not eternal rest? Too hot down there?

(Was warm enough today. Just show your head.)

Most likely you would try to steal my cap.

(Be useless with a hole through it. A man has got to have a hat, Yank, not a cap.)

How long you been here, Reb?

(As long as you.)

So why ain't we in hell yet?

(Because there's no use, Yank. We'd fight each other there, same as we done here. In hell or in heaven, whichever. I'd hate a sharpshooter there as much as here. Ain't no use in moving us, thisaway.)

And I've no secret depth of love for you. But why particularly sharpshooters?

(Another name for assassins. Might been you that took my earthly life, Bluebelly.)

War is killing, Reb. You gentlemen shot at us, too.

(Naw. We considered it just pickin' nits.)

And a grayback is a grayback, to me.

(I think I'd wait till hell freezes over before I'd stomach calling you my friend.)

Mutual, I'm sure. You think they hear us?

(I wish they would. I hate the indignity of tourists walking through our bones, admiring how brave, long-suffering we were, and all.)

I infinitely prefer them to you. They know who won this fight, what it was for.

(What was it for, Yank, if not for Southern independence? Make you respect our rights.)

Your madness is equaled only by your stupidity. A slave driver talking about rights. I forgot to mention hypocrisy. Liberty and Union!

(I'm tired, Yank, mostly of you. But also I'm tired of nowhere, Yank. Of nowhere.)

Then go to hell.

(I'll take you with me, Yank.)

Wouldn't be hell then.

(That ain't hell? Then what is?)

You and I are hell. If they could hear us, they would stay away.

(They are all asleep. I'd like to be able to sleep again.) ❧

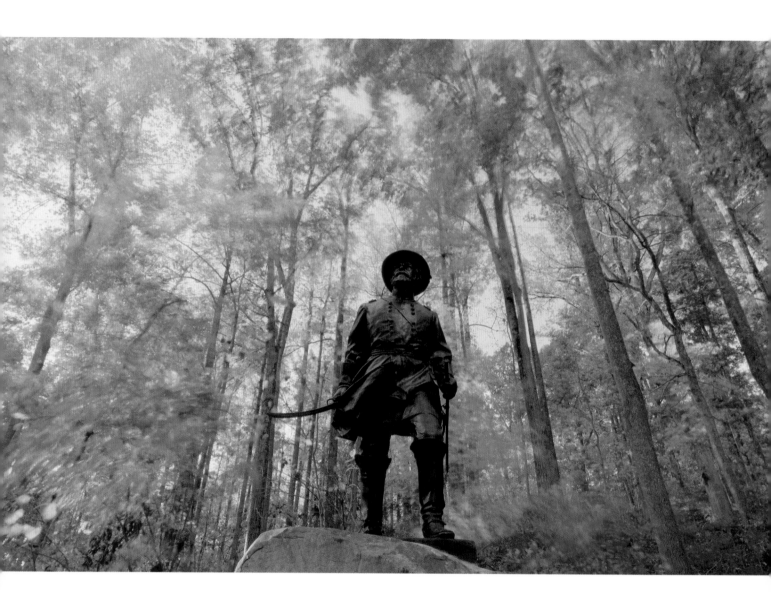

46. *FAITH*

I told my boys, We are the stuff of dreams;
we are the muscle of the Republic,
the blood and guts of Justice.
We are the flesh and bone of Liberty.

My men, we are the Army of the Free!
We are the breath and sinews of the Lord.
If blood's required, then it's for us to bleed:
we are the grapes of wrath, His terrible swift sword.

We are the evidence of things unseen;
we are hope's substance: so let them see
our faith, for what is faith but hope believed?

Up, men, and fight, that Right may live!
Look ye to the Stars and Stripes unfurled!
The gates of hell shall not prevail, so give
them hell; commit the sins that save the world! ❧

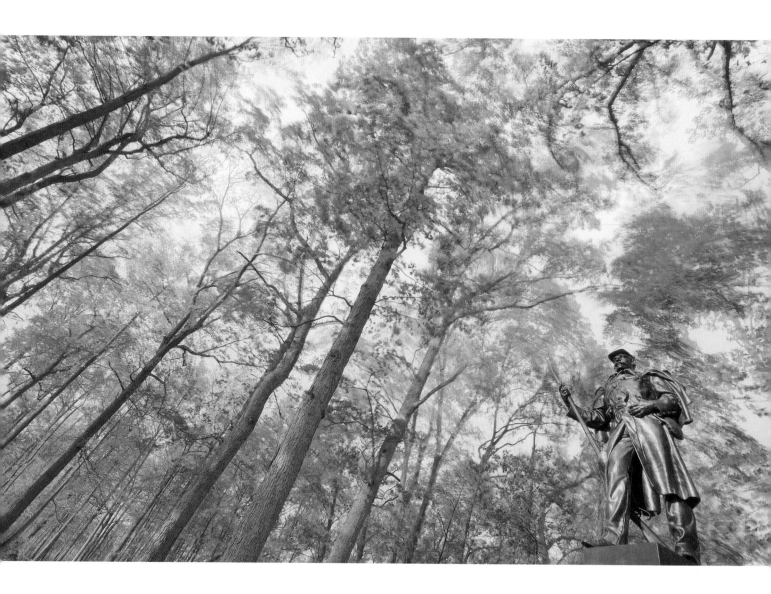

47. *FACE-TO-FACE*

My name eludes you, you American, but you know who I am: I am who you used to be. Here on this little hill, where we were buried after the battle, above that killing field and in the light whose shadows cool those hooded woods—right here you come face-to-face with yourself.

On this hill and all around in summer, the Indian People used to gather. I have seen their spirits, talked to them. There are many, but you no longer see them, never did, nor I. Some fought, on both sides, in our war—Red Confederates and Federals—for: Nothing. For the real Lost Cause, forever lost; for property they believed not theirs; for their Mother Earth; for freedom, not from some few laws, but from all written laws (truly children of promise, of words spoken and given); for equality of all created things; and for the honor of remaining who they were. Or so I imagine them.

We speak only in signs. I hear their language, but it is as old as the silent stars, and they hear mine, like the noise of machines. And so we speak in signs, the Grand-fathers and I. Yes, we replaced them, you and I. Can you envision me? I have the pale face of death. Its ghostliness would frighten you; it is a face of the apocalypse. It is your face. I am who you were, and who you will be. I am America written in your soul. Have you come to pray for me?

You and I are the face of hell for darker peoples. We are the pale horse; we are the east wind; we are the beginning of time for a timeless people. And we in turn were driven by the winds: famine, pestilence, war—a seething Europe thronged with skeletons. And where did they come from, the Grandfathers—the restless ones, hunters, warriors, traders, tillers of the river bottoms, fishers of cold untainted streams?

I walk here for restless humanity, for the nervous race that woke to see itself. Where are the simple ones, the Innocents, the poor in spirit and the pure? Not here. The simple ones are in a world of light; the ones who do not see themselves see God. But you and I are on this battlefield, you with breath in your chest and I your old spirit—we are poured out on this fortune's field together, face-to-face, innocence burned up. You and I came across that field beneath Palmetto flags gashing the shaking hot air, insane with property and rage, offended honor in our maddened visage, bound to kill and die for our rightful rights, glorious as banners. We will never be grandfathers of an innocent race. We are the dead, you and I. Long live the innocent, the simple—wherever they are. In the palm of God, in the Kingdom of Heaven. They see us, but we will not see them. Here; talk to them in signs. Lift up your hands to greet them: they will replace us. I see their angel faces, those children of an unknown God! Let us walk. ❧

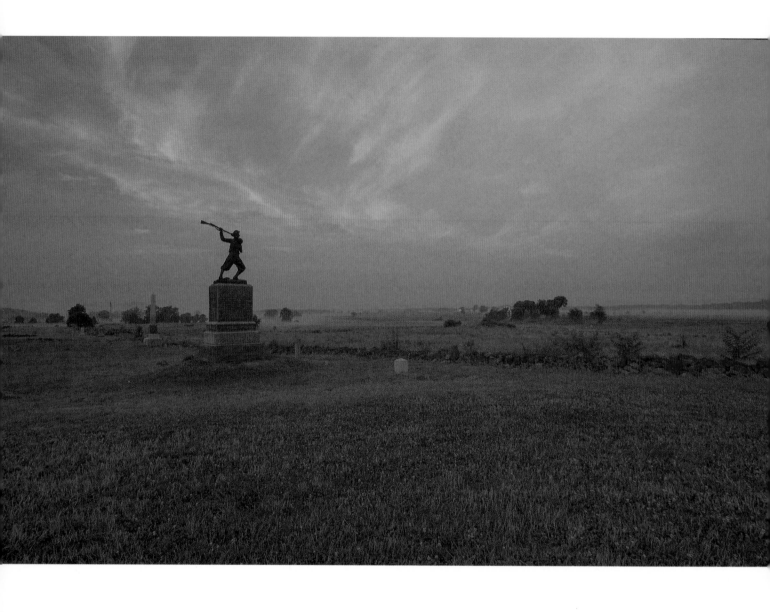

48. *DREAMS*

We come futher than anybody except the Texas boys. And yesterday we marched futher, too. We was dry as dust when we got here, and then we had to wait and then go in. It was pretty close to sundown when the general says to git up and move, and go give 'em hell.

We stepped into line and advanced to a road and acrost it, and the Yank artillery, boy, they guv us hell. "Hadn't we ought to go a little faster?" Hatch says. I think we all wanted to run like everything to get to the bluebellies before they shot us all to rags. Ain't nothing worse than advancing at a steady pace in shot and shell, knowing that soon as we get close enough to charge proper, they'll load canister; then when we get up close, it'll be double and triple canister. The right and center of the brigade, I don't think they had no Yankee guns in front of them, but we boys on the left, our whole regiment, tuk hell and plenty of it oncet we crossed that road.

See, I'd had this dream, night before, that told me I'd get blowed up, and sure enough. "You gon believe some damn dream?" Hatch says, and sure enough, yes, we get tore up ever whichway together.

❧

It was me, we'd fired triple canister soon as the Rebs crossed the road. Don't leave nothin' to chance, more than's necessary, is my watchword. Our section was trained on the left regiment of that Florida brigade. "Where in hell are they from?" I ask the lieutenant. I never seen a flag like that before. "Florida," he says, cool as you please. "Blast it away!"

Well, we done that, when they come up close. You know there's nothing left just in front of a gun shotted up to the throat with canister. It was like a red spray that you ain't quite sure you saw, then the arms and heads and musket-stocks come down, but you're too busy reloading to mark it, or in our case, running our asses off to the rear because the Reb brigade off to the right come right through the battery like wild Indians. Of course, I didn't quite make it, shot in the back, goddamn it.

So your Reb friend here, he must have been one that my gun done up when the lieutenant told us to shred their flag and the sergeant pulled. Well I'm powerful sorry, in a way; though it's half sorry that we didn't open sooner with the canister and stop the graybacks from taking our guns. Even though the boys got them back in short order. I mean, I'm sorry because this Reb here's only a boy. Who let him enlist? The poor boy is lost, don't you see, about as far from home as he can get, wandering around babbling about his dream.

Well, I had a dream, too. It was the waking kind. A nice, snug house with calico curtains and a little grape arbor, and my wife taking two fragrant golden-brown loaves out of the oven, and our boys, our little boys, waiting just as patient as two little saints behind my Ellie, except fidgeting. And sometimes the dream would be tucking them to sleep in their little trundle bed next to ours, and the crickets setting up a chorus under the night stars, and the frogs getting out their word from the pond, and our cow letting us know she was having a dream too, maybe. Because my dream was to be back home. And these devils, like this boy here, didn't allow as I ought to have the life that I had enjoyed hitherto

and had been grateful to God for every day. No, these fine gentlemen wouldn't have it so, but they would fire on the flag, and break up the best country the world has ever seen, for some phantasy of a cotton empire. Dreams are what you live by, and dreams are what you kill by. Because you see, when the president's call came for volunteers, I just had to go. Maybe that was a dream, too, a wordless one, a dream I couldn't see but could feel. It was the Trumpet of the Lord, somewhere in my soul.

❧

Well, I'm lookin' for Hatch, and I cain't figure if I am here, why he ain't here, too. You ask that Yankee friend of yours, will you, whether he's seen him? And ask him what, just what, him and his crew got against our going our way just like free folks got every right to do. And you ask him what, just what, this cuss-awful war is for, and what I been killed for, if it ain't just so this Yank can tell us what to do and me and my people bein' made by force of arms to do as we're told. It's the right of the small man to stand up to the mighty, and the mighty killin' us for it.

Oh, I don't suppose the Yankees ever would get down to Florida. Anyhow, this time of year, it's like roses in steam, down home, and no Yank could stand it long but would be on a ship straightaway back up the coast. So why cain't I get home? Is it this Yankee and his like, keepin' me from my home and family and kin? I am powerful far away, and if only I could go to sleep, I could dream and be back home.

❧

I'm sorry for the boy, I truly am. He does not seem to have any idea about what he came here for. But I do think that it is the responsibility of a boy old enough to enlist and kill to inquire as to what it's all about. Though I expect, and I have come to surmise, that war is about killing some other people's dreams. Ain't there room for more than one? We all got to have the same dream? And soon as we get at fighting over them, all we dream about is peace.

Tell the boy, will you, that the dreams are running out like sand through an hourglass, and we're all going to be awake for a long, long time. ❧

49. PERISH

My most embarrassing moment out here? That's an easy one, though I'm not particularly interested in relating what it was. Oh, hell. At my age, what difference does it make? Why not. It happened just up ahead there, as a matter of fact, by the First Minnesota monument. We're walking that way anyway.

You'd think in forty-plus years of tour guiding, a lot of awful things would have transpired, but in actual point of fact, there haven't been many. Oh sure, I committed my share of factual blunders early on, fell on my ass a couple of times—things like that.

So I'm sure you know enough about the First Minnesota. In service since First Bull Run. Went in here with 330 men and lost 224: 68 percent. They were right along here, no other infantry units at hand, and three regiments of Wilcox's Alabama Brigade advancing down toward that swale in front of us. Those figures, by the way, are from *Regimental Strengths and Losses*. The former chief historian here in his book on the Second Day gives a lower present-for-duty figure and therefore a higher percentage loss: 82 percent. Either way, the First Minnesota suffered some of the highest casualty rates of any Union regiment during the whole war. It hardly matters to split hairs when four out of five of your men are shot.

General Hancock needs five or ten minutes for reinforcements to plug the center of the Union line, so he points to the flag of Wilcox's lead regiment, and in a voice everyone can hear, he shouts, "Take that flag!" Colonel Colvill, one of the few who survived the charge, wrote later that every man in the regiment knew what the order meant—suicide—but not one soldier hesitated. They fixed bayonets and bought Hancock his time. At an enormous cost. Bruce Catton said that July 2 was a day that took a lot of saving. The First Minnesota were some of the saviors. Because of them, "government of the people, by the people, for the people, shall not perish from the earth." Or at least, not quite yet.

But here I am, talking as though I'm doing a tour. Habit—bad habit. My apologies. But I identify with Hancock having to give that order. Sometimes a man's got to do what a man's got to do, and if there ever was a *man* on this battlefield, it was Winfield Scott Hancock. I taught shop and coached football for forty years, and I know what it's like to shout orders to young people who don't want to obey them. I can only begin to imagine what force it takes to order men to charge to their death. I think it wasn't that the Minnesotans were more valorous than other soldiers; it was that big man with the thunderous voice standing in his stirrups shouting, "*Take that flag!*" He must have been something when he issued orders. He made men of those boys.

So when I meet this couple at the guide building a few years ago, the first thing I notice is their license plate: Minnesota. They're young people, late twenties, nice-looking. He's in jeans and a T-shirt, and she's in jeans and a sleeveless. They're both wearing what we used to call "tennies," Keds, back in the fifties. Low-cut canvas shoes, real light and thin. What I notice is what I'd have to call *smoothness*—I mean of their faces, the way they shook hands with me, the way they walked. Balance, you know? Like they were Native Americans: ramrod straight but not stiff. Fluid. *Smooth*. They weren't Indians. He was blue-eyed, and so was she. Real Minnesotans, I suppose.

They're polite, soft-spoken, but what also strikes me is a sense of power. "Give this young fella twenty years in the military" I thought, "and when he gives an order, when he says *Jump*, the only question is 'How high?'" They're really fit, those two. Powerful, but not like *athletes*, you know? I played football for eight years. Hell, that's a story in itself. When I was in the early grades, I took ballet lessons every Saturday for years. When a kid should be watching *The Lone Ranger* and *Sky King* at home, I'm at school learning *tendu à terre* and *retiré devant*. So in the spring of fourth grade, I'm walking home with my ballet slippers under my arm, and a fifth grader asks me, "Are you a boy or a girl?" Not insulting, just curious, you know?

So from that particular point in time, I never touched those ballet shoes again, and in the fall I go out for football. It's just flag football, but it's the first step to junior high football. My dad feels good about that. He's finally proud of me. When I get to high school, I tell the freshman coach I'm a defensive end. That's the most aggressive position in football. You blow a guy out of your way, knock him on his can, run over him, and nail the quarterback, stick him good. Hopefully he doesn't get up. If he does, he's going to remember you. He's going to hear your footsteps whenever he drops back to pass.

But you see, I'm not really big enough to play defensive end. All I've got is the anger, the rage, and it's not enough. I never start a game on the freshman team, and I ride the bench for half the JV season. Then one practice, I see an assistant coach talking to the head coach, pointing at me. I think, "Oh crap, they're pullin' me again." The assistant calls me over and tells me, "Jerry,

you're not a defensive end. I know it and you know it. If you want to stay on this team and play football, you're going to work with me after practice every day for the next two weeks."

He turned me into a wide receiver. I had quickness at defensive end; that's all I had going for me. That and height. Grace is what a wide receiver needs. And willingness to get hit. You're in the air with the ball like a *grand jeté*, and the cornerback crashes your ribs at fifty miles an hour. You have to feel a little suicidal. But I did, and I had speed, agility, quickness, air. The one thing that prevented me from being a great receiver was poor hands. So I never got that football scholarship and went into the army instead. When I got out, I learned industrial arts at the community college and spent the next forty years teaching not very bright kids how to work with their hands. You do get to love the velvet feel of sanded hardwood and the sheen and fragrance of varnish and shellac. And I was a give 'em hell football coach. I was disciplined once for almost taking a kid's head off. He smart-mouthed me while I was holding a football, and I shot a perfect spiral at his face. He ducked just enough. I still had the rage, and normally kids didn't mess with me.

Anyway, a lot of tourists did embarrassing stuff *to* me, like insisting we circle up and pray out here in front of some memorial, or bringing a flute to play some Civil War lament, or lugging along a guitar or banjo and wanting me to sing along. But this couple, when we get out of the car here, after I've explained the whole thing, because the young woman, she'd asked me to take them to the First Minnesota, we get out and then the way they stand, it hits me. They take each other by

both hands, a perfect *en face*, and I get this chill, like the Minnesota boys must have felt when they heard the Rebel yell coming, and I think, *Oh shit, not here!* But what I feel is something like flight inside, upward. They do a *pas de cheval*, then *dégagé* and into such a lovely, airy *pas de deux* that without any idea what is wrong with me, I burst into tears. I just stand out here and bawl. An old bull-necked guy with a steel-gray crewcut.

I was a forceful guy. It played hell with my first marriage, and I don't have the greatest relationship with my boys, though it's gotten better lately. What I'm saying is that this couple, they walk back toward me and she lays a hand on my shoulder, and she says, "You understand."

I didn't think I understood shit, as far as I knew, just stood there like a grade schooler blubbering. I can still feel her hand.

I suppose they were with the Minnesota Ballet, or St. Paul Ballet, or whatever they got up there. He put his hand on my shoulder too, as I got in behind the wheel, and said, "Thank you."

I still don't think I understand what all that was about, but ever since, I can't come past this monument with the Minnesota soldier up there, flying forward— can't come here without tearing up a little, as you can see. Maybe that boy up there was one of those who perished. A lot of boys perished. ✎

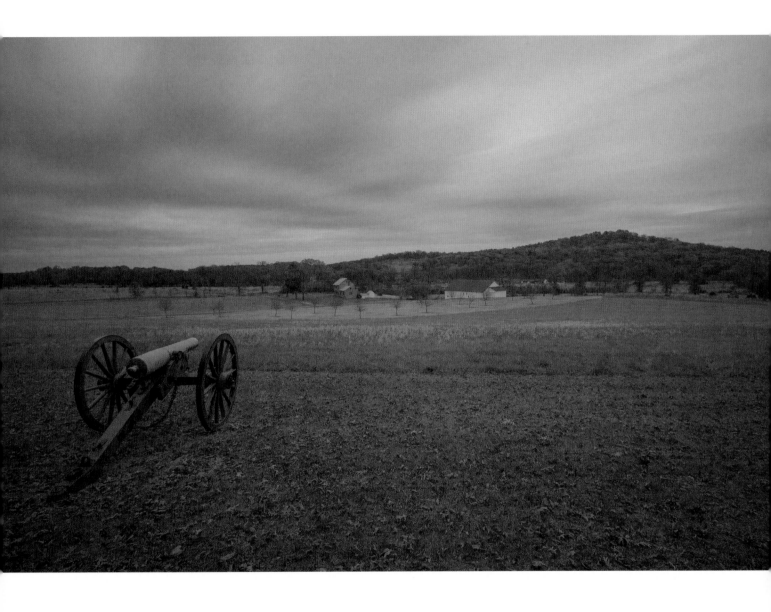

50. *ROSA'S REPUBLIC*

"Another Texan," you say? Why, hush my mouth and call me Shorty. Boy howdy! That's what Texans say these days, I hear. We didn't talk that way. We had some dignity and literacy. Expect you think I am a bloodshot Rebel, just like some other Texans on this field. Well, sir, if you have ears to hear, sit down on that rock yonder, and I'll spin my tale.

I knew Sam Houston when I was a boy, looked up to him as governor of Tennessee. I trained his horses when I was sixteen. He'd lived with Cherokees, you know. His second wife was one—a stately woman named Tiana. The Cherokee weren't like Cheyenne and Sioux—did not know horses like Comanche did, and so the governor employed me well. A few years later, when I heard he'd gone to Mexico, I followed him, and fought at San Jacinto in 1836.

Before that, I had married my wife, Rosa, Rosa Maria, just as Mister Houston had married outside his own race and people. I worked for him again, no stable boy this time but oversaw the president's big stables. I didn't go to Washington when the Republic of Texas became a state and Mister Houston became a United States senator, and when the war with Mexico broke out, we left the state and moved to California. Rosa Maria moved out there with me, to California, and stayed with me when I went broke, as faithful as an angel. The gold rush changed the place. It seemed that every man was either gold hungry or a Bible thumper—what the whole country would become. But we were happy.

When I lost her, I lost my will to live and so I moved to Illinois. I was a Lincoln man and got a regiment when war broke out. "A veteran of San Jacinto" sounded good. But I didn't like it much, so I resigned, jumped states again, enlisting in this Indiana regiment, a common foot soldier again with no one to take care of but myself. They knew I'd been a soldier in my younger days, could hear I was a Texan, those good farm boys some thirty years my junior, and worked it out of me where I had fought. You know that San Jacinto lasted barely twenty minutes, and wasn't hazardous particularly, but they elected me their captain. I declined. Politely, I declined, and took my bullet here while standing with them on the battle line. That's what I came for, and what I got.

I had become a Catholic for Rosa, as Mister Houston had done when he married, and so, for Rosa's sake, I would never take my own life. Mister Houston remained faithful to his Cherokees, even though his patron General Jackson treated them like criminals, and he stuck fast by the Union even though some maddened Texans threatened to kill him, and they evicted him from the governor's chair. He was an honest man and fearless, and he told the Texans they would lose this war under an avalanche of Yankee perseverance. Mister Houston knew faithfulness when he saw it, and so did I. Governor Sam would approve, I do dare to hope, of this blue uniform and of the old Republic, the Texas Republic, for which it stands, where Rosa waits for me and everything is possible. 🐾

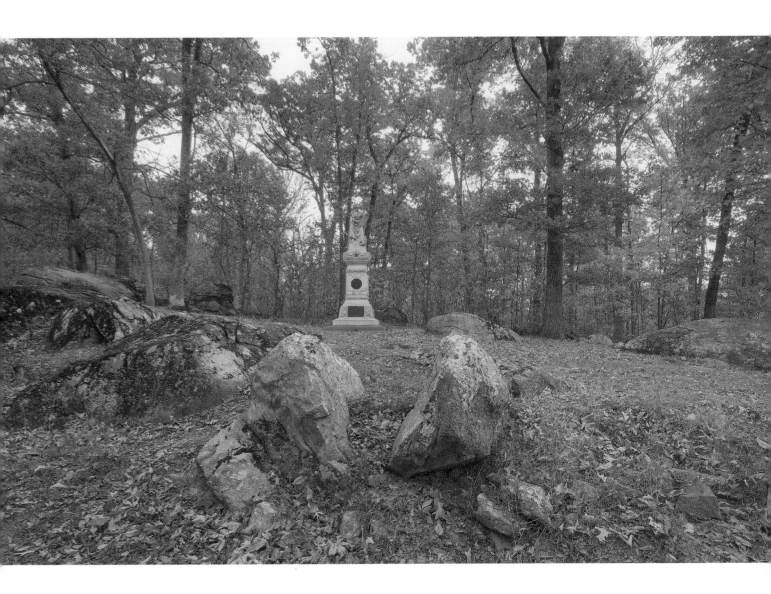

51. *CULP'S HILL*

When we returned tonight, the enemy was in our breastworks. We had thrown the works up this afternoon—a line of molehill with a small ditch to kneel in while firing—and now there they were, packed in on the other side. The sight of them nauseated me. Dim and pale gray, the Rebels put me in mind of a row of maggots—vermin that you might find on the underside of a dead possum in the moonlight. It turned my stomach.

We charged them with the bayonet. When our colonel gave the order to fix, I thought of lancing into a soft, maggoty body, and I vomited. Sergeant thought it was fear and clapped me on the shoulder. He said, "You'll be all right, son. We'll run them off." The regiment did run them off, I think, but of course I am not all right. At the word "Charge!" we rushed toward our little works, and the line seemed to catch on fire all at once. Flames from muzzle flashes lit the long embankment; the sound was like a thunderclap, a hand from heaven striking in punishment; and a long, low billow of smoke in a line bloomed in front of us. I wondered, had I run into a tree? The blow to my chest felt like a stone hammer. I think I staggered forward a step or two, and my knees folded.

I lay upon my back, with a pulsing weight piercing my chest. Panting, I felt a spray of blood sprinkle my chin. "Oh, God," I said. I couldn't lift my hands. With a mighty effort, I made them move. Numbness crept over my breast. Picking at this jacket, I wept with rage at my fumbling fingers. I rested, then tore the buttons loose. I raised my head a little and saw blood spreading along the buttons of my undergarment, and at the same time, a sick metallic taste crept over my lips. "God help me; I am killed!" I cried, but the sound was weak as water.

I lay looking upward toward the hazy black sky through the branches. I am shot through the lung, I thought. "Come carry me, Jesus," I whispered. But Jesus hasn't come. I breathed a little, and I heard bubbling at the hole. Sticks and rocks pushed against my back, but I could not move. A gradual fire kindled from the numb center of my breast. Sounds of every sort—crying, shouting, rushing water, thunder—spun across my face. It goes on, the night, I thought. I closed my eyes.

But with closed eyes I saw a squirming line of pale-gray maggots, soft and gluey, bursting air like kneaded dough. I think I screamed, perhaps inaudibly. I wouldn't close my eyes again. But there seemed a fine and gritty ash descending from above, and I tried to blink my vision clear. My eyes then seemed to swim, and still the night went on and on.

I waited for the morning, yea, more than the watchman waiteth for the morning. Then Mother's face swam up before my eyes. It could not be, I knew, yet oh, how dear and brave a sight! She knelt beside me on the rough and trampled ground. I felt a little water poured onto my lips. I coughed, and the trickle stopped. Oh, thank you, comrade! God bless you, my dear friend! Did we drive the awful maggots off? I felt them crawling on my wound, or was it fingers gently unbuttoning? Then that, too, ceased.

I wait now for the morning. Yea, more than the watchman . . . Voices of Zion, the gates of Zion. Hear, the fountains of the deep: they are breaking up! The night is far spent . . . Yet no morning cometh. How beautiful, upon the mountainsides . . . a fire, it burns in my breast. Warm silence, and the night goes on forever. ❧

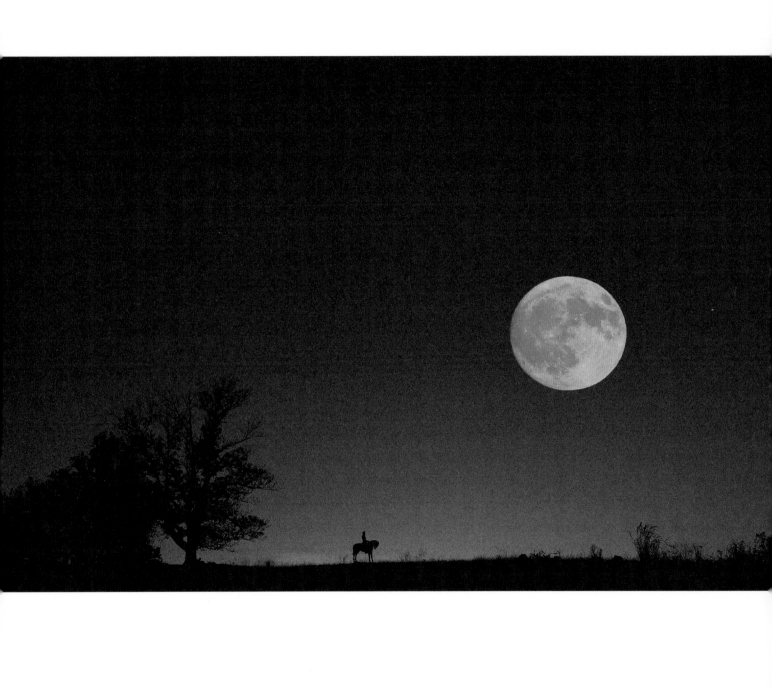

52. POET

I meant to write the poem of your eyes,
But how could I have put their light in words?—
For breath is frail, and all but spirit dies.

That day you placed your gentle hand in mine,
I called upon the angels for the words:
I meant to write the poem of your eyes.

Could I compose their music into rhyme,
The sound must rise above my earthly words;
For breath is frail, and all but spirit dies.

Had time and circumstance been less unkind,
I might have gleaned celestial fields for words.
I meant to write the poem of your eyes.

The wound I bear is final and sublime;
It puts an end to striving and to words,
For breath is frail, and all but spirit dies.

I leave, My Love, my last, long earthly sigh:
O may it reach your heart in place of words!
I rest within the poem of your eyes;
For breath is frail, and all but spirit dies. ❧

53. MANY MANSIONS

When I was a young fella working for the Park Service, I lived in that house right there. They told me I'd see bloodstains on the floorboards upstairs, and I did, but the funny thing was, I didn't see them right away. They told me I'd see ghosts, too, but I never did. Said there was a young, silent soldier they'd sometimes see standing in the sitting room, as if he were wondering where he was or why there were other people—who knows? I never saw him or any other ghost. I don't believe in them. The blood on the floorboards thing shows it just took the suggestion a while to work on my unconscious mind. There's no blood still there—that you can see. Maybe with some kind of infrared camera.

Another young couple lived in one of the other battlefield houses at the time. They both said they heard things, like scraping footsteps upstairs, at night someone up or down on the stairs, a door opening or closing, someone maybe saying a prayer. They weren't a couple of flakes; they were our friends. Good, rational people. It shows what a powerfully self-deceptive tool the mind is.

Deceptive for what? Well, I think that if you want to hear things, you'll hear 'em. The mind is a tool to satisfy desires. If you desire to live after death, the mind will produce the evidence. If you want evidence for answered prayer, there's plenty of it, as long as the mind blocks out the billions of starving people who haven't gotten answered. You want evidence for God? Well, people have believed for millennia, even though the actual, objective, factual proof isn't there.

I mean, take that blood upstairs. I haven't been in that house for decades, but presumably it's still there in some scientifically measurable way. It's proof of unanswered prayer. The whole Civil War was unanswered prayer. As President Lincoln said, both sides were praying up a storm, but both sides couldn't be answered, and neither side was answered fully. Quite an understatement.

If there's blood up there, it's Union blood. Third Corps, possibly Fifth or Second Corps. The Federal units were pushed back toward here, and a lot of the wounded would have been carried or walked, but the Confederates didn't make it to this point. Now, at the Trostle, Rose, Bushman, and Slyder Farms, you've got Rebel blood. I mean, if there's still blood on those floors at all, which everybody claims but I find hard to believe.

Ghosts and blood—that's what you've got here if anything is real. I mean, the battle itself isn't a reality. It doesn't exist. The evidence is gone, except for what people wrote and said, and the stuff they left behind, and the graves. But evidence isn't the thing itself. Ghosts and blood—those would be living evidence of the living thing. To the supposed ghosts, the battle is still going on, or was a couple of days ago, so it's a real thing in real time—to them.

You could deny that it happened, like there are Holocaust deniers. Except in the case of the Holocaust, survivors are still alive. It would be hard to maintain a reasonable denial. But what if the Civil War is only a myth invented to justify a national identity and civil rights? And the Battle of Gettysburg was made up to bring money into the town and to employ old battlefield guides like me? Could be. Hard to prove otherwise. All the monuments and position markers, the photographs? I suppose they could be explained away as fakes somehow.

You see, I don't accept my own skepticism. I think it's stupid. Get me enough to drink, and I'll admit that

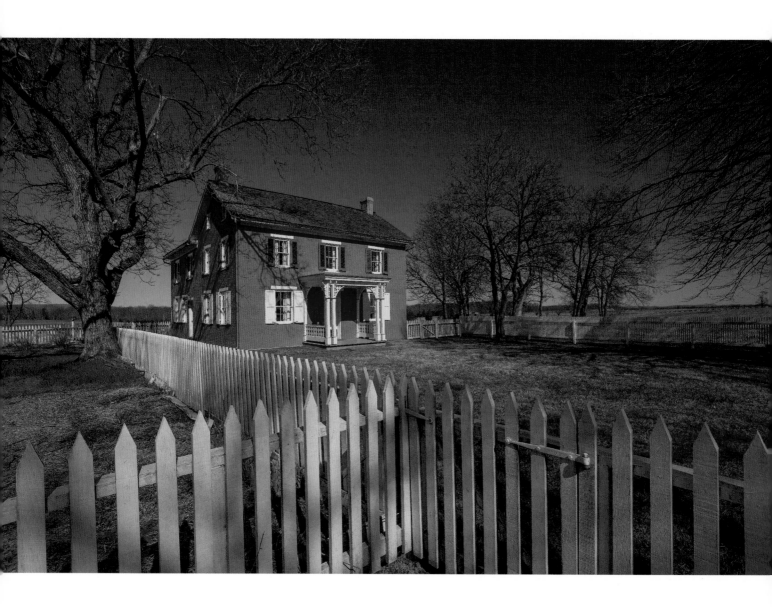

my friends really saw ghosts, and my own eyes did not deceive me when I saw blood on the floor. But that puts me into a world I don't want. Why do some people see ghosts and others not; why did some young men spill their blood and others not; why are some prayers answered and others not? I'd rather live in a place where all prayers are answered; or there is no God, period. I don't like God somewhere in between. A world where everybody is a Jew and gets exterminated; or we all live happily ever after. I prefer a world where everybody lives forever; or nobody is ever born. The whole thing as it is is just too damn unfair!

You tell me this is in any way fair! Look at all these houses still standing on this battlefield. The superintendent and his family live in the Rose House. What do they believe? I have no idea and I don't care. Have they suffered? Maybe, but let's say not. Let's say they're prosperous, healthy, happy. Then some young couple lives in the Trostle House. In that house, a baby dies; the couple divorces. I know people who lived over there, on that other farm. During that time, the guy, who I had lunch with every day in the summer, is shot to death on the streets of Baltimore for absolutely nothing. That's fair? Maybe in that house across the Emmitsburg Road, a teenager is going to overdose, or get crippled in an automobile accident. Is God looking after the superintendent but ignoring the kid? Maybe someone in the Bushman or Slyder House is watching television with his wife, who's dying of cancer. Or maybe he's alone. Like me. ✒

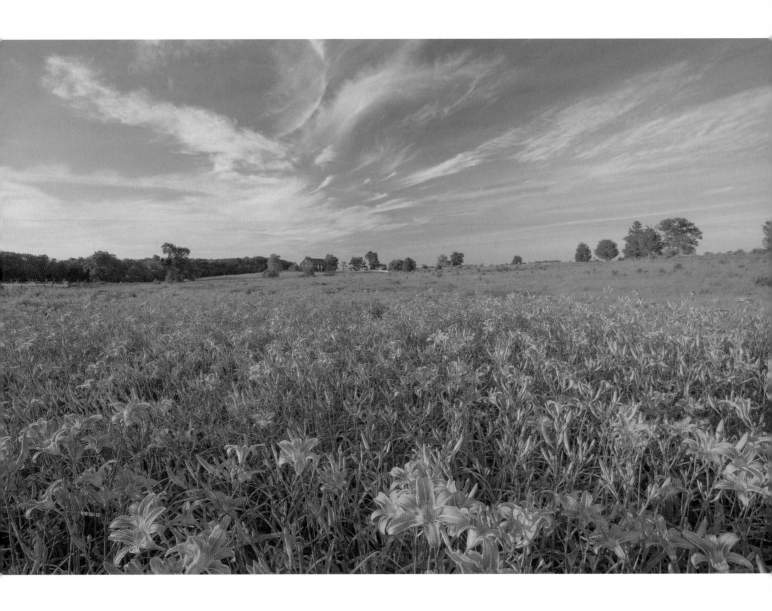

54. *PEONIES*

We lived here, and my mother planted them. My father built the house—"on graves," he said—some twenty years after the battle. I kept the bushes here until I died. You see, they're gone except for that wild-looking remnant over by the rock. The house is gone, and now it's as it was before we came, the way the soldiers saw it long ago. Except for those remaining stems and leaves.

I saw you water them the other day. I thank you, sir. And here you are again with water in that jar. Do I know you? We didn't have relatives back east here, and when I died, well, I was the last. You can't be doing it for us, then, but for the peonies themselves. Perhaps they remind you of something, or someone, the way they used to for me. I wonder what. Your mother, too?

Our old foundation must still be here beneath the soil and weeds. But it's the peonies, though, that bring me back this time of year, late spring. They came out redder than my mother thought they would, transplanted from her childhood home. "The blood," Father said. That blood, long gone into the soil, makes things a little different in the loam forever, though maybe not enough to see except where bodies had been buried thick. That blood's the real foundation here.

Dad said he found some things when digging out the cellar, but he never told exactly what. I think some photographs he kept in an old coffee can weren't our family. He must have found them in some haversacks or jacket pockets in the ground. Just why he never told, I'll never know. I would think you'd tell your only child. But Dad, he didn't talk a lot.

He had been in the war, though not here at Gettysburg. Down south somewhere, but where of course he never said. Maybe those pictures were some people he had met and couldn't tell my mother. The stories that we hide, or that just die out, and nevermore get told—those are the flowers that we water, our perennials. They make us what we are, though it's no surprise that we barely know most of those stories, because we barely know ourselves. I wonder if he found a skeleton or two, or more. If so—and you and I will never know—it could be that his silence was the way he paid respect. The silence had a story, and it made Father who he was, and I suppose me, too, though I would never guess those real foundations. And Mother, she was silent, too, in her lovely, gracious way.

Those peonies won't last forever—nothing does—but what we reverence, like the flowers by a house or on a grave, they are the stories, what remains of them, the evidence of things unseen. Orchids blooming by a vanished fence, lilacs in a hollow in the woods, and we who water them, preserving the green unknown. Thanks kindly, Stranger. I'll see and know you when the spring we've all been looking for blossoms on these fields at last. 🙢

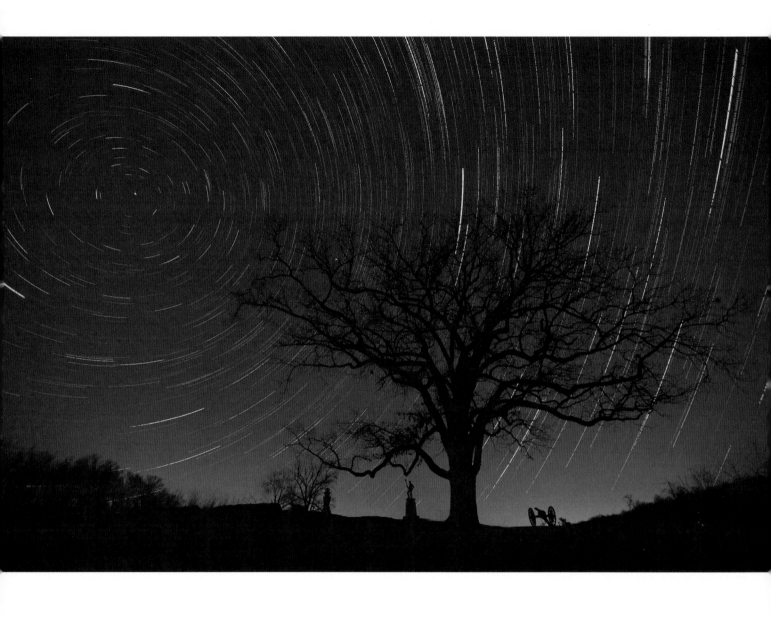

55. NIGHT AT DEVIL'S DEN

What fools we are! Of all God's creatures, we alone behave lower than what we know. I was in the 124th New York when it charged to save Smith's Battery, right there, those guns you see not twenty yards from where you stand beneath this agonizing Witness Tree, which on the day I died here was only one of several slender youngsters attempting life among these giant rocks. See how it reaches now with crooked arms, imploring heaven, asking why, a widow on her hard, gnarled knees, wracked with painful age, uncomprehendingly reaching toward God with withered arms, dry hands like the last leaves of an unredeemed December.

Look up! There's Polaris, the cold and pure North Star, which flickers heaven-blue and cobalt, high at the center of all its circling stars. There glides fierce Arcturus with his sons, and the Drinking Gourd so many trembling slaves pursued, directing them to freedom, as certain a beacon as heaven is sure above us fools, above our mad, distracted Earth. Those seven stars that circle it, the seven stars that point—the Ursa Major and Minor of rapt astronomers—are your poor eyes able to discern their jewel-clear colors? Unfurl the colors in your mind, Watcher! I see many glittering hues of blue, our true uniform, attended by greenish white, by topaz, yellows pale and deep, brilliant white, pale emerald, and by the aging flames of red stars swollen out with burning through the silent aeons—all witnesses and children of the artistry of God.

But here below, that second of July, we raged like rabid wolves—we who knew the universe, contemplated the stars while lying on the grass in summer, watching for shooting stars—see one there!—shooting each other's

bodies, bodies made of particles descended from the stars, starlight incarnate! Smith's Battery, there—the four crews stood close against their hot tubes and shouted huzzahs, shouted, "Give them hell!" as we swept between the guns and charged down the slope in front, down that triangular field into the faces of Texans and Georgians coming up like furies, yelling, cursing—a maelstrom of brainless disregard, maniacal, murderous, as if the Testaments had never been inspired, as if the seas had ceased to lave the grateful shores—or mountains had disrobed their purple and ground themselves to rubble—or April had been beaten like a slave and shed her white petals in a blood-flecked circle around her tear-salted feet—or mothers have ceased to soothe their children upon warm breasts—as if no man ever loved, nor Shakespeare ever writ—nor Jesus walked with Truth and Beauty among the lilies of the fields: all shattered in madness!

Our Colonel Ellis rode among us, mounted like a jousting knight, sword pointed forward through the smoke, toward the Rebels' howling throats. I ran beside him; I heard the bullet strike his skull; and in that same instant, I was struck twice in the chest, as though kicked by a horse. When I awoke on my back, I saw the stars: they seemed to weave and spin, but as I breathed my last fainting breaths, they resumed their places in a lovely stillness. I felt the moving Earth, just as I had felt it on boyhood summer evenings looking up into the starry deep, and though I felt moans and curses, weeping and prayers round about me—many voices—they were distant, their thronging noise dissolving, and I heard the music of the spheres. It's true, what the ancients claimed, that if you listen above these confused alarms and crazed babble, where ignorant armies clash by night, you can

hear the stars keep their courses. We sail among them, deeps around us on every side, the warm Earth a mothering nurse though we squall and struggle—but through the stillness above, higher still, a constant timbre, singing sweet and grand—the angel music, beautiful as stars— lovelier than heard music here below—choirs of angels, harmony of stars, pure celestial symphony in emerald, azure, sweet white, cochineal carmine crimson, rose carmethene, with the deepest, purest, diamond blue— resolving into harmonies of gold and white: melodious robe of God! ❧

III. THE THIRD DAY

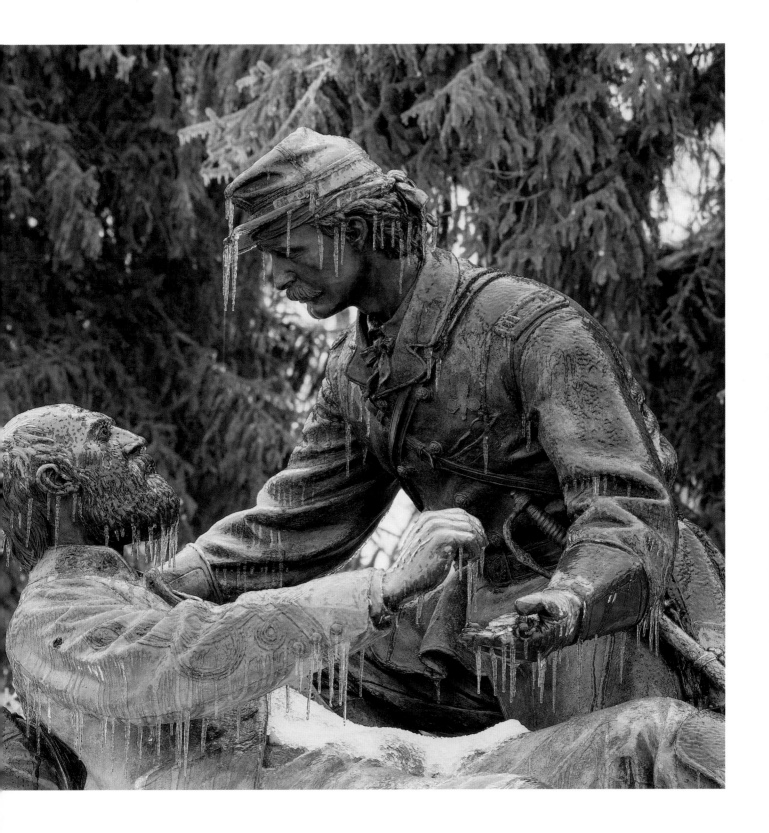

56. THE WOMAN IN WHITE

O, would that I could comfort you, but I, like you, have come to seek the dead. I fear my husband is among the dead. I lost my husband here. Of course I wait, but time is something else to you. The dead and living are the same, except each thinks the other is the dead. But Always is a different word, it's true, for you and me. For me, it's stillness without rest; for you, it's repetition of a thing you love or fear. And you have no idea where you are. But we whom you call Dead know where we are, because the place and we are one. I cannot leave this spring, these woods, because they are myself, and I am they, until—until the seed of time bursts.

Will you pray for him? Our prayers are useless, for we have no will, but you, the Living, still agonize upon that cross. Perhaps your prayers will break the last long silence that arrests my heart. I died of grief. Broken hearts dig long graves. I wouldn't live for anything, if living meant somewhere else. Please, do pray for him.

They didn't know him!—don't you see? The order came from above, to charge here—across this little meadow, toward those trees where enemies were waiting with those muskets. The general who made the order knew nothing about him, not even his name. And enemies, "enemies"! What did they know of him? They saw only enemies themselves! They saw a line of men in blue, the flag of the United States, and next to that the Massachusetts flag—the way my husband saw their Rebel flag, if that, once musket flashes and the smoke began. I had watched militia practice on the green, so I knew what it looked like here that morning. But I can never see him. He was killed, the papers said. His family came here—but I was here by then, too, a wedding gown, a movement of light, a woman in white. Who see me here see the pale, faithful wife of war.

Why he is not here too, I cannot know. The Fields of Asphodel lie far away. But would not his love bring him back to this spring? It is your spring too—you who seek my voice in measured syllables—this spring where Muses walk in white. To dip a trembling cup into this spring— have you come for this? Look once at my face; I shall lift aside my veil for a moment. Will you look on Love and Terror? Grief will fix you here with me, if you do. Better you should let me pass; for even Moses, who spoke with God, was not given to see His face.

Then pray for him, if you would be so kind. Perhaps he lingers at my grave, as I linger here; and in your prayer we shall find each other. Pray as you walk; pray for us. �

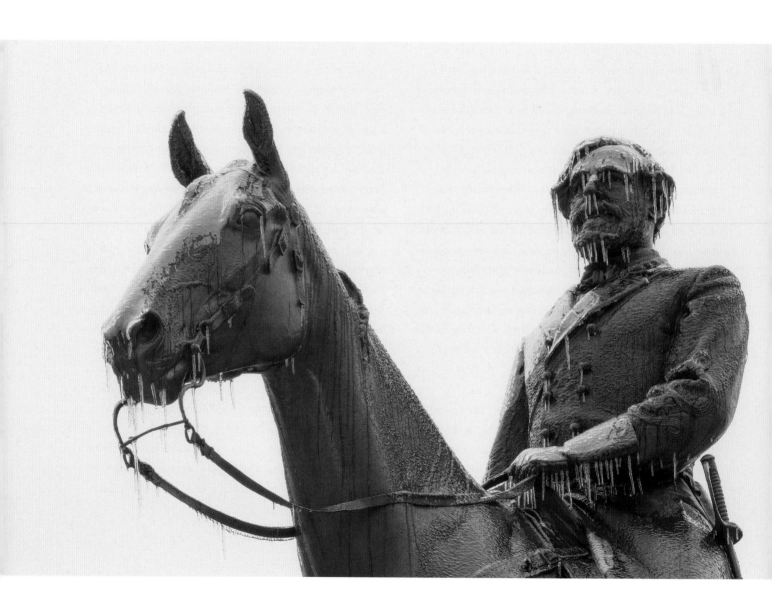

57. CARRY ME BACK

I'm so mad I could spit. If you hadn't come along just now, I don't know what I would have done. Probably followed those guys and done some stupid I don't know what. I mean the guys in that big SUV that pulled out just as you were driving in. Right under General Lee!

All right, I'm being incoherent. It's hard to calm down! Can just see the headline: *Last Casualty of the Civil War—Old Guy Loses Temper, Keels Over at Virginia Monument.* But you should have seen it! Right there, at that sign: *Keep Off.* Two big guys, thirty-something, rich, shaved-head-work-out-at-the-gym types in a sixty-thousand-dollar vehicle, watching their boys climb up on those bronze figures and swing all over them.

So, I see them as I'm walking back here from the bench out there. One guy is posing right at the sign. Standing right at it, and the other guy is taking a picture with those boys climbing behind him. The guy has this self-satisfied, defiant smile on his face, like he's saying, "To hell with you." By which he means me, you, and everybody who has respect for the past, for history, for the future that won't have this memorial art anymore. Look at that figure, missing the broken-off sword! No respect, and happy about it, proud of it, defiant about it!

I come up toward them and stop ten feet from the guy, and stand. I look at the sign, and then at him. And he says, "You got an issue, Grampa?"

I was so mad I couldn't speak, which was probably good, or when you drove up you would have seen your old pal dead, punched in the face. The thing is, these buttheads will do damage to the country and even to

themselves and their children, just to show us how much they hate us. If we were for public streets and roads for everybody, they'd say, "All right, we're going to tear up all the streets and roads in this country." And they'd find enough cowardly curs in Congress to pass the vote.

They trash us, they trash the past, they trash what this country fought and died for; they trash their own futures. And here, they trash Virginia! Those SOBs had a Virginia plate! I'm from Michigan, and I'm outraged! That's the whole point: do it against one state, and you're doing it against all of them. Abuse one of us, and you abuse all of us. I can hear one of those guys almost: "Oh, you like history? You read history books? Well, here's what I think of your books, *Grampa*!"

When you and I were growing up in the fifties, we wouldn't have dreamed of climbing on historic monuments in front of a sign telling us to keep off—and our parents wouldn't have let us, anyway. Much less encouraged it. You tell me that those buttheads want to go back to the fifties? They have no idea of the fifties. You and I are the fifties, two old grampas, and they despise us, and our respectful ways, and our reverence, and our "land of the free" and "home of the brave," and our "all men are created equal," and truths that we hold to be self-evident.

I'd like to go back to the 1950s, I really would. I still like Ike. What would the old general, a good and decent man, think of those bald guys and their bald selfish disrespect? You talk about terrorism. They're tearing up the Declaration, the Constitution, the Gettysburg Address—tearing up what used to make these states the United States of America. They think they're being

rebels, but they aren't rebels the way General Lee and his men were; they're just pumped-up, fuel-burning, resentful brats that think having the most privileged country on earth isn't good enough. Ruin it for everybody. I'd like to go back. Back to the fifties, back to Ike and the world war, to the Civil War—anything but now. Just take me back. ✒

58. *IN MEMORIAM*

The granite of the past is dust,
 Yet here is raised memorial stone
 Commemorating blood and bone,
And weapons that have sunk to rust.

In time, the earth will claim this, too.
 But in the interim of years
 Let all the curious passing here
Remember what we tried to do

And how impossible it was,
 For reasons that were meant to fail.
 How rash, how passionate the brave
Who raise their flags because they must,

And not because they will succeed.
 So may the Maker of our days
 Commit to earth our passing rage,
And let the spirit bless the deed.

Beneath no churchyard's ancient yew
 Our valor lies, but in these fields
 That annually their harvests yield
Of ever-green and bitter rue.

Soon no memorials but these
 Will teach the traveler of our cause:
 A nation's justice and its laws,
Its paths of righteousness and peace.

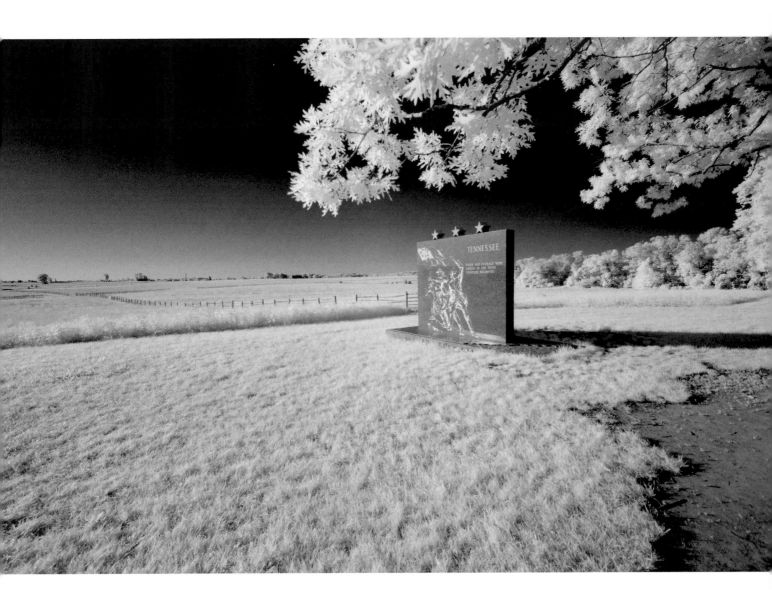

Let those memorials be our home,
 And memory our resting place.
 Let Honor's blossom be the grace
That flowers from this crumbling stone. ❧

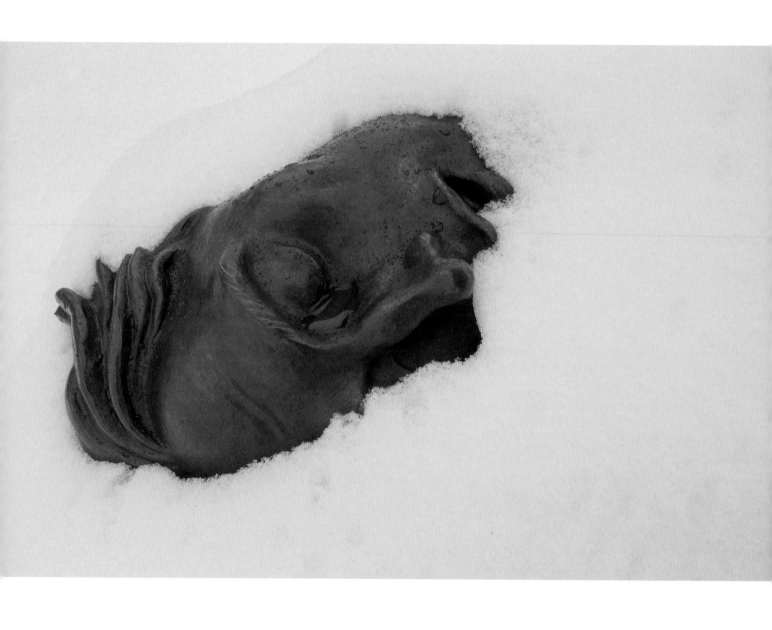

59. *JUDGMENT*

No angel come to carry me. I'se blowed
to Kingdom Come without no chariot—
only a flash of fire and light, the caisson
hit, me carryin' a shell fo' Massa
batt'ry. The sky come down and then the earth
jump high. When Zion hear the watchman voice,
they know I'se comin' all alone, no Jesus
comp'ny me. First blind me, then I let go.
I see no chariot. No chariot
swing so low. I wait. Sisters, the Judgment
of the Lord be true and righteous altogether.
The night far gone. O Brothers, turn away—
the wrath be come, the Judgment Day be come.
Stay low until the Wrath of God pass by.
This be the fire. My blood be over them. ✒

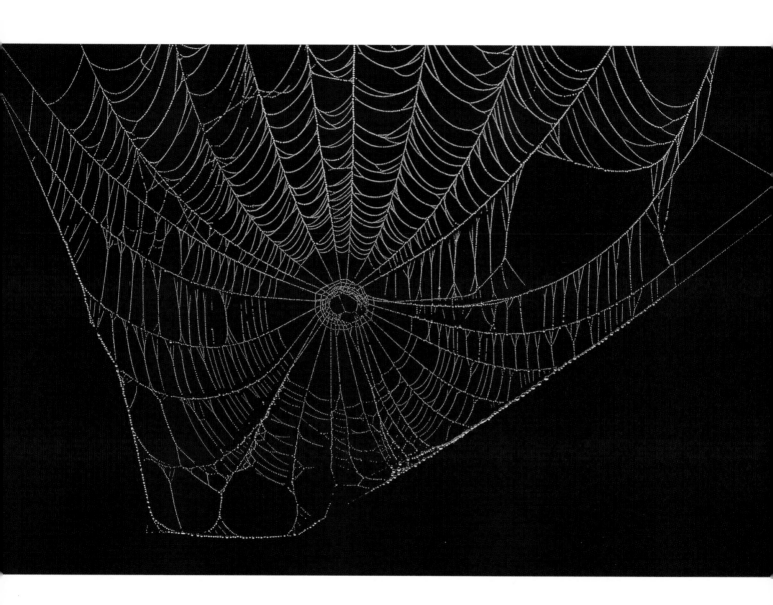

60. RAIN

It rained the first time I was here, oh, about thirty years ago. A more lonely and desolate place I had never seen. No tourist buses, no cars; must have been about the lowest time of the year. And chilly, too. I put on my cotton cap, clutched the collar of my jacket tight around my throat, and stepped out of the car.

The air smelled like rain—you know, that deep smell, like it's coming out from inside everything, and everywhere has now become a private place. I felt alone with the past. I felt those boys from Virginia were still here. It was that moment Faulkner described, which somehow lasts forever in the mind of a Southerner: the warm afternoon of July 3, 1863, when the order hadn't been given yet to form up. The Charge was still a few hours off, or maybe the bombardment is over and they're waiting. Doesn't matter. It will always be this way. The men are always here, to me, when it rains and the rest of the world's away. The possibility is here again, was always here, and always will be here.

Of course, there was no possibility, and that's the soft delusion of the rain. What lay ahead an hour, or three hours, was not possibility and never was possibility, but was destruction. The only reality—what *really* lay ahead, like a solid thing you somehow couldn't see—was death and defeat, the "lost" of the Lost Cause. Possibility, for them, meant only that respite of not knowing, that inexhaustible and inescapable unknown that called them forward into what was now only immaterial thought but would be palpable and mortal, injurious to all but the unvanquishable corner of the human mind where spirit resides, and where the ineluctable defeat of the flesh—which distills the past and all of history into the valorous daze of a single resentful, ruinous, and morbidly loquacious idea and a mothering grudge—where that defeat becomes your only victory, endless and ineradicable like the odor of verbena, inexhaustibly renewable the way ascending vapors drawn of human blood and sweat come back to earth as a private, obligating, and unrelenting rain. ✒

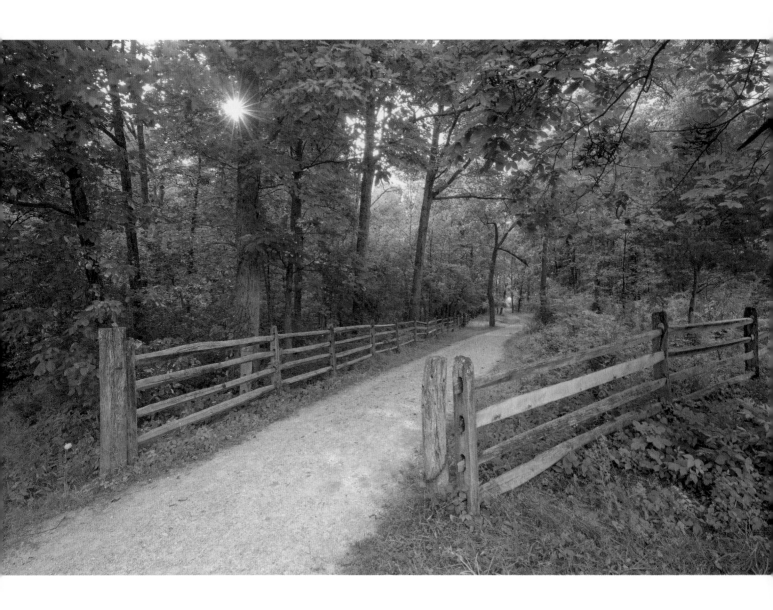

61. LIGHT IN THE TREES

"It's beautiful," she said. "It's all still beautiful, even after slaughtering all those trees." An officer in the US Navy, she has returned to this infantry battlefield annually for over twenty years. In early July, when the battle was fought, she drives out after dark to visit the surviving Copse of Trees, the "high water mark" of the Confederacy. In silence, she watches the old witnesses to Pickett's Charge come to calm and breathtaking life, illuminated by fireflies thick as stars in the Milky Way. "It's a little like heaven come down to Earth." She's not a religious person, she told us, "but light is light."

This year she ordered a little group of us to follow her to the small clump of trees that was the visual focal point of the climactic event of the Battle of Gettysburg: a brave and angry flood of twelve thousand men keening the Rebel yell across a half mile of open fields. A fantastically rash and heedless charge ordered by an angry man (General Eisenhower said that Lee "must have been mad enough to want to hit that fellow with a brick") in whom the soldiers who followed him had unquestioning faith. The attack broke against artillery and stout, courageous infantry defense. Only one-third of the Rebels made it back to Confederate lines, where their grieved commander awaited them. In one of his finest moments, Robert E. Lee rode out among his returning men, telling them, "It is all my fault."

Back on Cemetery Ridge, men of the Sixty-Ninth Pennsylvania, whose thin blue line had stood before the converging thousands of inflamed Southerners, counted their survivors and prepared to bury their dead. Fewer than three hundred Philadelphians had faced the apex of the Confederate wave here in front of the Copse of Trees, and half of them lay on the trampled ground.

"It was like a flood tide," our officer remarked. "A high water mark." Thousands of lights enspirited the trees with a strangely vivid and brilliant glow. After a few minutes, she continued: "When I am overwhelmed, I come here. When I need an answer, this is where I go. I have never been disappointed."

Never? Even in the dark, she sensed our skepticism. "When I say 'never,' I mean 'never.'" She is a straight talker. "I am an officer in the armed forces of the United States, but at times I am dismayed and dispirited by the electoral majority. I get depressed and angry about the choices millions of careless citizens make. Sometimes I loathe our so-called leadership. I fear for our country. I fear the future. But here is my comfort. This battlefield is a ship of light on a dark sea. We are all on that ocean together, whether we like it or not. The spirits of those men are still here, in some way. Can you feel a Presence here? Can you hear them?" ❧

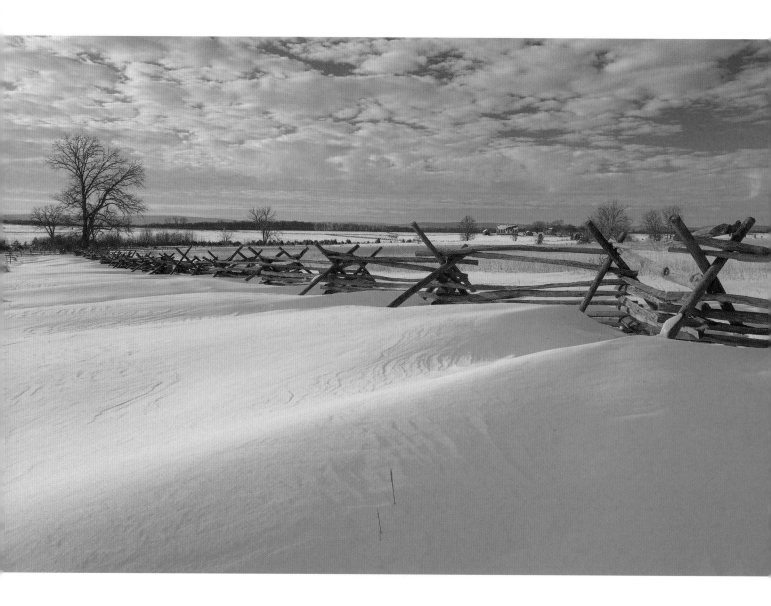

62. HOME SWEET HOME

I remember when the Krauts were here. That area over there, where the motel used to be. Before they built the Home Sweet Home Motel, there was a POW camp for Germans captured in the war. I used to help deliver laundry there. My mother would take it in—the dirty laundry—like many women whose husbands were overseas. So while Dad was fighting Jerries somewhere in Europe, we were doing their dirty laundry over here. And let me tell you, the Germans had a lot of dirty laundry.

You know what I mean. In terms of personal cleanliness, they were A-1. I knew that already, of course, because my mother came from East Prussia, and everything in our house was neat as a pin. You could eat off our floors, they were so clean. I should know, because I and my sister cleaned them twice a week when we got old enough—which was about eight. Before that, I remember *Mutti* on her knees with a scrub brush and pail.

Oh yes, we grew up speaking German until we went to school. After that, it was *verboten* in public. This area was full of Germans, but Germany was not very popular after Herr Schicklgruber took over. So my sister and I could understand the prisoners, though they didn't know it. They had some choice things to say about Sis, even when she was only twelve. Young guys, you know, away from home. They were polite to us but hell on each other, some of them. The fanatics who had been in the SS, they lorded it over the others. Bullies over here just like they had been at home.

You know what their problem was? They didn't know where their next *Bratwurst* was coming from. I mean, you're away from home in a foreign country, across the Atlantic Ocean; you don't speak the language; you know the people probably hate you; and you don't know if you'll ever see your home and family again.

Some of those guys never did go back. It was their own choice. Knaus and Musselman and the other apple producers used the Kraut prisoners for labor during harvest season. They liked it pretty well over here. They had it good—a lot better than they had it over there—and they knew their home sweet homes were nothing but rubble probably, and the country would take years to get back on its feet. So they stayed here. Married American girls—maybe widows—and raised nice families right here. Or in California.

I hated those bastards, all of them. They were well taken care of in that facility. Well fed, warm, good medical care. And my dad was over there trying to stop Germany from conquering the world. Another fight against slavery. Say what you will about the United States, but we stopped the Germans and the Japs from turning the world into another plantation.

My dad never came back, you see. Died in one of their POW camps. You can bet he wasn't taken care of like these German POWs were. Same thing happened eighty years before. If you were a Union prisoner sent to Libby Prison or Andersonville, what were your chances of seeing home again?

You know the soldiers' favorite song in the Civil War was "Home, Sweet Home"? When their bands serenaded each other across the lines, "Dixie" and "John Brown's Body" played back and forth to needle each other, they'd almost always end with "Home, Sweet Home," played by both bands and sung by soldiers on both sides. Kind of like "Silent Night" in 1914, sung by the Huns and the British together on Christmas Eve.

And you bet we made a nice Christmas for those homesick Jerries. My mother baked *Stollen* and brought them German Christmas cookies. Some of those fellas had tears in their eyes. *Mutti* did that hoping in Germany somewhere some *Hausfrau* was doing the same for our dad. Fat chance of that.

Well, they obliterated the camp shortly after the war and built the Home Sweet Home Motel. The place was here for forty, fifty years. It's all gone now, as you can see. A fellow would never know there had been anything here, anything at all.

I wish they'd left it. I mean the prisoner-of-war camp. Just left it standing here. Preserved it, taken care of it. Given tours of it. But in the interest of history, I suppose—I mean Civil War history—they tore it all down. So now you see the fields kind of as they were when Pickett's Charge came over them.

I think that's a mistake. If the idea is authenticity, the camp should have been kept. War isn't pretty, peaceful fields. It's soldiers wanting to go home—soldiers in prison camps or worse with wives and children waiting for them. It's my dad, never coming home. ✒

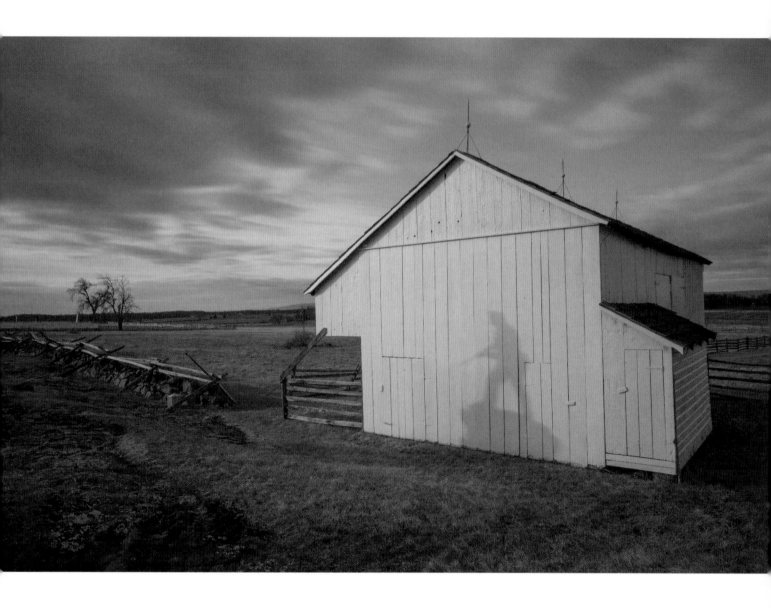

63. BRYAN HOUSE

On the Ohio River, we would see their black folk chained together on the decks of flatboats and the big paddle wheelers, the saddest people you ever saw. I never thought our business was to free the slaves, but on the other hand, I hated slave drivers like poison. Those people here—I mean the family of free blacks living in that white house on our left flank, and all the black folk that cleared out when the Rebs came—they knew the war was war for right or wrong, and Mister Lincoln said if slavery isn't wrong, nothing is wrong.

After the battle, the Bryans got their house and garden back. We learned their names, those of us who stay here. That white house was in a sorry state when they moved back in, was almost ruined, but Bryan worked hard. Yes, he took on more debt, it's true, to plant his trampled fields and to get through the first hard winter. The folly and greed that made this war had almost wiped him out, and credit did not come easily here, in this town on the Mason-Dixon Line that had little liking for their black folk.

But they were decent people, the Bryans. I watched the daughters grow up here in spite of what they had to deal with, and his wife had dignity the way those sad people I saw sold down the river had their way of carrying their danger without doubt or ceremony. The Bryans had to move on eventually, and other people came in and tried to make a go of it. But after the Bryans left, the house always has felt empty to me, the way it is right now, never again really lived in. Museums have their place, I guess. But that white house has always seemed to me alive with memory of what we used to be and what we fought for here.

Old General Hays—a fighter, General Hays—he saw the Rebel left flank coming this way across those fields and moved us out end-on to them. When we let loose on them, their line just withered up and crowded toward the right. Our fire killed them by dozens, seemed like hundreds, slaughtered them, and helped break that monstrous charge. We few who took the bullets of their flankers died on the Bryans' property.

The president would tell the nation, toward the end, that all of us had felt the judgment of the Lord. There are not many willing to believe that quaint Old Testament opinion, but had you seen us lying in this white-fenced yard—the palings broken down like twigs, after our wild killing across that freed man's land—in that awful quiet, you might have thought that all of us had come to rest in the true and solemn righteousness of God. ❧

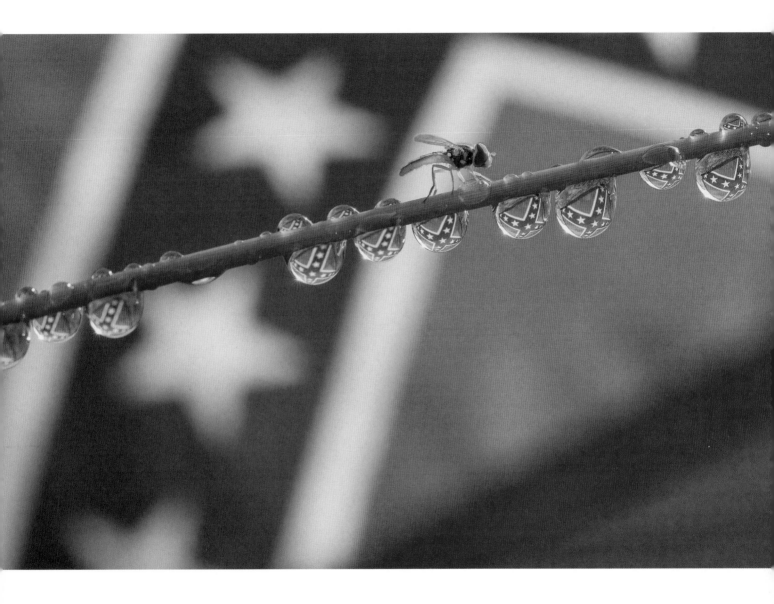

64. *STARS AND BARS*

*The whole damn battle was uphill. But that don't
matter now. We charged them Wednesday in the
woods, uphill against their line—a half a dozen
color-bearers paid the price, but we skedaddled them,
for sure. And here on Friday up we come, upslope to this
here line—the futhest any Rebels got, the Twenty-Sixth
again. So I say, let's dispense with sorrow. We done
pretty good, I'd say. We looked them gunners in the
eye, up ten feet from that wall. They looked us back in
disbelief, till* Pull it! Pull it! *that lieutenant cried. And
that was all.*

 But I say, it don't matter now.

 We done the best that man can do.
 We whooped and hollered, anyhow,
 and showed them boys in blue
 what men are made of in the South,
 and may the Good Lord shut my mouth
 if we warn't brave and true.
 No, I don't hang my head in shame
 and mourn what might have been.
 We won the battle just the same

as if we had: the South will rise again.
You mark my words, you Yankee line:
we ain't done with you-all yet.
The South might sit and bide its time,
but it will not forget.
Yes, Pull it! *that damnyankee screamed,*
and blew us all to hell.
But we'll come back, just wait and see:
we'll settle up and serve you well.
Someday, a hundred years or two,
we'll get our rights and property.
We ain't done yet, I'm tellin' you;
you'll hear from General Lee.
We'll Confederate the USA
and fly the Stars and Bars.
It's Dixie's land, O look away!—
the future's sure, and ours.
We'll whoop and holler like before;
the South shall rise upon that day.
Can't tell who really wins a war
until the future has its say. ❧

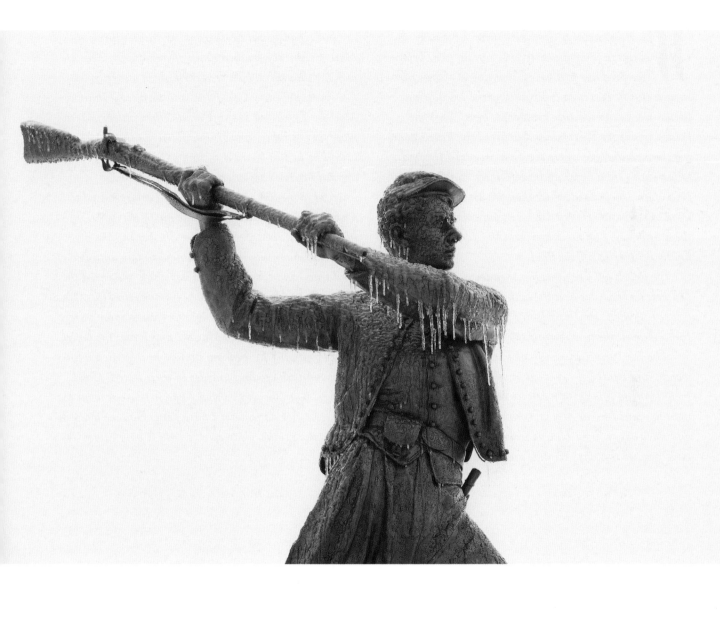

65. *INNOCENCE*

We didn't want to close with them. Our new brigade commander, Webb, ran up to us before we fired our first volley, shouting to charge the enemy. But he had been commanding the brigade less than a week, and we didn't recognize him. We stood loaded, ready for the command to fire—the Rebels pouring through the hole where our own Seventy-First had fallen back—and here's an insane officer running in our field of fire, inebriated, so we thought, and frantic. We stood our ground. He tried to wrest our colors to carry them before us, but our bearer held the staff fast. When finally he hurried off, we fired.

The Rebels fell like ninepins; then we charged. Muskets clubbed, we beat the bastards down. We hoped before they died, they'd recognize the Philadelphians, the Fire Zouaves, the new recruits at Antietam ten months ago who ran, surprised and flanked and helpless in the woods, and badly led—not led at all. It's us, you gentlemen! How do you like it when it's out here in the open, man to man? I swear they saw our short French jackets and these baggy, light-blue pantaloons and knew we'd have revenge this day. We did, and some.

But what would Mother say? We didn't think of Mother then: the crushed skulls of godforsaken Rebs was our thought, who'd seen them shoot our friends like sport. Revenge, we'd have, and then we'd think of Mother, if we lived to think at all. The battlefield is no place for a mother, though I doubted not that Mother would be first to board a train for Gettysburg when news arrived her son's among the wounded.

And so she did. I knew she would come, but when I woke to see her sitting up beside me in the night, my hand in hers, the tears did come. She bent to kiss my forehead, anointing my tight-bandaged face with her fond tears, and though I could not speak, she heard the gratitude and love that gleamed from my dim eyes. No Mary could have loved her son nor grieved more purely than my sainted mother. May the angels and the Good Lord forgive her for bearing sinful sons who died with curses on their lips and murder in their hearts. Good Mother, how you wished that I had never seen what I have seen, nor done what I have done. Had we foreseen what was to come, clear-eyed, would it have come? ❧

66. THE GAME

I got the board game *Gettysburg* when I was ten years old. I learned the names, the places, and the times when units came to the field. I always lost when I played someone else.

I haven't seen the box for many years. It might be moldy, or someone threw it out. It's just as well. I wouldn't be a general for anything. I wouldn't want to be in charge, decide the life and death of anyone. I think to play such a game has some effect on a person.

I can't explain it, but I feel that everything we do has consequences for ourselves and others. A boy can play with war, maybe, but not a man.

My brother's grandson sits for hours with his video device, hunched over it like Gollum with the Ring. He looks like a device himself. I told my brother once that Daniel was defining channels in his brain that never go away. "He'll be a warrior like his dad," my brother said, and I knew better than to bring it up again.

A sore spot in our family is how my brother went to war and I stayed home. I couldn't do it, don't you see. I couldn't go and kill another man because of what some people said, because someone I didn't know told me to go and shoot. Just why a government has such a right, I'll never know. "Authorities" are men and women just like me, who only pretend they know.

At any rate, I think that Daniel will know how to use weapons of contemporary war, the way I learned to shoot a rifle with my Daisy BB gun. We played outside, my brother and me, a game of Civil War—Blue and Gray lined up. We shot them, not each other, though we had to be careful. The first to knock down every man of the enemy army would win. The Blue and Gray were little plastic soldiers you could buy in bags of ten. We didn't drive the losers from the field; retreat was not a possibility. We shot them down. Quite a game.

But boys are boys. Maybe there's not much difference from my grandnephew's concentration on a screen. Look out there, that quiet field. What kind of game was that, 150 years ago? It was no game, but doesn't it look like a game if you imagine it from somewhere overhead? And if you couldn't hear or smell or touch the truth, the falling boys could be a row of plastic toys or virtual images deployed by gods or circumstances, by those in power wanting more, by nations or ideologies.

If I were God, I think I'd have a look myself down closer, ground level, hearing how the wounded cry, and maybe feeling wounds myself. That's something I'd be able to do if I were God. Except that God knows how it turns out. No rolling dice for Him, Einstein said. That means no game. A game's in the uncertainty, the contingency. If I knew the result, I wouldn't feel fun or fear, the tension caused by ignorance of how a thing turns out.

I wonder if a difference between ourselves and God is that because we don't know, we can play a game, but God can't. Unless we're it. ✤

67. THE UNIVERSAL SOLDIER

Not many of us died to protest the war, but I was one of them. The tear gas triggered a reaction in my lungs. Seven months after the incident, I died in a hospital bed. No direct connection was established, even though my father filed a suit and lawyers argued it for several years. I tried to communicate to Herbert (which is what I called my father; we weren't close) that the suit was a useless generator of negative forces that were in fact affecting even me. But I found that at least in our case—daughter and father who never understood each other—I could not get through. As it says somewhere in the Bible, "a great chasm has been fixed between us and you." That chasm you would call Death, but I would call it Life.

My dad, Herbert, called me a "flower child," and how it exasperated him, a veteran of World War II. Not that he saw combat. He rode a desk in Washington, but often just those types are the most vehement, the superpatriots, the VFW fanatics who ride in every Memorial Day and Fourth of July parade. I was the only one in the family who was against the war in 1968.

It wasn't anything at Penn State that turned me against a war I'd never have to soldier in. My male friends, of course, were 2-S, and until the lottery, they were safe. In fact, I really didn't care, until I went to Gettysburg one afternoon with a shy and angry boy who drove me there in his brother's car. His brother had been killed by the Viet Cong, or the North Vietnamese, but the shy and angry boy said the ones responsible were really Lyndon Johnson, Robert McNamara, and all the willfully indifferent public who made the war we had no right to wage. I felt that I was one of those he blamed.

I grew up with my father's horses, and by age twelve I was a competitor in shows. We had money. When I was sixteen, I hated the money and had nothing more to do with competitions. But I still loved the horses. I was the horse girl at school—high school, I mean—the rich horse girl. I took up the guitar to make a different image for myself. Became the lanky folk singer, learned everyone from Dylan to Donovan. I think that Peter, Paul, and Mary's version of "The Great Mandala" changed me.

I wanted to know what the Mandala was. Under the influence of marijuana and a few long-haired, self-absorbed, and carnally minded boys, I studied Brahmanism, read the Upanishads and Bhagavad-Gita, went to Vedanta classes and generally made my father hate me. Because he feared what I had learned, of course. I never talked about it much when I was home, but the beads and straightened hair and "hippie uniform," as he called it, communicated who I was, what I had become. We hardly spoke, and he avoided me. But he paid my tuition.

My horses, on the other hand, knew that I hadn't changed essentially. All of it was clothing, even in my mind. When I went riding, I could be myself. The trouble was, I didn't know who that was. Just a girl, like any girl, who grew to hate her father for neglecting her, and put on whatever costume he would hate, and be whoever would hurt him most.

So when that boy took me to Gettysburg, he went all by himself. That is, he took no one along, just some empty girl with long, brown hair, good legs, and lots of Eastern wisdom unapplied. A girl who played along and sang along, with no idea who she was.

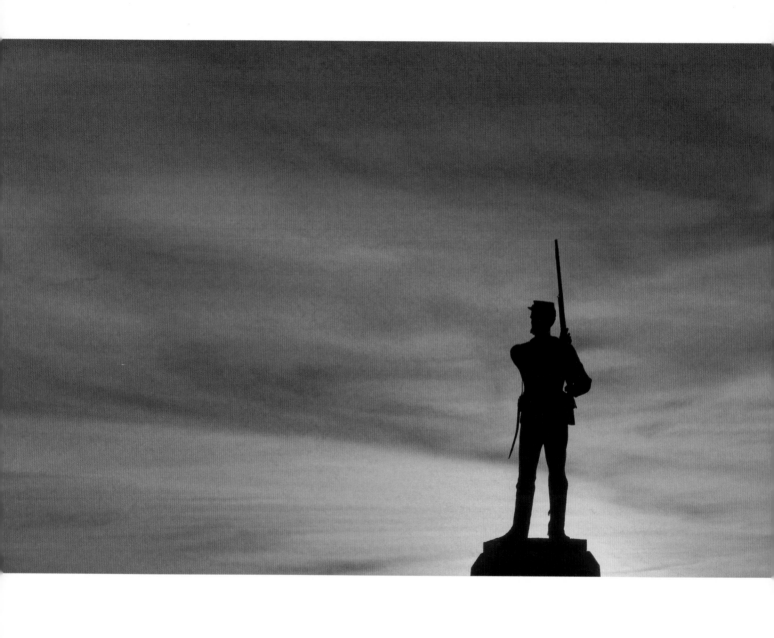

We saw a line of tourists on horseback winding through a field, and it was like I stepped on a mine. The earth spun, like I was on a bad trip, and my sensations weren't my own. The boy seemed not to notice, lost in his own experience. But everything here was so vivid—the smells in the fields, the greens upon greens of the trees. Birds seemed large and miraculous, as palpable as meteorites, and the ground beneath my feet felt familiar as the beaten dirt inside our stables. I was on the Great Mandala, and I could feel it turn.

That night I dreamt I was a young man, an officer in blue, on horseback, and I dreamt of my own death, shot and falling off my horse, with horses milling all around. From then on, I might not know who I am, but I knew who I was. I knew who I had been, and that young officer was me. However many lives I might have lived on this Wheel of Birth and Death, that was the one, the single one, the only one, that I could remember.

I determined that I would never kill again. I'd never die a soldier's death again. I was a young woman, so I would have been safe that one time around. But for the sake of all the men I'd been, the sake of all the soldiers I must be until I laid down my life for peace, I would protest the war with everything I had, and was, and owned. I was tear gassed about one hundred miles from State College, one hundred miles from home. "You can hear the whistle blow a hundred miles."

I came back to Gettysburg again, alone, and wandered where I read the horsemen fought. Buford's cavalry west of town, the field where General Farnsworth charged, and the Cavalry Field east of town. I don't know where I fell. I don't know the name I wore. But I would not be him again. I would not be my father for the world. But more than that, much more than that, it was like Cervantes's Don Quixote, which we read in my first college English class. "I know who I am, and who I may be if I choose." My father said we were "quixotic," I and all my dove hippie friends. But I knew who I was, knew who I had been. And who I may be if I choose. ❧

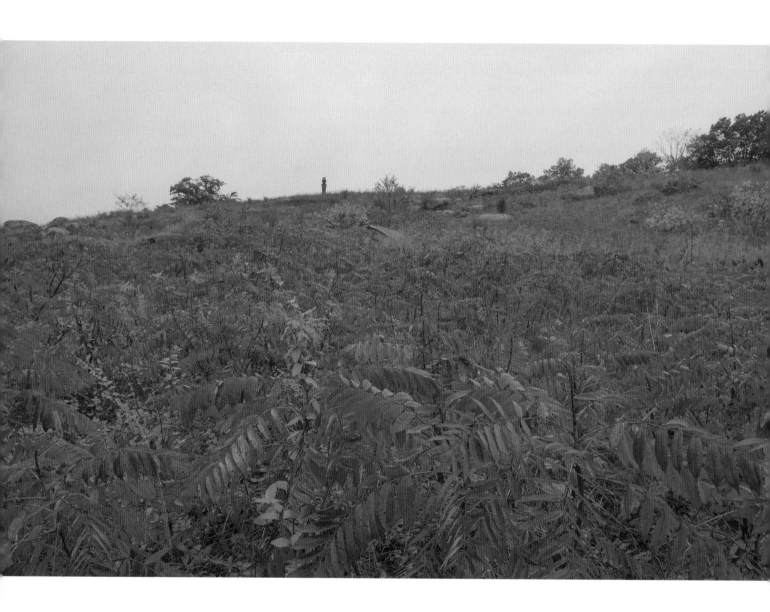

68. *LEGION*

Can't help myself! Could you? I mean, if you were the same. The same, you see? If you came from where I did. I mean, if you had my nerves, my constitution—my deprivations! If you were missing what I'm missing! I never mean to do it, and I try to stop—I tell myself to stop—but a voice below persists, you know, persists, and I crave the sweets.

Oh, the sweets! The fragrance, the aroma—I try to be content. This time's the last, I swear. But anyone who knows addiction knows you can't resist. "Resist temptation"? Sometimes I think I am temptation. I know that thousands of us act the same; I'm not the only one. I'm not a freak. I'm just the same as everybody else. I follow orders. That's exactly what addiction is! You follow orders! Of course I know my own addiction! A choice? What choice? It's sweet that makes you crave the sweet. And there are endless kinds! You can't exhaust the choices. Because that's the only choice. It isn't to drink or not to. It isn't fill the cup or not. It's what to pour! There's aged Kentucky, sweet and redolent of oak. The Tennessee that gushes from the mash they make out here is best of all. I could stick with that alone. But then there's sweet Louisiana ruby, like claret only heavier. Incomparable. Or Alabama crimson, almost golden when you hold it up between the sun and your thirsty eyes. The peachlike tint of Georgia alizarin—oh, the fragrance! Sticky as honey in the blossom. How could I—how should I—resist? Virginia amaranth—to savor drop by drop. Carmine of Carolina! The cardinal of Missouri, distilled like brandywine, trickling out until its burgundy notes are savory as salt. How can one not crave more and more?—a running-over cup, a beaker from the river Lethe! But wait! The subtle fruits of Northern climes tease palates cloyed with drowsy hours of that Southern slow carnelian! The vintage of New York—strawberry, raspberry, overtones with rusty tang and lingering cherry. Oh, the candy apple draughts of New England—how I long for them! Aged to bittersweet perfection, maroon at the dregs. Pennsylvania—vermilion, incarnadine! And then the sweetest, late-harvested elixir: the poppy and the rose. I must have it. I need to have it. My master beckons me to sweep these fields. More! The poppy and the rose! ❧

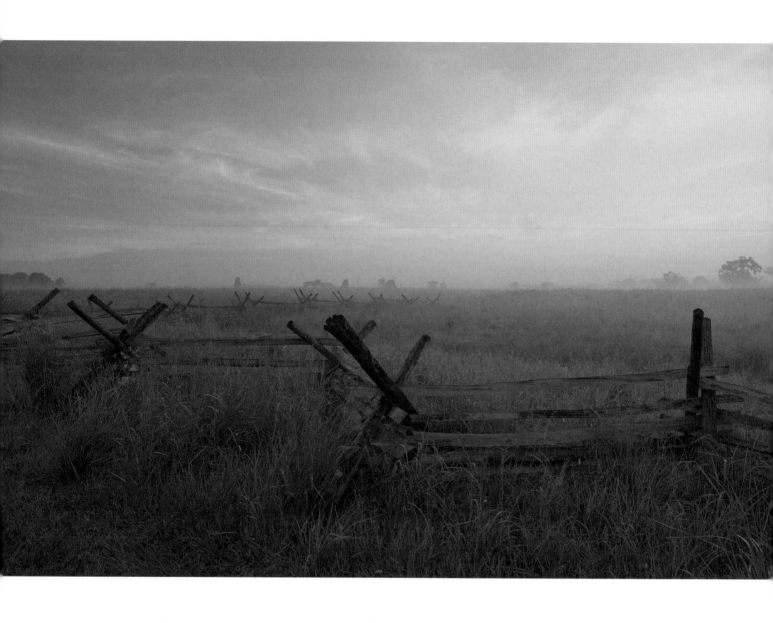

69. WINGS

Tourists come in pretty decent cars. The SUVs are new, the vans are grand and shining, the German cars accelerate with liquid growls. Her car was different—easily the oldest on the field, a dented green Toyota needing shocks and touch-up paint. She parked behind the Pennsylvania monument and got out, smoothing down her shapeless housedress, a flowered laundry-room blue, needing repair along the time-bitten bottom. Flip-flops on her wide feet, she stepped across the grass to the largest memorial at Gettysburg, a massive marble square several stories high, surmounted by a lone, flowing-robed Winged Victory, her sword pointed against the sky.

The monument's exterior is walled with tall bronze tablets bearing names—Pennsylvania's thousands who struggled here, that the nation might live; that the woman might elect her own government; that the government would be one of laws, not of men, with liberty and justice for all. Carrying an old purse by its strap, she walked among the casual vacationers who stopped to read a name or two on one of the plaques, then posed for snapshots or got back into their cars.

But she stopped at every tablet. She read names, and then moved to the next. One after another: one column, one regiment, one company, name after name; then she moved to the next tablet, all along the south wall, then around the corner, while the tourists took their photos, the children ran, guides lectured to walking groups, and all rejoined the multicolored, shiny flow of cars, to be replaced by more who came and went like a long-exposure stream of time.

A half hour later, she emerged around the northeast corner, still reading names, stopping at each high tablet, the purse suspended from its strap. She moved along the east wall, now fully in the shadow of the monument, unhurried, careful, as out of place among vacationers as the poor are always out of place. Reading, reading, reading the roll of the last, best hope of earth, inscribing them on her immortal scroll.

Reaching the last bronze tablet at the corner where she had started, she turned without a glance at the battlefield, her baggy cotton washwoman's dress still straight like a sack, ruffled once a little by a vagrant breath of solitary breeze, and walked on her peeling flip-flops back to the dusty, sun-faded car. It was unlocked; she dropped her purse onto the empty passenger seat, settled behind the wheel, and pulled the door shut with a rusty crack. I thought I saw her turn the key a couple of times. The engine started on the third; she backed out of the parking place and drove, alone, maybe to a room somewhere with a hot plate, old stuffed chair, and television, names of the living and the dead written in her heart. Hope is a plain face, and a working woman's hands, and a purpose as mysterious as footprints on the summer grass.

"Bloom forever, O Republic, from the dust of my bosom!" ✒

IV. AFTER THE BATTLE

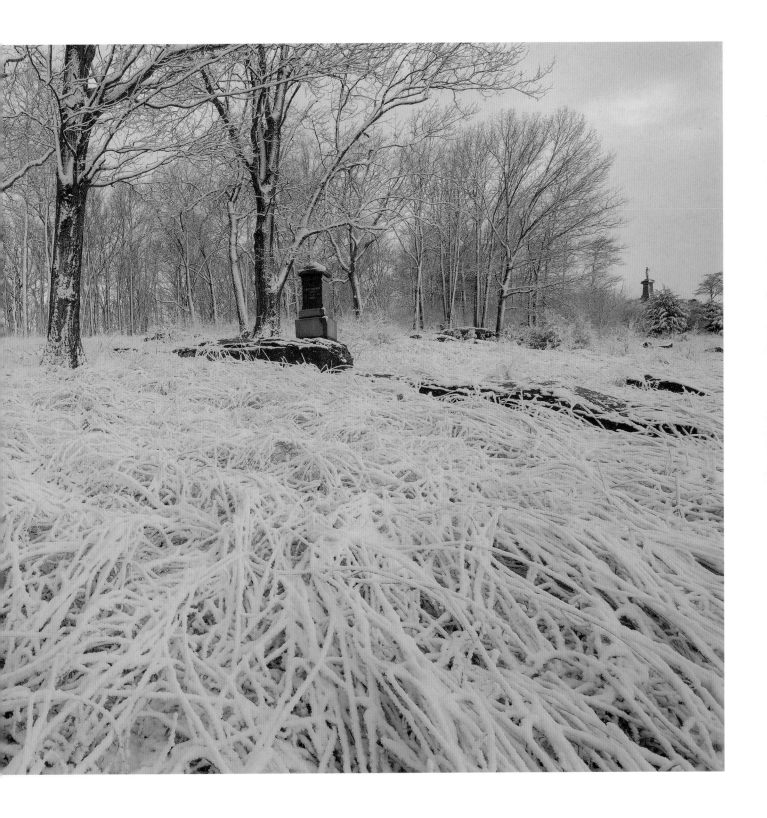

70. *THE SIXTH CIRCLE*

The rain on July 4 was a blessing. The Lord is a very present help in time of trouble. *It washed away the terrible heat and burn of the days before. Through God's grace, I fell in this swale and was not as exposed to the sun as the other wounded. Behold,* the sun shall not smite thee by noonday. *I gave thanks for God's faithfulness all day on July 3, viewing the wounded and dying out in the open under the burning glare in this inferno, this increasingly foul valley.*

That night as the rain began, I gave thanks again. I was immobile, but the Lord provided. I had fallen just near the little creek, and though I felt that I was perishing from thirst, the men able to crawl to the water and put their faces near were drowned by the dozen as the windows of heaven were opened and the creek rose. Putrefying bodies on both sides of me, I offered praise for my deliverance. Yea, I have escaped the snare of the fowler, and the noisome pestilence. *Water came around my head but cooled instead of submerging me.* For surely He hath heard the cry of the humble.

The Lord watched over me all through the war. I recovered from my wounds and served in the Invalid Corps until war's end, offering my testimony to those with ears to hear. One soldier, who had lost his private parts at Chancellorsville, suggested that I become a preacher. After prayerful consideration, I took up the rugged cross. I was blessed with long life, a successful ministry, an accomplished wife, and obedient children.

After many years of faithful service to the Lord, I was called home.

Yet I am here, the scene of my deliverance from death. I rejoice that my ministry was not concluded with my decease. I have been carried and placed here to bring the Word of God to these men hovering over their bloated, burned, and drowned bodies. Yet I am troubled, even unto the point of dismay. I have been here for untold time, preaching God's faithfulness through my own witness, singing psalms of praise for my deliverance and God's unbounded mercy. Has one of these desolate souls listened, much less heard? Has one responded and turned toward the God of Mercy? Perhaps I am to know the true profundity of my deliverance by observing its contrast to the depth of these men's heretical despair. I am made all the more aware of God's gracious gifts through being, as it were, one of the blessed among the damned. For here they are, all about me, shades engulfed in flames of wrath, walking about not hearing my exhortations, though I preach without ceasing. I raise my arms and extol the goodness of the Lord to me, for surely the lines have fallen in pleasant places. *I proclaim the Lord's favor, yet all are deaf to me! Listen to the cacophony of voices, yet none hear mine! They have no hope; they have abandoned hope! Nevertheless I shall go on, as long as I know that* "there but for the grace of God go I." How long, O Lord, how long? ✒

71. *HEAVEN*

I found him here, my boy, in Letterman,
the hospital just east of town, shot through
both lungs, just after they covered him up.
There was nothing I could do for him then.
I held the white hand awhile; wouldn't you?
Wouldn't you have prayed that the bitter cup
could pass from him; that he'd come back to us?
I prayed all of that: my mind was confused.
Finally I walked outside, and I thought,
If God came down to Earth, what would he do?
Would he banish pain? Would he stop the wars?
Or would He wipe his neck and say, 'It's hot'?—
and stand there in His faded coat of blue
beside the pearly, evanescent door. ❧

72. *MYSTERY*

I stood directly in front. At fourteen, I was small for my age, and the gentlemen allowed me to wrest from between them a place at the foot of the speakers' platform. President Lincoln was the tallest man I ever saw. And the darkest. I mean not only his sallow complexion, but it seemed that on him a black suit of clothing was blacker than upon anyone else. And of course, there was the black band upon his arm, for the death of his son, as I learned later. His boy had died almost two years before; the president still wore his grief. I had thought at the time—I noticed the band almost first—that Mr. Lincoln was wearing it for sorrow at the thousands in the ground behind us, who had died in the battle. I thought it was for them.

But as he said, "It is for us, the living," I thought his eye glanced down upon me. Perhaps he was consulting the small sheets of paper that he held, but I felt a glint of light somehow. That is how boys think, I suppose; yet, now long since a man, I feel that glimmer still.

I have read the Address many times, and I have it by memory. What I remember of the president's voice is clarity and how it seemed to carry. He had the strength of a grieving man, speaking to others in grief—the strength nothing in this world can scare. I wondered, Where did this man come from? What brought this man into our world? He seemed more than an ordinary man to me.

As president, he was the nation's voice, of course, a representative, an embodiment of the people as a whole, regardless of their politics. In this, Lincoln was like any other president. But he was also different from the others. No face was like his face. The sorrow and the strength of ages rested there; the eyes of compassion looked out and gathered us. And yet, withal, there was a plainness to his face, an ordinariness that was in some way absolute—plainness that went beyond the representative, beyond the epitome. Can the ordinary have an apotheosis? Can the unexceptional be extraordinary? And let me ask, can homeliness be handsome or even beautiful?

I was almost frightened by his face at first. Then, as he began to speak, the sublimity of that visage, of what it conveyed, carried me above the words. For a few moments, I hardly heard them. I couldn't comprehend that infinitely complex countenance. Abraham Lincoln was the most remarkable person since Christ, and of course, he was shot on Good Friday. I wonder, might the bruise and blood, the gash and disfiguration, of the One bruised for our iniquities have been reimaged, in its sublime grotesqueness, two thousand years later in the features of a burdened man, the suffering and grandeur externally and visibly brought forth?

This savior of our nation, could there be a resurrection other than the one he spoke of: in us, that is, and in those who follow us? That face I saw was the great unknown of my life, even though I looked upon it closer than it was given most mortals to look. I study it within my memory, where it moves through shadows and light. Memory takes me back to that November hillside, before the graves, in midst of civil war; it carries me to grief and sorrow, takes me to the promise of an unspent youth and of a new nation. Wounded for our transgressions; bruised for our iniquities—the finisher and mystery of our faith. Yes, I saw Abraham Lincoln face-to-face. ❧

FOUR MOURNING WOMEN

73. SARAH LINCOLN GRIGSBY

Poor Abraham, brother of my youth
and fellow orphan—O sad, quiet child!
You blamed my husband for my early death,
and now they blame you for all these killed
in their war. You mourn our mother and me
and your own child, your young love, and the life
you might have lived—a life of poetry
with a dear and kindred-spirited wife.
How cruel to put you here, to speak the lines
of a country's sundered heart—sacrifice
all around. How I mourn you, who were kind
and true, Abe! Why must you bear the light
that strikes through you and grows through what you've said
to make a nation of these early dead? ❧

74. NANCY HANKS LINCOLN

He looks like me this afternoon, his face
a melancholy mask of Jesus Christ:
baptism, resurrection, and God's grace—
a hard salvation at an awful price.
I'm not as simple as they'd have me be.
I taught him letters. I taught him to think—
taught him what to do with those ABCs.
I brought him to water, and he did drink.
That is my boy, president of these states—
as good a man as any, better than most,
as sure of his strength as I'm sure of his height.
Seeing him here is like seeing a ghost.
I know what will happen, because it always does;
and he knows it, too. We all do, people like us. ❧

75. ANNE RUTLEDGE

There was a platform here, that clear November
day when we four stood wondering together:
his sister Sally and his two mothers
like the women at the Cross; and the others,
thousands in their bonnets and their mourning black.
I cried for him, and I wanted to go back
to when it was just we two—in the spring
that year there was stillness in everything,
as if the air held two motionless feathers
that would never be swept by the wind—we two together.
That is how I felt here. I understood
how good it would be, eternally good,
if we could have left them here, and their war,
to walk along the river, as we did before. ❧

76. SARAH BUSH LINCOLN

I felt sadness for the others, the three
who left him years ago. They mourned for him
as he mourned them. Abraham said of me—
his stepmother, neither lover nor kin—
that everything he was, or would ever
be, he owed to me. O, I knew better,
and said so to Nancy, and Sally, Anne—
because they made his soul, whatever part
God had left to the work of love and chance
(though I think we do come with our own heart)—
for it is enough, and more than enough,
what he said. He was a gift I got and gave,
because the only thing that lasts is love.
I held his hand, and sent him on his way. ❧

77. SOLDIERS' NATIONAL CEMETERY
Litany for the Dead

"Do you ever pray for them?" he asked, the young man studying for the priesthood. We had started the tour that morning, walking the ground where Wisconsin regiments of the Iron Brigade had fought. Now, as afternoon shadows lengthened, we stood by their graves in the Soldiers' National Cemetery. I didn't answer right away, so he continued with another question: "Would you pray with me a litany for the dead?"

"Certainly. But I'm not a Catholic, you know."

He replied to my hesitation by pulling a small prayer book from his jacket pocket. Holding it open between us, he pointed to the text. "When I stop, you say the next line."

God, the Father of Heaven, he read.

Have mercy on the souls of the faithfully departed, I responded.

Lieutenant Colonel George Stevens, I thought. *The only commissioned officer buried in this cemetery. He wanted to rest with his men, refusing the privilege of shipment home to which all officers were entitled.*

Be merciful; spare them, O Lord, he read. **From all evil, O Lord, deliver them.**

From the gnawing worm of conscience, I responded.

Here lie men of Battery B, Fourth United States Artillery, whose guns defending the seminary blew men of Pender's Division to a spray of blood and bone.

From long-enduring sorrow;

I gazed up across the iron fence into the adjoining Evergreen Cemetery. The afternoon sun gilded the memorial to Virginia Wade, the only civilian killed during the battle. Her true love, Jack Skelly, killed down in Virginia at the beginning of the Gettysburg Campaign, lies near Jennie Wade's grave. His dying message, entrusted to Wesley Culp to deliver to Jennie in Gettysburg, died with Wesley on Culp's Hill. *Are they together now, somewhere above or beyond this graveyard? Or are they separated in eternal nothingness?*

From horrible darkness;

November chill darted through my bones. I wondered how long the litany ran. The seminarian continued:

From the shades of death, where the light of thy countenance shineth not—

Deliver them, O Lord, I read.

From the evils to which immortification in this world must expose them in the other—

Several weeks earlier, I had guided an ROTC staff ride—college students studying not for the priesthood, but for battle. Splendid, respectful young men and women, who would be ordered to kill and burn in defense of our country. Some of them would soon rest in graves like these. *Honor is no comfort to those who must destroy life.*

From the pains of purgatory, so justly inflicted upon unexpiated sins, I recited slowly.

From the torments incomparably greater than the bitterest anguish of this life.

The evening's Ghost Tours would be starting soon, when the sun goes behind South Mountain and the smoky red harvest moon comes over the trees. *Spirits of the haunted dead.*

Hasten the day when Thy faithful shall be delivered from the mansions of sorrow.

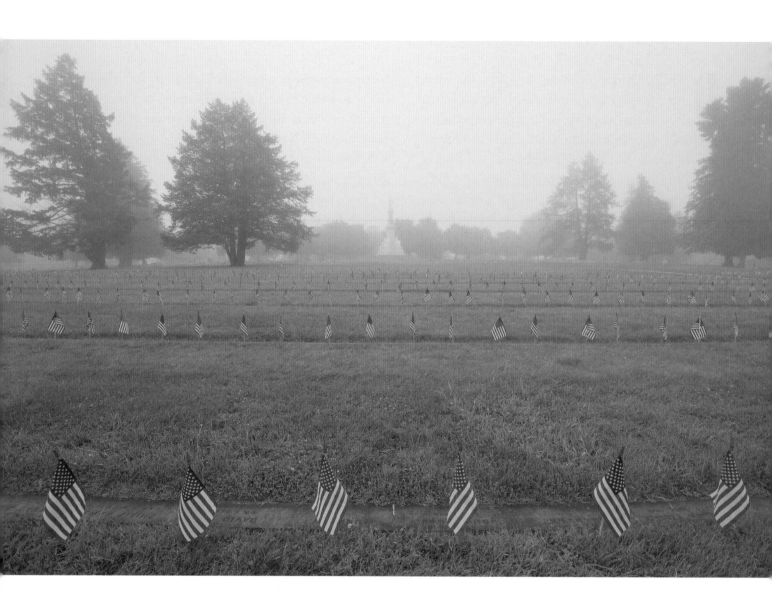

Not far away, the dead of the First Minnesota lay in narrow graves. July 2 was a day that needed many saviors.

May Jesus comfort them, and His unfading glory shine upon them. The seminarian cleared his throat politely, but my attention had not drifted. I was staring at the last lines:

Give them, O Lord, eternal rest, I said at last.

And let perpetual light shine upon them, we read together. **Amen.** ⁊

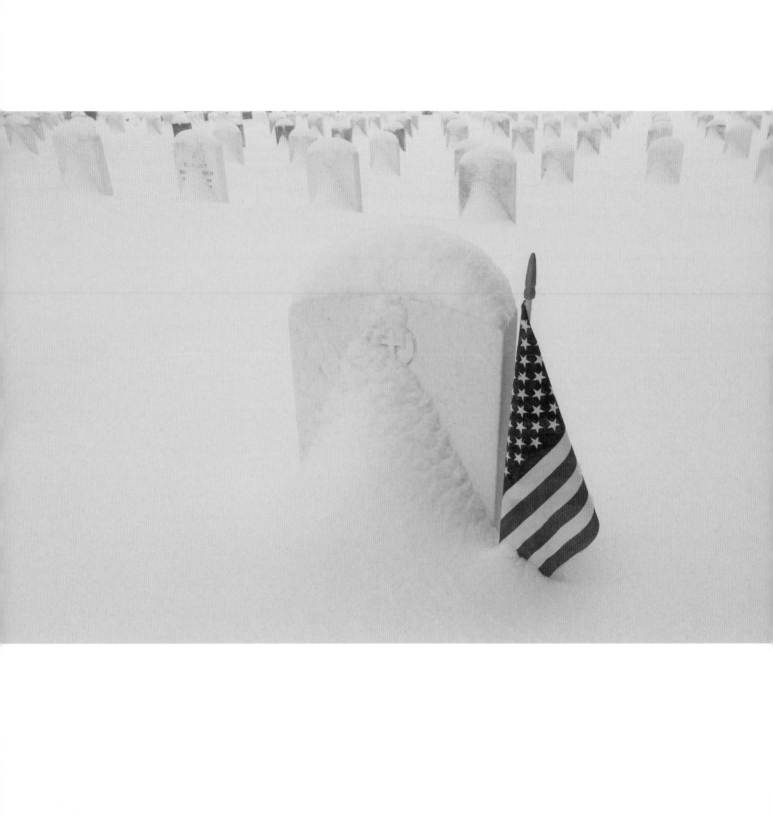

78. BRAHMA

The killer on the battlefield,
The spirits of the silent slain—
I compass both. The iron wheel
I measure, and I turn again.

Behold the secret of these graves—
The Maker and the bones of man:
I am the Savior and the saved;
I perish, and return again.

Betrayer and the Sacred Head,
I am the soldier and the soul;
I am the living and the dead:
I am the portion and the whole.

I am the Harrower in hell,
The sapphire Driver and the driven;
I am the Other and the Self.
Find me, and you have found your heaven. ❧

79. REMEMBRANCE DAY

When I arrived, the crowd had all dispersed, the microphones were gone, the stage where celebrities had sat was empty; only a thousand folding seats remained. The last red leaves of autumn, glowing dimly in brooding crowns of 150-year-old trees, dripped lazily on vacant chairs. Worn from a hurried walk across town and feeling the rocky sleep of a night vexed by nightmares, I walked to the front row and sat down directly under the podium, where politicians had made speeches this Remembrance Day, marking the date, November 19, when Abraham Lincoln had delivered the Gettysburg Address. A Lincoln impersonator had recited the words, as was the custom every year. Lost in thought, I hardly noticed a white-haired man slowly make his way up the steps and across the stage. He came to rest behind the podium. With a steady gaze of apologetic irony, barely acknowledging that I was his sole audience, the old man began to speak:

Many score of years ago, our Fathers brought forth upon this continent a new nation, conceived in liberty, and dedicated to the proposition that all of us are created equal.

It is altogether fitting and proper that we have come to praise that nation, for it was the last, best hope of humankind. Its purple mountain majesties, how beautiful! Its fruited plains, how they fed the homeless, gave refuge to the persecuted, and nourished the aspirations of a grand Republic! How its alabaster cities have gleamed the promise of truth and justice; how their commerce and industry have arsenaled democracy in a raging world! America the Beautiful, how God has seemed to shed His grace on thee! I have come not to praise America, but to bury her. I have come to remember her. I have come to mourn our perishing Republic, to eulogize the fading glories of a resplendent dream.

With a start, I shifted uncomfortably in my hard chair and, without realizing it exactly, must have mumbled an incoherent objection. But the man, whose mournful countenance seemed almost a satire of my own, now looked over me as if gazing at some unseen multitude of the living and the dead.

Perhaps today both our shining seas are calm, but at our coasts the grating roar of moving tides sweeps our shores with human misery. Not long before he died, President Lincoln dreamed he stood upon the deck of some mysterious ship, moving at night across a moonless sea toward a distant, dark, and unknown destination. That end is closer now; the ship approaches its dread and fearsome goal. You hear the ascending, rhythmic roar of surf upon a massive reef. By the dim and flaring starlight, you see the dark, hulking shape of something menacing and vast.

Oh, what a voyage we have sailed! When this good ship was new, how its towering masts gleamed; how its varnished spars shone in the golden sun! How excellent its form; how intricate the pattern of its sinewy rigging; how sure the balance of its oaken keel! In form, how exquisite; in function, how it seemed to skim the pearly waves! Its crew, a varied and contentious lot to be sure, still managed somehow to haul the lines together, to trim the sails as one, to dream the same bright heaven on a verdant Earth. Its skilled and faithful gunners were a match for anything. And its captains! What captains we have had!

But now, what change shadows its decks! The crew is meanly tumultuous, shouting deprecations in confusion. They have forgotten their mission, and dream selfish dreams.

The best lack all conviction, and the worst are clenched with passionate intensity. And on the quarterdeck, where a cankered pilot spins an unresponding wheel, some rough beast, his hour come round at last, slouches across the creaking boards and stands with arms folded, his chin uplifted.

And the ship slides ahead as if on grease, all that great glory spent. Jefferson, who wrote the Dream, sleeps in a dead Enlightenment. Lincoln, the greatest Captain, who brought the Dream to birth anew in tragedy and strife—he was the last Romantic; whatever poets name the book of the people, he spoke here. He stood for what is beautiful, true, and just. He dreamed a Dream where all are judged not by color but by character; not by wealth but by good will; not according to power but by principle. And seas were bright because the countenance of heaven shone in our uplifted faces.

But all is changed, that vessel rudderless, and the ship drifts upon a darkening flood.

I awoke with a jerk, feeling a sudden chill. Shadows of the late November afternoon spread like a fingering tide across the platform and the empty podium. A gauzy cloud of gnats above me rose and fell, drifting as the chilly autumn breeze lived and died, and gathering swallows flitted in the lowering sky. ✒

80. *PAIN*

I helped the Lincoln sojers bury them, and then I helped the doctor dig them out. The doctor fixed to send them all back home down south. Was times he couldn't find a name or photograph to 'dentify the corpse. And other time, most time, was something in the uniform, or with the few remainders—a Bible, maybe, or some letter home had sent—and so he wrote, and mostly they wrote back. Sometime, the people they come up to Gettysburg and take the body home—or what be left, a skeleton and cloth.

The army give me twenty cent for every Rebel I inter. Inter a dozen, and you rich for days. But I inter a good sight more than that. It ain't good work. I mean it good, so: decent. It good for money, too. But it give you dream. You think sometime, How this poor white man die? You see they struggle with the pain. They stiff in shape nobody ever do: they arm an' fis' clench up, and leg twis' together, jus' like they screamin', only very quiet. They grind they teeth 'n' grit, like so. Sometime they still present that awful face.

You see, they lie there under heaven, all expose. The light shine down on them, and then come rain, but nothin' for the pain. I see some men with Bible in they teeth, so they don't scream. But mostly, suh, they jus' lie out and yell. I think they yell and moan for Mama, cry out for Jesus. But ain't no one so alone as a man in pain. Where Jesus in the pain?

I bought my freedom, yes I did. But after I run off and come up north. It be years I work, and then I send that money south to Massa. And money for my wife and girl. But no one come. I think they sick or dead. I never got no paper say I free. I 'spec ol' Massa tuck the money,

that's all. "You be a fool, you send that money," Isaac tell me. I know, I know. But I ain't gon' to be like them, and I ain't got nobody to live with 'cept for me. What Jesus do? A soul ain't property, so I could steal myself and not break no commandment. Sho! But that ain't what the massa think. And I will show the massa, suh, who be the better man.

I dig the sojers in and out, and work as orderly in hospital, and do odd job. They's lots here to repair. So someday after Lincoln sojers whip the South, I travel back and look for my poor wife and daughter, if I can. Meantime, is no help for the pain. I cry mos' night. I think of little baby and my wife. I rather Jesus be with them than me. Jes' let me take the pain. They's something in it, I 'spec, or people wouldn't have no pain. In heaven they won't be no pain; on earth they's nothin' else. It all go back to Adam and Eve. I ask, Why they get us in this terr'ble mess down here? God see them eat that shiny fruit. They think He not gon' see? Why, we both got mo' sense than that. They didn't have no pain; what was the use? Why they want somethin' mo'? Why God want us? The Lord could rested satisfy with all the res' he made, but He mus' go and spoil it all and make a man. And then throw in the woman, too. It don't make sense. Unless God, He in pain. When you in pain, you busy. Look at me. So God, He work six day, and He don't rest until the seventh, when all that could be made be made. They's nothin' left to do. He still in pain. We ack it out.

I learn to read. I read the Bible for myself. I didn't spen' no money on it; it was given to me. The way I read it, they is two Bible: The Ole one, where mos'ly,

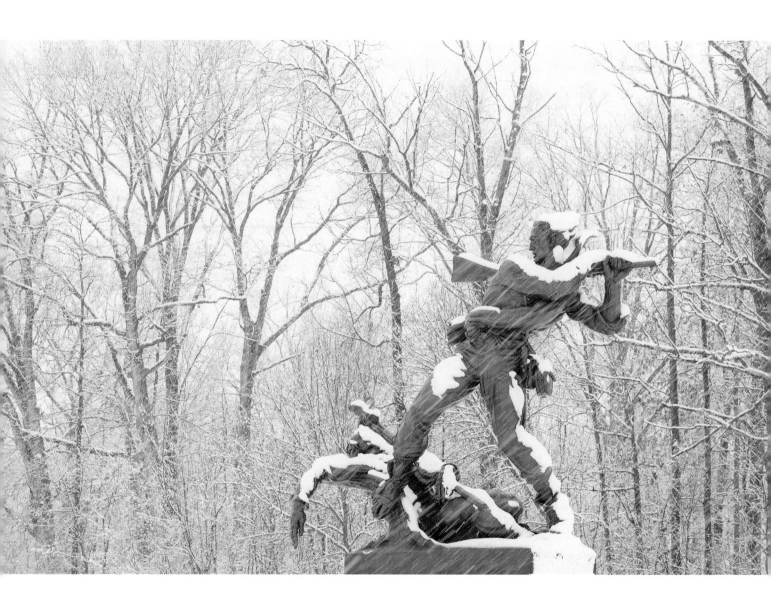

but only mos'ly, they's someone they call God, but He be Massa. Then they's the other one, the New Tes'ment, and God be Jesus, good and makin' trouble with the world and sufferin' pain. He on this battlefield alone. Oh Jesus, Brother Jesus, first we bury you, and then we dig you up: it ain't enough to suffer once. You got to suffer from now on. Help me, Jesus! Help me, Jesus! Only you can understan'. You can understan'. Help me Jesus help you. I want to help you, Jesus—bring you to the Promise Lan'. ❧

81. HARDTACK AND COFFEE

When I was in grade school, I read about how soldiers lived before I read about how they died. My youthful mind thought soldier life was pretty good: a lot of company, hard food but nice and simple, snug quarters in the winter, cards and snowball fights, baseball in the summer. And a few hours of daily drill instead of school seemed not bad at all: no arithmetic.

Only later, I learned about the war's "arithmetic," as Lincoln said of Grant's purpose to grind the Rebels down. On second thought, he used the term before Grant, didn't he? He needed to find someone who would accept and apply the arithmetic. It sounds inhumane, but what else can you do when arithmetic is all there is?

Meanwhile, the "numbers" went on writing letters home, waited for mail, marched through the drills, obeyed the urges to pray or visit the "camp followers"—not knowing that they were digits. I think the very minutiae of daily life is what divides us from ciphers. Do numbers long for home or miss their mothers? Do cardinals and ordinals write to their sweethearts, gamble with their meager pay, get drunk out of desperation, clutch their Testaments and prayer shawls and photographs? As Shylock says, "Cut me, do I not bleed?" Do numbers bleed?

I'm a Jew. Don't talk to me about numbers. Six million, that's a large number. One—that's a number I can comprehend. There was one Jew in Jefferson Davis's cabinet. One Jew here, one Jew there—you've got a Diaspora. One Jew dreaming God's own dreams—you've got a prophet. One God—you've got a universe.

How many Jews served in the Union armies? Quite a few; but I know of only one personally. An ancestor of mine. Then my dad, he served in World War II aboard a carrier. He showed me a picture he shot with his Kodak of a kamikaze going down. I wonder what he thought—his son becomes a war buff. The Civil War. Collects bullets first, one by one. Then articles of uniforms, one by one. A professional man, spends his many dollars one by one, hundreds by hundreds, then thousands, on rifle-muskets, swords, sidearms, and one thing after another.

He told me late in life, "Buy all you want, *Schlemiel*; you'll never fill the hole." "What hole?" I ask him. "The question *Why?*" he says. The question *Why?* is the hole. The big one. Coffee, poker, baseball—nothing fills. The battles only dig it wider. The causes dig it deeper. The results show only that maybe it's really empty in there.

So in the camp, and on the march, what has the soldier got? The little things. A smelly pipe. A deck of cards. A letter from his girl. Little things, like hardtack softened up and fried in grease; a little coffee chewed when there's no time to stop and boil water. A pair of socks from home. Little things. The big thing—that's for God. ❧

82. *BEAUTY AND TRUTH*

Unlike some other spirits of unrest,
I wasn't killed in battle here nor died
of wounds. After the war I went out west.
I married Ruth when I was forty-five.
My wife was proud of me for Gettysburg;
but what I fought for here, only she knew.
Our promise to each other was made with words,
but they held. True hearts keep the old words true.
When I lay dying of the consumption,
she never left my side. I am waiting here
knowing one truth will call the other home.
These shimmering flowers are for Ruth,
who made a faith for me through all those years,
believing that I fought here for the Truth.

I found that army life agreed with me.
Do as you're told: that's all there is to war—
obedience where conscience might be.
Think what you please as you tackle the chores,
and do what you need to get yourself through.
After the end I decided to stay,
for lack of anything better to do.
I liked the work well enough; I got paid.
I thought I never thought about the war—
the past was laid in the eternal past;
what's done's done. That's what the bottle is for.
I suppose it caught up with me at last,
but glories go down slick at ninety proof.
It wasn't beautiful, to tell the truth.

I battled the innocent in Montana;
deserted the army and went for gold.
There was only my reflection in the pan,
and I didn't like it: face without a soul
is what I saw. I gave it up and earned
my daily bread the honest way—enough
to build a house in town and go to church,
though I'd lost belief in anything but
the love that burned in my condemned breast.
My lungs had caught the fire that touched our youth:
to die for Beauty, and to kill for Truth.
Nothing's perfect, maybe not even God,
for all we know. And that is why I came
to love these fragile fields, that mortal blood,
that violent and unfinished faith.
Keeping faith's more beautiful than we knew,
and whatever's beautiful is true.

These flowers everlasting are for you
who kept our faith and turned its beauty into truth. 🙠

83. HONOR (THE REENACTOR)

I played five parts in the movie *Gettysburg*, three Union and two Confederate. Including a guy in the Twentieth Maine. Oh yeah, all that fire you hear in the movie—it's all us. No enhancement. Only imagine what it must have been like on that hill during the battle.

I know it's not realistic. Just ask me if I was ever really killed or wounded in a reenactment or during that filming. The one essential thing about being a Civil War soldier, we don't do: risk our lives. See our buddies killed next to us. See heads go flying in front of artillery, blood spraying, arms spinning into the air. I know, it's more like grown-up boys playing than like Civil War battle.

But I do it for other reasons. I do it to learn. What did wearing a wool uniform in summer feel like? What were buttons made out of? How did they brush their teeth? But mainly, I do it to honor them.

What is honor? Do you read Shakespeare? Falstaff says honor's "a mere scutcheon"—a design on a shield, like on a gravestone or something hanging up in a church. "Who hath it? He that died a Wednesday," he says, and then goes on to act dishonorably. The Japanese died for it in World War II. But nobody can say what it is.

President Lincoln said we can't honor the soldiers who fought on this field: they honored themselves by fighting for a noble cause. I think honor means that you act as if God is watching you, whether you think He's watching right now or not.

To me, reenacting is like serving in the Old Temple in Jerusalem, in Old Testament times. It was where God lived. A battlefield is like that: it's an intersection of heaven and earth. So if you serve in the temple, you honor God, whether you can see Him or not. When I'm in uniform, I am acting as if those noble soldiers who fought here see me, whether they actually do or not. It reminds me to act honorably in everyday life.

I know you've read Shaara's *The Killer Angels*. Sergeant Kilrain listens to Colonel Chamberlain say things like I just said, and then says that's all uplifting and beautiful, but if a man has an angel in him, it must be a killer angel. Maybe it's a devil. Maybe a battlefield is not only an intersection of heaven and earth; it's an intersection of hell and earth. If war isn't hell on earth, I don't know what is. It's rage, it's hate, it's murder. That's the part we don't reenact. Some say it's the essential part.

But I don't think so. The essential part is invisible. It's easy to see the mayhem. But try to see God. That's what I mean by honor: to try to see God when the opposite is visible, and to act on that vision. Some of the men here did that. I serve their memory. I honor them. ⟿

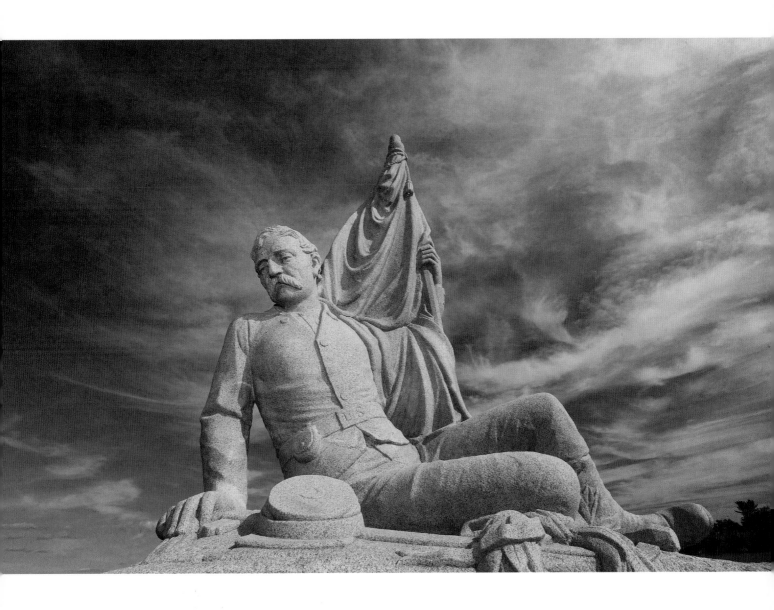

84. MAJOR DUNLOP'S HAT

That's it right there, perfectly preserved. You see the ragged hole where a fragment of shell went in and where his soul went out. A little blood is visible inside, though it's almost black, but I'd rather not unlock the glass case to take it out and show you. Humidity and temperature are controlled. One time a member of his family came in and said she had the right to it. But I said the major's hat belongs to the public, owned by the nation for which he gave his life. It belongs to the ages. She sued my museum, claiming that we charged admission and were a private, for-profit company. We argued that her claim of descent from Major Dunlop was fraudulent, because he had no children. Well, the hat is here, as you can see. It's one of our most popular attractions.

Actually, we didn't know that Major Dunlop had no children, but the burden of proof was on her, and she was no historian. She came to the hearing drunk, or probably on some medication, which did her case no good. All these little things affect the court, which is to say the judge, who is a human being first to last. Essentially, there is no justice. Or at any rate, there is no justice in this world. Justice might be blind, meaning impartial, but I think she's just stone blind, and subject to a pinch now and then.

What's that? I have no idea whether Major Dunlop died for justice. He died for orders, sure enough. For Liberty and Union I might say, but not being a New Englander, he most likely didn't die to abolish slavery. Died to prove he was no coward. He died for his friends is a pretty safe bet, because that's usually what it comes down to in battle. But as to some abstraction—justice, or what have you—one's best not speculating is how I view it. We load on those poor nineteenth-century people a lot of our own ideas, our own hopes and wishes.

Yes, I mentioned Major Dunlop's soul. Does that surprise you? Because you think I have none myself. I'll pass on feeling insulted, because I think the question is a fair one. I mean the question you implied, whether we have souls. I sense your assumption is that we do. But I ask you what it is. If Major Dunlop is somewhere now, alive and well, it's not as Major Dunlop. Maybe a luminescent orb, some eerie floating thing the ghost hunters claim to see. Or he has reentered earthly life as a plumber in Detroit or a rickshaw driver in Calcutta— with no thought of Major Charles Dunlop in his head. Who is he, then? Maybe he's a Civil War buff like you now. Or, say, he could be me.

Now that would be justice. But if there's justice, who's holding the scales? Who's putting a thumb on one of the plates? Let's say the major died for justice. For what? Where is the justice for which the major so nobly died? Do we have it? So he died for nothing, if he died for justice, which, if I remember my high school algebra, means justice is nothing. I mean as a thing in itself. Maybe it's fairness, whatever that is. He died, basically, for people like me to figure out what justice and fairness are. He died, and I'm left holding his hat.

What does that mean? It means that he handed the whole ball of wax to me. Justice is what I say it is. I decide. I am "We the People," and I'm the judge and jury, not someone else, a king or a duke or a dictator. I'm basically corrupt. I'll grant you that. And I'm ignorant. The only person less qualified than I am to govern me is someone else. Died for justice? Well, he died for me. That's what I mean when I say I'm holding his hat. And I'm not letting go. ✍

85. NORTH AND SOUTH

"You know why they don't have uniforms? Oughtn't they have Confederate uniforms? Could be just anyone, this way."

He spoke half to himself, half to me. "I think that's the idea—to represent any soldiers, anywhere, at any time," I said.

"But this is the North Ca'lina monument, ain't it? Kind of a funny idea, if you ask me. Well, I don't know nothin'."

I had seen the North Carolina plates on his Buick LeSabre as I parked near the monument. The man, maybe in his midfifties, wore an old pair of jeans and a clean, old white shirt. He was hatless, with unruly gray hair.

"The sculptor was Gutzon Borglum. He also did Mount Rushmore."

"Ain't been there, but I seen pictures."

"Borglum was kind of odd. He's the one who started Stone Mountain but got angry and quit. He made sculptures of General Sheridan and Abraham Lincoln, but he was a member of the Ku Klux Klan."

"The Klan? Hell. You a professor? You know a lot about this place. I don't know nothin'. Only drove up here yesterday."

"What part of North Carolina are you from?"

"You can tell by the way I talk? Hell, ain't near anything."

"I noticed your license plate. First, I noticed your car. I've always wanted a LeSabre."

"It's a good ol' car. You know where I can find any more markers or some such for North Ca'lina?"

"Well, I could show you a couple. I can show you around the battlefield."

"Oh, I ain't gonna claim all that time from you."

"I've got the time, if you have. I'd be honored to show you around."

"I am much obliged to you, then. Let's go." As we walked toward our cars, he said, "Let's take my car. You always wanted one." He reached the keys toward me. "You drive it."

"I thank you, sir." I took the keys and extended my hand, telling him my first name.

"William," he said. "I am pleased to meet you."

As I drove slowly toward the Virginia Memorial, I said I liked how comfortable and quiet the car was.

"Yeah, it is," he said, looking out his window.

"How long have you had it?"

"Couple months. Ain't my car. My son's car. I never had use for a sedan. I got me a pickup for the farm, and one vehicle is enough to maintain. I don't travel. Hell, I never been outside North Ca'lina till now. Pretty up here."

After getting out to look up at the statue of General Lee, I said, "Let's go back and start at Day One. Where the battle began."

"It was more'n one day?"

"Three days." Evidently he was not a Civil War buff, so as I drove us back around toward McPherson's Ridge, I asked, "What brings you up to Gettysburg now? It's kind of the off-season."

"Oh, I just felt I wanted to see it. My son was a soldier. We lost him about sixty days ago. I just wanted to . . . I don't know." He looked back out his window.

"I am very sorry, William."

"Thank you, kindly. You have any children?"

"Yes I have. Three."

"Then you know. Course, he was my only."

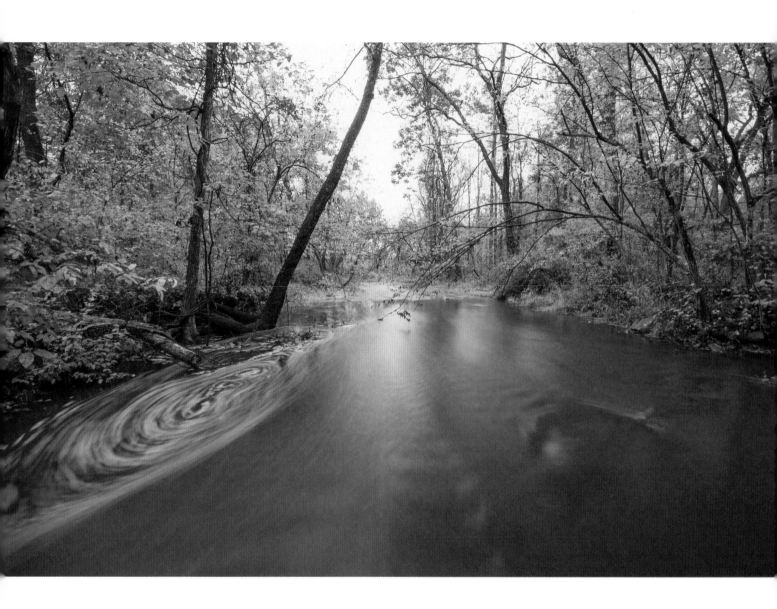

I drove to the Twenty-Sixth North Carolina marker across from the Iron Brigade monuments in Herbst's Woods. As we walked to the pink stone, he said, "It looks brand new, compared to the other ones up there."

"It is one of the newer ones. Most of the monuments on the battlefield were 1880s and '90s. This one is 1960s. There's a matching one on Cemetery Ridge."

"So them boys come up through the woods here."

"They did. Then up the slope of Cemetery Ridge two days later."

"Figures. If you come from where I come from, it's uphill all the way."

"Those two days together, they lost about 80 percent. No one got farther than they did, though, in Pickett's Charge."

"I heard of Pickett's Charge."

I pointed to the Twenty-Fourth Michigan statue. "Those boys from Michigan fought these North Carolinians. The hat's too small; they wore tall, black hats. They lost around 80 percent too."

"Fought each other out."

"Pretty much."

"You must be from up there somewhere."

"I am. Those Wisconsin boys over to our left were my boys."

"Did you have any kin fightin' with them?"

"No. My people came over after the war."

"My people been in North Ca'lina forever."

"Did you have any relatives here at Gettysburg?"

"Hell, might could have been. My great-granddaddy or somebody, I don't know. We was raised by my auntie, and she never talked much."

I nodded. "I had a little bit of that myself."

"Yeah?" he said, looking at me carefully. "I would have thought that up north, they would have put Sissy and me in an orphanage. Down south, we take care of our own. None too well, though. Say," he said suddenly; "this is kind of North and South, you an' me here."

I nodded. "Two old guys at a time."

"Yeah, it goes slow. Hell, I musta been twenty before I learned 'damnyankee' was two words." He laughed a quiet, short laugh.

I said, "I think no matter what people have wanted to believe, the North and South never reconciled with each other."

"Ain't never really forgave, both sides. Ain't nothing ever gon' happen but bad, if we don't."

"You can see that now, in this country."

"It ain't no different now to back then. Ain't my type sends boys to war. I always figured it was your type starts the wars that people like my boy got to go off and fight. Course, you didn't know what you was doin'."

I put my hand on his son's car. "You're right."

He looked up at the stone Michigan soldier. "I kinda think that you forgive me for bein' a Southerner, a hillbilly. And for growin' up hatin' Yankees."

"Surely do. Maybe not till I ran into you, though."

"Just what I mean. Ain't never been treated with respect by a live, breathin' Yankee up till now. Course, I ain't never really met one till now either."

A couple of hours later we returned to my car. We got out of the Buick, and I handed him the keys. Thanked him for the ride, and he thanked me for the tour.

As we shook hands, I said, "I am a writer, William, and someday I will make a memorial to you and your son, the only way I know how." ✐

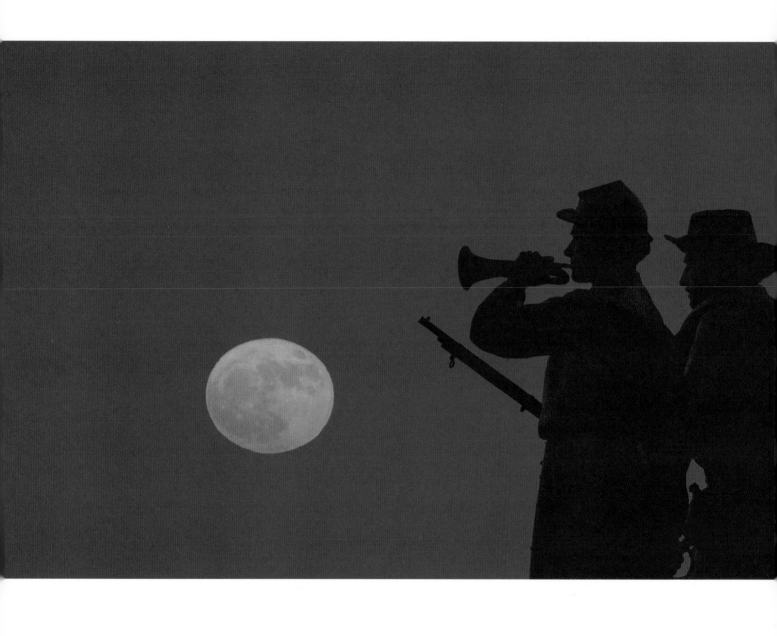

86. *NIGHT*

*N*ight. There were no stars. The sky was heavy, and there dropped a little rain from time to time. The ground, already wet with rain and blood, could soak no more, so rivulets ran here and there in fields, swollen like maggots. You heard and felt the heavy rolling of the Rebel army pulling out, all night. They left their dead. Tomorrow all our own dead would be buried by their comrades. It would be too late.

My mother held the lantern, looking at the men whose faces were turned up. The ones turned down, I had to roll. I cried the whole time, but she didn't seem to notice. The soldiers in the fields who'd lain upon their backs since Wednesday looked like swollen Africans. The sun had burned them black. The ones whose eyes were open frightened me, the whites stood out so hideously, but Mother said they all were dead. The living ones were in the barn or had been carried to the seminary.

"What are we looking for?" I asked, as any child would ask, but Mother didn't answer, only walked on, bending, with the lantern shining on the trampled hay. Then she would light upon a body and would look. "Who are we looking for?" I begged.

"No who, but what," she said, concentrating on the little spread of light ahead of her. "Why must we come out here tonight?" I asked that too. She didn't answer, and I think she couldn't. Three days down cellar had unhinged her mind. I know that now, but I was more afraid of her that night than anything—except the Rebel officer who left the pike and walked his big horse over to us.

"My compliments," he said, a tall, high figure in the dark. His hat was black; his beard looked black against his coal-dark slicker. The stirrups gleamed a little from the lantern, and the horse showed its yellow teeth, chewing on the bit. It threw its head from side to side and tossed, but stood still, while Mother's lantern cast its drippy light. Our clothes were sticking to us in the warmth and drizzle. We weren't the only ones out there: squares and shafts of light spread from the barn and out-buildings where doctors worked. Pale shirts of attendants moved slowly, like dull moths. They carried barrows out and dumped them—arms and feet and legs, I knew—and pails of dark red water.

"You hadn't ought to be out here with this small child, ma'am. May I be of some assistance to you?" Mother shook her head. "Then, ma'am, I'll escort you back to your home." I looked across the dim fields toward the Fairfield Road. It was choked solid with walking men. "Your safety is concerning me, you understand."

She shook her head again. He touched the brim of his hat and said, "Just as you wish, ma'am." The big horse turned and made its way across the field. A horse won't tread on bodies that it sees.

I shivered now, despite the heat. "Please, Mother, why? I want to go back home!"

She looked at me as if she couldn't understand why I would ask, then said, "I'll know the face. I'll recognize him. We'll find it with him, lying on the ground. I saw it in a dream. It's here."

"What's here, Mother?" I pleaded.

"Our Bible that the Rebel stole. He has been punished, as surely as Providence is merciful and just."

I weakly said, "Mother?"

"My father's small, black Bible. It's here. It's out here somewhere."

Far into the night, we looked for the Bible on the field of the dead. 🙤

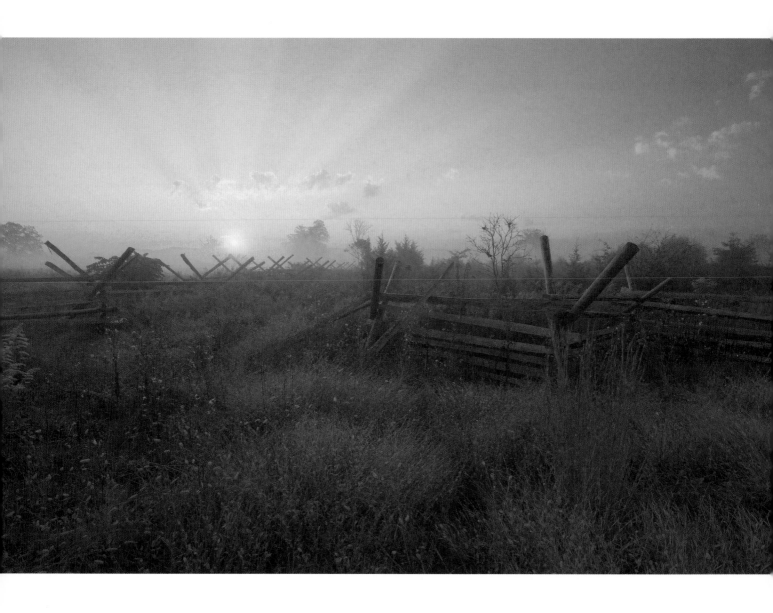

87. *LIGHT*

You living seek the light of ages.
 You crave the courage and the faith
still shed from our ghostly faces—
 some light that lingers after death.
You want to see the mystery we saw,
as if we were the Prophets and the Law.

We dead are painted on the urn
 of time with photographic light;
we walk in beauty now. We burned
 with what each other thought was right,
for truths our armies thought eternal then.
We stand above our passions, marble men

whose light is everywhere you look.
 Our marching songs, soft pipes still play;
our letters are a living book
 illumined by Eternal Day.
Our sacrifice begins again each spring
by nature's art, holy in everything

and careful to the smallest death.
 Don't hallow us: there still remains
for you some work to do, to bless—
 some flickering day to be saved,
a battle to be fought, faith put to test,
before you find your comfort and your rest.

There is a vision to be seen,
 and there is music to be heard;
but there are other, newer fields
 where gleams the terrible swift sword.
We fought our fight for you, and now you stand
under the One whose light is in your hands. ❧

PHOTOGRAPHER'S ACKNOWLEDGMENTS

PHOTOGRAPHER'S APPENDIX

PHOTOGRAPHER'S ACKNOWLEDGMENTS
Chris Heisey

❧ *More notes from the photographer are available online at www.siupress.com/gettysburgnote.* ❧

Doing a book project with Kent Gramm has been a joy. His writings strike me in a profound way. His book *Gettysburg: A Meditation on War and Values,* which I read in the mid-1990s, changed forever how I experience Gettysburg. After savoring that wonderful book, I knew that I wanted to meet this master wordsmith. When we did meet some fifteen years ago, a friendship ensued, and I am the better off for that blessing. Teaming up to do *Gettysburg: The Living and the Dead* and adding my images to his richly woven words have been a revered honor.

Generous people have freely given me help in making this book possible.

No photographer learns this craft on his own. Thirty years ago, Nghia Trung Le taught me photography's basics at our workplace at Holy Spirit Hospital in Camp Hill, Pennsylvania. Shooting images for this book made me gratefully think of him often, since he recently passed from the horrible ravages of ALS. His story of fleeing South Vietnam in 1975, when Saigon fell under Communist rule, is a tale of heroic courage.

I thank Bishop Ronald Gainer for his gracious support. Tim Schropp has been more than generous to me. He helped me "paint the rocks" at Devil's Den with flashlights on a frigid winter night for the star trail image, and it remains one of my favorite photo shoots at Gettysburg. My friends Newt Wertz, Charlie Rulapaugh, and Shane Swetland gave me appreciated input. As did Christian Charity Sister Geralyn Schmidt, an artist whose talent I respect and whose marrow-deep

faith inspires. Rachel Schlegel offered me her able designer's eye, and I am thankful to her.

Teachers have had a positive impact on me, and none more so than Dr. Dalton Smart. I am deeply appreciative of all his mentoring over the past four decades.

The National Park Service has many dedicated professionals who serve quietly. When I locked myself out of my car on a cold evening at Little Round Top, slicing my finger into a bloody mess trying to free my keys, it was a kind park ranger who rescued me, the fool, while not making me feel like one.

I am sincerely grateful for the generous support of Gettysburg College and the Civil War Institute on this project.

Working with Southern Illinois University Press has been a collaborative joy. It takes many skilled hands to cooperate on a book of this style. I say a heartfelt thank-you to Sylvia Frank Rodrigue for minding the details; her professional engagement throughout the entire project has made it an enjoyable endeavor. Judy Verdich and Linda Buhman have been a pleasure to work with, and Linda's deft designing skill made this the handsome book that it has become. Wayne Larsen has also expertly guided the book through its final publication process, and I am grateful to him.

My son, Aaron, is a wonderful son, and it is rewarding to parent him alongside his mother, Kim. When he was a little boy, we spent countless hours climbing rocks, throwing water balloons, sliding down snowy hills, and doing all else that was unforgettable fun. He grew up

in Gettysburg in many ways, and I could not be more proud of him now that he is all grown up.

My cousin, Ken, has been more brother than cousin, and I appreciate his tender support.

Finally, I thank my parents, who passed before this book saw the light. My father taught me to love sunrises, especially summer ones, and my loving mother instilled in me the passion to photograph the way my God-given eyes see altogether fitting.

October 2018

PHOTOGRAPHER'S APPENDIX
Chris Heisey

❧ Complete captions are available at www.siupress.com/gettysburgappendix. ❧

I. *PROLOGUE: THE PHOTOGRAPHER (1863).* Dead Confederate Soldier, Devil's Den
 Alexander Gardner and his assistant Timothy O'Sullivan took this image on July 6, 1863.

I. **THE FIRST DAY.** Union General John Buford Monument, Chambersburg Pike

2. *CAROLINA.* Twenty-Fourth Michigan Monument, Herbst's Woods

3. *INCIDENT.* McPherson's Barn and soybean field, Chambersburg Pike

4. *WHAT IS TRUTH?* McPherson's Ridge

5. *ONE ART.* The Railroad Cut

6. **THE MUSICIAN.** Generals Buford and Reynolds Monuments, Chambersburg Pike

7. *THE SINGER.* Sixth Wisconsin, the Railroad Cut

8. **BLOOD TRAIL.** Virginia worm fence, Trostle Farm

9. *'STANG .* General John Reynolds's death site

10. **THE FORESTER.** Gettysburg Lutheran Seminary reflection

11. *A MIGHTY FORTRESS.* Martin Luther Monument, Gettysburg Lutheran Seminary

12. **SHAME.** Union General Oliver Otis Howard Monument, East Cemetery Hill

13. *IVERSON'S PITS (1927).* Eternal Light Peace Memorial, Oak Ridge

14. *COURAGE.* Virginia Memorial, Seminary Ridge

15. *THE MUSIC TEACHER.* First Regiment Eastern Shore Maryland Monument, Culp's Hill

16. **BARLOW'S KNOLL.** Union General Francis Barlow Monument

17. *ALMSHOUSE.* Graves, Almshouse Cemetery

18. **STAYIN' ALIVE.** Confederate Artillery, Oak Hill

19. **PEACE LIGHT.** Virginia worm fence, Eternal Light Peace Memorial, Oak Hill

20. *ORPHAN.* Virginia worm fence and canola, McLean Farm

II. **THE SECOND DAY.** White-tailed deer skulls, Sherfy Farm

21. *BLOOD AND WATER.* Cemetery Ridge, Codori Farm, Emmitsburg Road

22. **EXCELSIOR.** Seventy-Third New York Monument, Excelsior Field

23. *CAROLINA HELL.* Barley field, Sherfy Farm, Excelsior Field

24. *THE OLD COUNTRY.* Union General Daniel Sickles's wounding site, Trostle Farm

25. *SLÁINTE FOREVER.* Irish Brigade Monument, Rose Woods

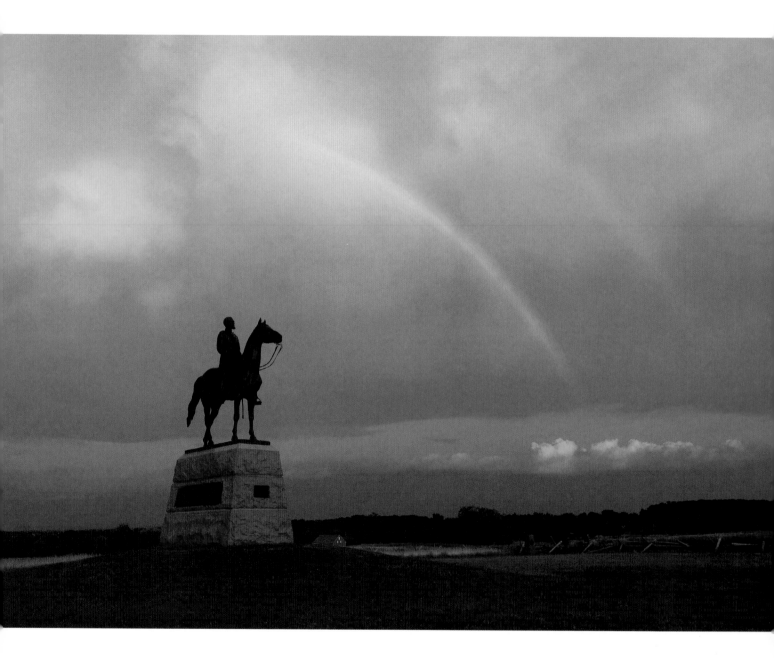

26. *BROTHERS (1863)*. Henry Spangler Farm

27. *SEMPER FI*. Fourteenth Brooklyn Monument, McPherson Ridge

28. *ADAMS COUNTY*. Henry Spangler Farm

29. *THE FACE OF BATTLE*. Little Round Top, Valley of Death

30. TOUR GUIDE. Pennsylvania Memorial, Cemetery Ridge

31. *WAR MEANS FIGHTING*. Praying mantis, Rose Wheatfield

32. *BLUEBIRD*. Fifty-Fourth New York Monument, East Cemetery Hill

33. *REVENANTS*. Seventh New Jersey Monument, Excelsior Field

34. *DEEP RIVER*. Sachs Bridge over Marsh Creek

35. *SURGEON*. Rose Wheatfield

36. *UNREST*. 145th Pennsylvania Monument, Rose Woods

37. *COLONEL CROSS*. Fifth New Hampshire Monument, Houck's Ridge

38. *THE GATE*. 124th New York Monument, Triangular Field

39. *BROTHERS (FALL OF 1968)*. The Angle, Cemetery Ridge

40. *STONE HORSES*. Seventeenth Pennsylvania Monument, McPherson's Ridge

41. *SLEEPWALKING*. Little Round Top at sunset

42. *CHAPLAIN*. Twentieth Maine Monument, Little Round Top

43. *WARREN*. Union General Gouverneur Warren Monument, Little Round Top

44. *VALLEY OF DEATH*. Ninety-Sixth Pennsylvania Monument, Valley of Death

45. *OVERHEARD*. Virginia worm fence, Trostle Farm, Plum Run

46. *FAITH*. Union General William Wells Monument, Big Round Top

47. *FACE-TO-FACE*. Fifty-Third Pennsylvania Monument, Rose Hill

48. *DREAMS*. Seventy-Second Pennsylvania Monument, Cemetery Ridge, at Sunrise

49. *PERISH*. First Minnesota Monument, Cemetery Ridge

50. *ROSA'S REPUBLIC*. Confederate Artillery, Bushman Farm, Warfield Ridge

51. *CULP'S HILL*. 123rd New York Monument, Culp's Hill

52. *POET*. Full moon over Union General Oliver Otis Howard Monument, East Cemetery Hill

53. *MANY MANSIONS*. Sherfy House

54. *PEONIES*. Daylilies, Henry Spangler Farm

55. *NIGHT AT DEVIL'S DEN*. Witness Oak Tree, Star Trail, Devil's Den

III. **THE THIRD DAY.** Friend to Friend Masonic Memorial, Cemetery Hill

56. *THE WOMAN IN WHITE*. Spangler's Spring

57. **CARRY ME BACK.** Confederate General Robert E. Lee, Virginia Memorial

58. *IN MEMORIAM.* Tennessee Memorial, Seminary Ridge

59. *JUDGMENT.* Louisiana Memorial, Seminary Ridge

60. **RAIN.** Spiderweb, North Carolina Memorial

61. **LIGHT IN THE TREES.** Henry Spangler Woods

62. **HOME SWEET HOME.** Virginia worm fence, Codori Farm

63. *BRYAN HOUSE.* 111th New York Monument and Bryan Barn, Cemetery Ridge

64. *STARS AND BARS.* Confederate battle flag and hover fly, North Carolina Marker, Cemetery Ridge

65. *INNOCENCE.* Seventy-Second Pennsylvania Monument, Cemetery Ridge

66. **THE GAME.** Trees shrouded in fog, Trostle Farm

67. *THE UNIVERSAL SOLDIER.* Eleventh Pennsylvania Monument, Oak Ridge

68. *LEGION.* Wild sumac, Houck's Ridge, Devil's Den

69. **WINGS.** Sunrise over Excelsior Field, Trostle Farm

IV. AFTER THE BATTLE. 121st New York Monument, Little Round Top

70. *THE SIXTH CIRCLE.* U.S. flag, National Cemetery

71. *HEAVEN.* Star trail, Devil's Den

72. *MYSTERY.* Abraham Lincoln Emancipation Proclamation Monument, Gettysburg College

73–76. *FOUR MOURNING WOMEN.* Soldiers' National Monument, National Cemetery

77. **SOLDIERS' NATIONAL CEMETERY.** Memorial Day, National Cemetery

78. *BRAHMA.* Veteran's grave, National Cemetery

79. **REMEMBRANCE DAY.** Hoarfrost on elm leaves, National Cemetery

80. *PAIN.* Mississippi Memorial, Seminary Ridge

81. **HARDTACK AND COFFEE.** General Dwight Eisenhower Homestead

82. *BEAUTY AND TRUTH.* Eighty-Third Pennsylvania Monument, Little Round Top

83. **HONOR (THE REENACTOR) .** Twentieth Maine Monument, Little Round Top

84. *MAJOR DUNLOP'S HAT.* Seventy-Fourth Pennsylvania Monument, Howard Avenue

85. **NORTH AND SOUTH.** Willoughby Run

86. *NIGHT.* Virginia Memorial, Seminary Ridge

87. *LIGHT.* Crepuscular rays over Virginia worm fence, Plum Run

BACK-MATTER TITLE PAGE. Confederate General James Longstreet Monument, Pitzer's Woods

PHOTOGRAPHER'S APPENDIX. Union General George Meade Monument, Cemetery Ridge

LAST PAGE. Spiderwebs, Cemetery Ridge

KENT GRAMM has published ten books of nonfiction, poetry, and fiction, including *Sharpsburg*, *Psalms for Skeptics*, and *November: Lincoln's Elegy at Gettysburg*, which was nominated for the Pulitzer Prize. He is the editor of *Battle: The Nature and Consequences of Civil War Combat*. He teaches American literature, creative writing, and Civil War–era studies at Gettysburg College. Gramm enjoys spending time with his children and grandchildren, fishing, and walking the American battlefields. Matching the four score and seven voices of this text with good friend Chris Heisey's striking and beautiful images has been an honor and a pleasure for him. The author is grateful to Sylvia Rodrigue at Southern Illinois University Press for her always cordial professionalism.

CHRIS HEISEY'S images have appeared in more than two hundred publications and media productions worldwide. He has coauthored two previous books, *Gettysburg: This Hallowed Ground* with Kent Gramm and *In the Footsteps of Grant and Lee: The Wilderness thorough Cold Harbor* with Gordon Rhea. Heisey has visited some 380 American battlefields and supports several historic preservation groups whose mission is to save threatened hallowed grounds.

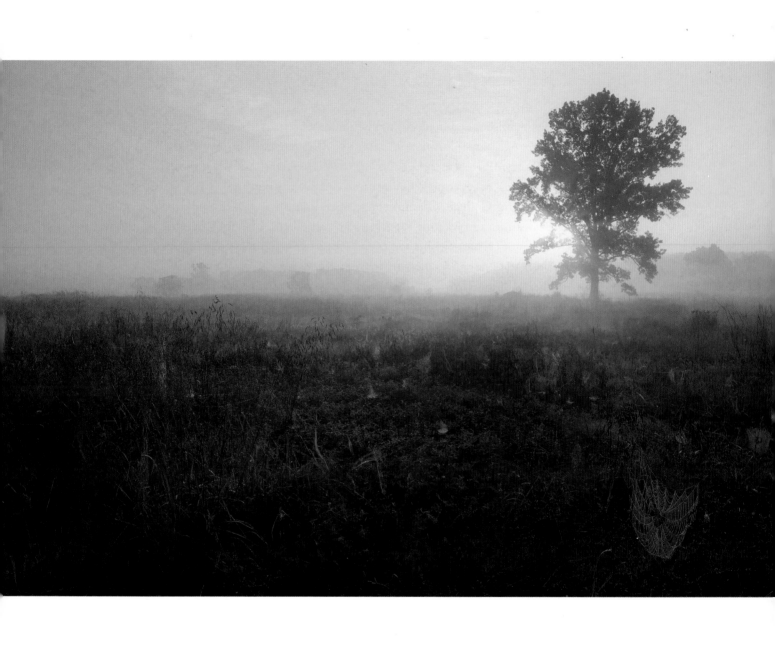